SARGENT'S DAUGHTERS

Sargent's

SARGENT'S DAUGHTERS

Erica E. Hirshler

Daughters

THE BIOGRAPHY OF A PAINTING

MFA PUBLICATIONS

Museum of Fine Arts, Boston

MFA Publications
Museum of Fine Arts, Boston
465 Huntington Avenue
Boston, Massachusetts 02115
www.mfa.org/publications

Generous support for this publication was pro-
vided by the Vance Wall Foundation.

ISBN: 978-0-87846-742-6

Library of Congress Control Number:
2009927634

The Museum of Fine Arts, Boston, is a nonprofit
institution devoted to the promotion and appre-
ciation of the creative arts. The Museum endeav-
ors to respect the copyrights of all authors and
creators in a manner consistent with its nonprofit
educational mission. If you feel any material has
been included in this publication improperly,
please contact the Department of Rights and
Licensing at 617 267 9300, or by mail at the
above address.

The Museum is proud to be a leader within the
American museum community in sharing the
objects in its collection via its Web site. Currently,
information about more than 330,000 objects is
available to the public worldwide. To learn more
about the MFA's collections, including provenance,
publication, and exhibition history, kindly visit
www.mfa.org/collections.

For a complete listing of MFA publications, please
contact the publisher at the above address, or call
617 369 3438.

Edited by Sarah McGaughey Tremblay
Copyedited by Marlowe Bergendoff
Designed by Carl W. Scarbrough
Produced by Terry McAweeney

Available through D.A.P. /
Distributed Art Publishers
155 Sixth Avenue, 2nd floor
New York, New York 10013
Tel.: 212 627 1999 · Fax: 212 627 9484

Second Printing
Printed and bound in
the United States of America
This book was printed on acid-free paper.

Contents

UNLIKE SARGENT'S PAINTING, which was made over the course of only a few months, this book has taken many years to complete. *The Daughters of Edward Darley Boit* has captivated me for more than thirty. I was a teenager when I first saw it at the MFA – a college freshman, only a couple of years older than the eldest girl who stands in the shadowy depths of the canvas and quite a bit younger than the artist who depicted her. Sargent's daughters stayed with me, and I with them, through college, graduate school, internships, and curatorial positions. I have followed the painting as it moved from gallery to gallery within the museum and when it went on tour to other places. Once, as an eager young employee anxious to please the curator and the museum's public relations photographer, I even dressed in a white pinafore and stood with one of the large vases that appear in the painting. It was an uncomfortable pose. How, I wondered, did it all come to happen?

Books and archives, conversations and coincidences have provided new information and insights. I have also simply looked – hard and over a long time. Two exhibitions and their accompanying catalogues gave me an opportunity to write about *The Daughters of Edward Darley Boit* in different ways, one in the context of Sargent's portraits of children and the role they played in his career (Barbara Gallati's *Great*

Expectations: John Singer Sargent Painting Children, at the Brooklyn Museum in 2004), and one in the context of Paris, the art capital of the nineteenth century and a magnet for both Sargent and the Boits (*Americans in Paris, 1860–1900*, with Kathleen Adler and H. Barbara Weinberg, at the National Gallery in London, the Museum of Fine Arts, Boston, and the Metropolitan Museum of Art in 2005–6). Both of those projects only whetted my appetite to learn more about this great painting, and I have continued to work on it ever since. I am not yet sated – a masterpiece always leaves one yearning – but the following pages do provide an abundant feast.

The responsibilities and demands of curatorial work are many, and thus it is with special gratitude that I thank Malcolm Rogers, Ann and Graham Gund Director of the Museum of Fine Arts, Boston, and Elliot Bostwick Davis, John Moors Cabot Chair, Art of the Americas, for giving me their encouragement and support – and the time – to pursue this project, which was unrelated to an exhibition or program. Mark Polizzotti, Director of Publications and Intellectual Property, was keen about my proposal from the beginning, and helped me to shape my ideas into a book that we hope will have both scholarly and popular appeal. Sarah McGaughey Tremblay was a gentle and encouraging editor, and my text has benefited enormously from her careful eye. The Vance Wall Foundation, Lynne and Frank Wisneski, and the Croll Fund for Research and Publications on American Paintings have provided critical support for this publication, and I am truly grateful to them for their generosity and commitment to scholarship.

I have been honored by the support of a circle of amazing women. Chief among them is Carol Wall, who has not only been an advocate, sharing my fascination with Sargent, his sitters, and the stories behind them, but also, with her husband Terry, a treasured friend.

The late Lynne Wisneski began her Sargent odyssey with me in 1999; her interest and zest for exploring new places and ideas are deeply missed. Peggy Morrison gave me a great gift – her time – and her preliminary work with the Robert Boit diaries made my own path through them easier to follow. Elizabeth Mandel provided much-needed research assistance at a crucial moment. Deborah Davis and Deborah Weisgall both led by example.

I am indebted to a group whom I call, with great affection, the Sargent squad. Richard Ormond, Elaine Kilmurray, Elizabeth Oustinoff, and Warren Adelson, authors of the Sargent catalogue raisonné, have been incredibly generous with ideas, research materials, photographs, and their own infectious enthusiasm for all things Sargent. Marc Simpson assisted with the most arcane of inquiries and tried to keep me tethered to reality. Trevor Fairbrother, for whom I wore that pinafore so many years ago, made me think about Sargent in new, smart ways every time I opened one of his books. Kathy Adler helped me to keep in mind the international context of the artist and his sitters. Kathy, Richard, and Elaine all read early versions of my manuscript, for which they deserve not only gold stars for wading through muddy prose but sincere thanks for helping me to better shape my text. Any errors are mine, not theirs.

For answers to research queries, patience with my obsessions, skillful production assistance and design, and assistance in a variety of other ways, I would also like to thank: Marlowe Bergendoff, Isabelle Black, Sarah Cash, Cynara Crandall, John Davis, David Dearinger, Peter Drummey, Eleanor Dwight, Tara Elliott, Paul Fisher, Richard and Susan Flier, Isabelle and Dick Frost, Barbara Gallati, Bill Gerdts, Katie Getchell, Sandra Goroff, Nancy Whipple Grinnell, Barbara Hostetter, Gisela Jahn, Marrian Johnson, Rhona MacBeth, Terry McAweeney,

Maureen Melton, Honor Moore, Jennifer Riley, Ellen Roberts, Carl W. Scarbrough, George T. M. Shackelford, Robert Sidorsky, Jodi Simpson, Ted Stebbins, Richard Virr, Barbara Weinberg, Francis H. Williams, Rosella Mamoli Zorzi, and some anonymous friends. I also am so grateful to my father, Eric Hirshler, who recognized my time constraints, offered encouragement, and helped me to read several letters and manuscripts.

I give heartfelt thanks and all my love to my husband, Harry, who not only willingly undertook the obligation of several research trips to Paris (!), but who also read and reread the manuscript, shopped and cooked, inspired and encouraged me, and gracefully put up with a wife who spent all too many weekends glued to a computer screen. This book simply would not have happened without him. I dedicate it to all the women whose lives, like those of Florie, Jeanie, Isa, and Julia Boit, have been obscured by the conventions of proper behavior and the shadows of art and history.

ERICA E. HIRSHLER
Croll Senior Curator of Paintings
Art of the Americas
Museum of Fine Arts, Boston
Spring 2009

x

SARGENT'S DAUGHTERS

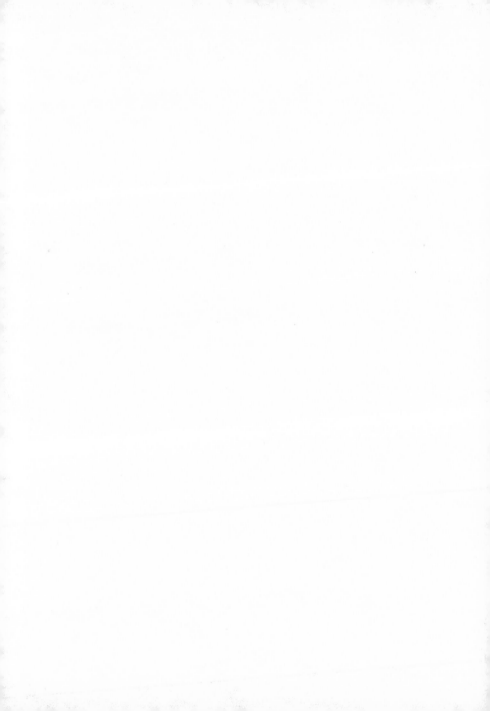

Sargent's Daughters

*J*OHN SINGER SARGENT never had daughters – or, in fact, any actual children. He left instead a legacy of a different kind, one of canvas and paint rather than flesh and blood. Today his sons and daughters hang in museums and galleries around the world; they seem as vividly alive as they did when they left the artist's studio in the nineteenth century. But one painting of children stands out from all the rest: *The Daughters of Edward Darley Boit*, a large picture of four plainly dressed young girls in a vast and indistinct room. They were the children of friends of Sargent's, and their parents allowed him to create a portrait of them that is barely a likeness, a painting that skirts the very definition of the genre. It is a haunting scene, one that has captivated and puzzled viewers for more than a hundred years. These girls are truly Sargent's daughters, his creation if not his progeny. Through them, Sargent's place in history has been assured. As the artist himself commented, Boit portraits had always brought him luck.[1]

The pages that follow are a biography, but not just of Sargent, or Edward Boit, or his four daughters. It is all three of those things and more, a rich tale of painter and patron, friends and families, privacy and public display, fame and obscurity. It is a story about how the portrait came to be made and what happened after it was finished, both to the people involved and to the object itself, the great work of art that now hangs at the Museum of Fine Arts, Boston. It is also an account of how viewers reacted to this unusual picture when it

was first displayed and how perceptions of it have changed over time. This is the biography of a painting.

Sargent's daughters were the children of Boston artist Edward Darley Boit and his wife Mary Louisa Cushing Boit, more familiarly known as Ned and Isa. Their girls were eight-year-old Mary Louisa, named for her mother and like her called Isa, standing demurely at the left in the painting; four-year-old Julia (nicknamed Ya-Ya) sitting on the floor; Florence (Florie), at fourteen the eldest, leaning against the vase in the background; and twelve-year-old Jane (Jeanie) hovering in the dim light beside her. The Boits and Sargent met in Paris, where all of them had lived since the mid-1870s. With numerous friends (including novelist Henry James) and interests in common, Ned and Isa had many opportunities to cross paths with Sargent. They all loved art and music; they shared a passion for Italy, an appetite for travel, and the untethered experience of being Americans abroad. In the fall of 1882, they collaborated to produce a masterpiece on canvas.

Their relationship did not end there. Unlike many portrait commissions, which most often are simple business transactions that conclude when the painting is complete, Sargent's relationship with the Boit family was long lasting and complex. He stayed with the Boits when he came to Boston in 1887, his first working trip to the United States. They kept in touch directly, in person and by post, and also indirectly, as their news was shared in the letters of their friends, including Henry James. The Boits and Sargent socialized with one another in London, after Sargent had established his studio practice there. And more than twenty-five years after the portrait was made, Sargent and Ned Boit collaborated on two joint exhibitions, watercolor displays that would demonstrate their relative strengths as painters and foretell each man's lasting reputation.

Today John Sargent is heralded as one of the nineteenth century's most brilliant artists, while Ned Boit has largely been forgotten. Isa Boit, the girls' mother, is often entirely unmentioned, even though her ebullient personality is clearly evident in Sargent's 1887 portrait of her. Few people are familiar with what happened to the girls, although some know that none of them ever married, and others have heard that they were crazy; the two ideas are sometimes inextricably linked in people's imaginations. The oversized Japanese vases that now flank the painting in the MFA's galleries are the only extant remnants of the Boits' plush lifestyle, which was full of people and possessions, trunks, harps, and canaries. The scalloped rims of the vases are damaged, a testament to the activities of their owners, who moved continuously within the glittering cocoon of expatriate life in Europe and who traveled back and forth across the Atlantic by steamship as regularly and easily as if they were frequent fliers boarding an airplane.

The Boits' lives have been partially reconstructed here, based on a wealth of documentation that remains, alas, frustratingly incomplete. Ned Boit's parents carefully saved the long and descriptive letters he wrote to them during his first trip to Europe in 1866–67. Ned himself kept a diary, briefly noting in it his daily activities, but the only volumes known to survive begin in 1885, three years after the portrait was painted. His younger brother Robert, called Bob, was the responsible businessman who stayed home and looked after most of the family's affairs. Bob was also the family historian, publishing a genealogical account of the Boit family and making lengthy, eloquent journal entries in a series of large ledger books that he later bequeathed to the Massachusetts Historical Society. Sealed from public view until fifty years after his death, Bob's diaries now add vivid details to the story, albeit frequently from a transatlantic distance.

Henry James's voluminous correspondence includes mentions of the Boits and their children beginning in 1873, his insights often related in letters to their mutual friend Henrietta (Etta) Reubell, unpublished pages now in the collection of Houghton Library at Harvard University. James's correspondence with Sargent does not survive, and Sargent, unfortunately, seems to have "binned everything as he went along," in the words of his great-nephew and biographer Richard Ormond.[2] Scattered letters from the painter concerning the Boits survive, some of them saved by Bob Boit, who carefully pasted them into his diaries.

And what of the Boit daughters themselves? Did they, like so many other women of their generation, write expansive letters and keep diaries? If they did, they have never been found, and perhaps they never will. "My sisters and I," confessed Julia Boit in 1960, "had to destroy all old letters + papers when we left Italy after my father's death – We were selling our property when World War One took place ... we had great difficulty." She added that their destruction was "a pity ... but when we had to leave our house in Italy we had to leave in a hurry as we were only allowed there for a fortnight owing to the war."[3] The few known photographs of Julia and her sisters have turned up serendipitously in the albums of other family members; there are a handful of letters here and there, but they are only scraps from a richly appointed table.

One important document remains – the painting itself, with its memorable likeness of four young girls dressed in white. In it, the children look as if they were playing some mysterious game. The littlest one, silent and observant, sits in the foreground with her doll. She looks charming, with her straight-cropped bangs, round face, and inward-pointing toes. To the left and further back stands another,

slightly older, pretty, and very still. With her arms clasped behind her back and one foot slightly in front of the other, she seems about to rise on her toes, a little ballerina. The two older children are in the back, in shadow, and harder to see. One mirrors the position of the girl at left, although her hands have fallen to her sides. Her face is the liveliest: her mouth is slightly open, as if she had just been speaking or moving about. The fourth leans back, the curve of her spine aligned with the shape of the large vase behind her. It seems as if we could walk right into their world, passing straight through to their enchanted dark space, where impossibly huge vases glimmer in the half-light. But when we get close to the girls, they vanish, dissolving into a jumble of paint, great slashing strokes of whites, pinks, greens, blacks, and browns, just as the history of their lives is fractured by incomplete documentation, stray whispers, and silence.

The painting itself continues to speak. Watching people look at it in the museum's galleries can be fascinating. Viewers seem to spend more time with it than they do with others in the room where it hangs. Often they are artists, bewitched by Sargent's ability with the brush. Sometimes they are mothers who use the picture's accessibility – the youngest girl sits so close to the visitor – to engage their own small children. Some visitors beg the museum staff for admission to the gallery if the room is closed for an installation, usually recounting the long distances they have traveled just to see this one thing, this icon, this masterpiece. People weep in front of it. James Elkins, in his book *Pictures and Tears*, a meditation on the emotional responses art can generate, wrote of a man who shared with him the fact that whenever he and his wife visited the MFA, "she goes to see John Singer Sargent's *Daughters of Edward D. Boit*. She stands there, crying, for about twenty minutes. He says she has never offered him

any explanation ... there may be a quality in the painting that disturbs memories this woman cannot quite recover."[4] Elkins assumes her recollections are unhappy, based on some ineffable discontent she sees reflected in the portrait – but they could equally be based on wistfulness, or loss, or even sentimental desire.

Reactions to the painting are often intensely personal and seem solidly rooted in the viewer's own relationships. Art historians are taught and reminded that it is impossible to be impartial, that every analysis is colored by the experiences of an individual observer at a specific time. Even so, *The Daughters of Edward Darley Boit* has elicited more interpretation than most portraits of children. Many have been tempted to see the Boit daughters enacting a narrative of the stages of childhood, from toddler to adolescent. This vision has caused other ghosts to appear alongside the girls, most notably those of twentieth-century psychologists like G. Stanley Hall and Sigmund Freud. With their theories in mind, some viewers look at Sargent's portrait through a veil of psychoanalysis, watching the girls turning inward as they age, transformed from the uninhibited (open, light) life of childhood to a more restricted (closed, dark) world of adolescence and adulthood. In consequence and over time, the painting has been interpreted in many different ways. Soon after it was finished, James described it as a "happy play-world of a family of charming children." The author later demonstrated in his novel *The Turn of the Screw* (1898) that he knew something about children and evil, but he saw nothing unusual in Sargent's depiction. In contrast, an anonymous blogger in 2005 found the image distinctly unpleasant, proposing that the "availability" of the youngest child, sitting in the light with her doll between her legs, meant something quite different from innocent play.[5]

How could such a transformation from purity to corruption take place? Or is that later interpretation entirely off the mark, revealing more about the observer than the observed? Is the painting a simple portrait, a complicated artistic problem, an emotional treatise, or some intoxicating combination? Who was John Sargent in 1882, and what did he see and/or seek that year when he painted these girls? What role did the Boits play in its artistic conception? Does the fact that none of the girls later married have any relevance to our understanding of a painting made when they were children? How and when did their portrait come to represent to so many viewers an illustration of defined psychological traits?

The goal of this book is to explore, insofar as it is possible, all of those questions: to investigate and bring to life the story of the artist, his patrons, and his sitters, and to relate what happened to all of them after the portrait was made. The painting – a physical object – also has a narrative, enacted both before and after its dramatis personæ had passed from the world. These stories can be told without destroying any of the special magic this canvas weaves, for one of the powers a masterpiece exerts is its ability to speak to many people in countless ways over a long period of time. Sargent's viewers, both past and present, have interacted with *The Daughters of Edward Darley Boit* on a variety of levels. There is no right or wrong response, no single way to react, no one path to falling in love. From this singular picture, a novel unfolds.

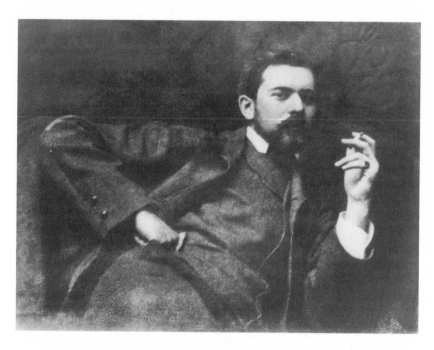

Sargent in about 1883

John Singer Sargent

OHN SINGER SARGENT'S *Daughters of Edward Darley Boit* is one of the paintings that his friend Henry James, both novelist and art critic, had in mind when he wrote that the artist possessed a "slightly 'uncanny' spectacle of a talent which on the very threshold of its career has nothing more to learn." Sargent's sense of design, his ability to capture character, and his facility with a brush were remarkable. He also had an almost unerring sense of how to establish a professional reputation, making and selecting for display paintings that would attract attention for their dash and daring but that would not be dismissed as too avant-garde. In his early years, the artist was careful to show both portraits and subject pictures, perhaps as yet uncertain as to which genre would provide him with the best path to critical acclaim.[6] In Sargent's *Daughters*, the two kinds of subjects he favored are inextricably linked. Both a likeness and a genre scene, the painting brilliantly combines specificity and mystery.

Sargent was a talented young artist in 1882, the year he painted Ned and Isa Boit's daughters. Like his patrons, he was an American thoroughly at home in Europe. He had even been born abroad, in Florence, to expatriate American parents who traveled perpetually from Italy to Switzerland, France, Germany, and back again. His father, Fitzwilliam Sargent, was a quiet physician from Philadelphia, although the family originated in Massachusetts. Fitzwilliam had given up his medical practice at the urging of his wife, Mary Newbold Singer Sargent, a forceful, restless, romantic personality and an amateur watercolor

painter; she, like the Boits, much preferred life in Europe to the United States. Sargent grew up with two sisters: Emily, a year younger and his constant companion, and Violet, who was fourteen years younger. (Violet was the same age as Ned and Isa Boit's daughter Jane.) Described by his childhood friend Vernon Lee as "an accentless mongrel," Sargent spoke and read four languages fluently. He loved music, was a talented pianist, and befriended many composers and performers. These literary and musical interests provided amusement for Sargent, but they never took him away from his devotion to painting. From a young age, he sketched constantly, and by 1870 his father was reporting, "My boy John seems to have a strong desire to be an Artist by profession."[7]

Sargent first studied art at the Accademia delle Belle Arti in Florence, but in 1874, when he was eighteen, his parents decided to move the family to Paris, where their son could take advantage of the best training programs available. There, Sargent enrolled at the Ecole des Beaux-Arts, the illustrious state-sponsored art school that emphasized instruction in the traditional skills of academic figure drawing and painting. He also joined the atelier of Charles-Auguste Emile Durand, known as Carolus-Duran, a young, popular, and fashionable French portraitist who had won acclaim for his bravura approach to painting and for his exciting images of stylish society women.

Paris in the 1870s had taken its place as the art capital of the Western world. Earlier in the century, Rome had been the city that attracted an international audience of aspiring artists, lured there by the remnants of the classical past. But Paris looked forward rather than back. During the Second Empire (1848–70), when France was led by Napoleon III (first as president and later as emperor), the city was reinvented – both physically, with the dramatic reorganization

of streets and neighborhoods undertaken by Baron Haussmann, and psychologically, with the establishment of the city as the world's hub of elegance and style. Government patronage raised the standards of artistic training and also helped to promote the desirability of French art; both actions made Paris a magnet for aspiring painters and collectors from around the globe. These activities were only briefly interrupted by the destruction caused by the Franco-Prussian War (1870–71) and its aftermath; when the violence had ceased, and despite the continually shifting political landscape of the Third Republic (1871–1940), Paris easily resumed its position as a cultural capital.[8]

The art world in Paris was multifaceted and complex, and was soon divided between convention and innovation. The Ecole des Beaux-Arts, which had been founded in 1648, promoted a time-honored approach to artistic training, favoring a methodical series of courses that allowed its students to master the represention of the human form. With these programs and through the annual state-sponsored exhibition called the Salon, traditionalists promoted art that dealt with uplifting historical and religious themes, crafted with scholarly precision and to such a high degree of finish that viewers were meant to perceive these paintings as windows into another world. At the same time, building upon the radical innovations of midcentury French painters like Gustave Courbet, who felt that art should reflect the real world rather than idealized visions, other artists began to reject academic principles, instead making paintings that represented contemporary motifs and celebrated the evidence of the maker's hand. Scenes of rural labor, images of the city, and other motifs drawn from modern life grew in popularity. Paintings once considered too abbreviated and sketchy for public display were now accepted as finished works. Critics had been debating the bold paintings of Edouard

Manet since the 1860s, torn by his simultaneous respect for tradition and his translation of such images into a relentlessly new vocabulary. In his *Olympia* (1863, Musée d'Orsay), for example, Manet used a traditional subject – the female nude – but instead of veiling her in the cloak of mythology, he deliberately chose an obviously contemporary model and setting and employed a singularly flat and direct application of paint. Into the midst of this intoxicating mix came the Impressionists, painters whom Manet befriended and supported. These independent artists held their first joint exhibition in May 1874, showing works that told no uplifting narratives, that represented only glimpses of the ordinary activities of the modern world, and that emphasized the individual gestures of the artist's brush. Sargent and his family arrived in Paris the day after the show closed.

There can be no doubt that almost from the moment he started studying with Carolus, Sargent was at the head of his class. His fellow student and friend James Carroll Beckwith reported of him, "His work makes me shake myself," while Edwin Blashfield recalled "a Boston boy named Sargent, a painter who was the envy of the whole studio and perhaps a bit the envy of Carolus, himself."[9] From his teacher, Sargent acquired much more than lessons in technique. At about this time, the French writer and critic Emile Zola had dubbed Carolus "a clever man" for his ability to make the avant-garde palatable. According to Zola, Sargent's tutor was able to take the innovations of the controversial Manet and make them "comprehensible to the man in the street." He "dr[ew] his inspiration from [Manet] but within limits, seasoning it to suit public taste," Zola explained.[10] Though Carolus had been an early admirer of Courbet's realism and was a friend of Manet's, his own mature work was less challenging. He shared Manet's interest in Spain and Spanish art, and echoes of its painterly flu-

ency are clearly evident in his work. His portraits and figural compositions, with their attention to fashion, glance, and gesture, vividly document contemporary life. Carolus's paintings were exciting and sometimes suggestive, but they never crossed the line into confrontation or vulgarity, charges that had been leveled against Manet's work. Instead, Carolus managed to combine modernism with tradition, earning himself a place as a refreshingly new painter but not a shocking one. Sargent picked up that skill from his French master, learning it alongside Carolus's advice on technique and his recommendation to put the study of the seventeenth-century Spanish painter Diego Velázquez at the top of his agenda. Sargent was interested and inspired by the art of the modern movement, but like his teacher, he merged those innovations with tradition, amalgamating a wide variety of sources into felicitous and adventurous works that could be appreciated by a wide range of viewers.

Despite his natural artistic abilities, Sargent took nothing for granted and spent the next three years working steadily to develop his technique and to train his eye, studying both the old and the new. He visited museums and the Salon, and in April 1876 went to the second group exhibition of the Impressionists at the Galerie Durand-Ruel, where he would have seen works by Claude Monet (whom he is said to have met), Edgar Degas, Berthe Morisot, and many others. A month later, he had left the studio he shared with Beckwith at 73 rue Notre Dame des Champs and was aboard the SS *Abyssinia* with his mother and sister, making his first trip to America, the homeland he had never seen. He went to Philadelphia, meeting relatives and family friends and attending the Centennial Exposition, where he was entranced by the extensive display of Japanese art. Sargent traveled to Newport, New York, and up to Montréal; he saw Niagara Falls

with his family and then journeyed with a friend from Paris as far west as Chicago, but by October he was back at his studies in Paris. That winter, he began his first important portrait, a likeness of his friend and fellow American Fanny Watts.

Sargent would paint many Americans in Paris, including the Boit girls, but aside from his family, Fanny was the first one to model for a formal portrait. He intended to display the canvas in the spring of 1877 at the Salon. The show, a juried competition, was the pre-eminent place for contemporary artists to achieve critical recognition, and it would be Sargent's first public exhibition. For this important occasion, it seems likely that (instead of fulfilling a commission from the Watts family) Sargent asked Fanny to sit for him, a common practice among aspiring young painters, who recorded one another or their families or friends in a bid to establish their careers. The strategy worked for Sargent: the portrait was accepted by the jury and was well received, he started to be offered some commissions, and he was honored the following year when his teacher Carolus agreed to pose for him.

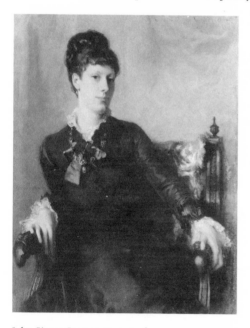

John Singer Sargent, *Portrait of Frances Sherborne Ridley Watts*, 1877

Despite this early and immediate acclaim as a portrait painter,

although it seems likely that their attachment was exaggerated by Louise's mother, to whom the portrait is dedicated. Sargent shows his subject, dressed in a fashionable black gown, standing before a light gold curtain, presumably in his studio. Right arm akimbo, Louise holds out a white rose in her left hand, striking a pose similar to the one Velázquez had employed for his dignified likeness of the court jester Calabazas (about 1630, Cleveland Museum of Art), which was then in a Paris collection.

Sargent showed both of these paintings at the Salon in 1882, once again offering a genre scene and a portrait to demonstrate his breadth as a painter. If anything linked *El Jaleo* to *Lady with the Rose* (displayed with the title *Portrait de Mlle ***), it was the sheer scale of their large canvases, which made Sargent's presence at the Salon quite impossible to ignore. The two paintings also made something else very clear: Sargent had now given up one master, his teacher Carolus-Duran, for another, Velázquez, the old master so esteemed for his lively handling of paint and his seemingly spontaneous and credible arrangements of figures. No longer merely praised as the talented student of one of France's leading artists, a pupil whom "M. Carolus Duran should be proud of having formed," Sargent had come into his own. He was now a mature artist whose astonishing works were reminiscent of the great Spaniard himself.[12] Twenty-six years old and a painter on the rise in the most sophisticated and modern city of his age, Sargent understood that his contribution to the next year's Salon would be eagerly anticipated and much discussed. That canvas would be *The Daughters of Edward Darley Boit.*

Ned and Isa Boit

*H*AD SARGENT NOT painted his four daughters, Edward Darley Boit, always known as Ned, might be remembered only as one of a large number of late-nineteenth-century American painters who traveled to Paris, exhibited with some regularity at the Salon, and earned high acclaim from members of their own social circle. He was never able to advance his painting career into the first rank, owing either to casualties of circumstance or perhaps a lack of sufficient professional ambition or ingenuity. Yet he was a talented artist, particularly as a watercolorist, and he was dedicated to his craft. Sensitive to the accusations that his career was only the hobby of a wealthy man, Boit said painting was an "arduous profession," one that was inappropriate as a "refuge of those who prefer to do nothing."[13] Despite his limited place in the annals of art, his reputation is secure, inextricably linked to his friendship with Sargent and to Sargent's portrait of his daughters, four of Boit's eight children.

Boit was born in Boston in 1840. He was named after his father, also Edward Darley Boit, a Harvard-educated lawyer and the son of John Boit, a naval officer and explorer who sailed up the Pacific coast in 1792 and gave his ship's name, the *Columbia*, to the great river in Oregon. Ned's father had married Jane Parkinson Hubbard in 1839; the Hubbards were an old New England family with sugar plantations in Demerara (British Guyana) and long-standing affiliations with Harvard University. Edward and Jane Boit had three sons – Edward (Ned), Robert (Bob), and John – and two daughters, Jane and

John Singer Sargent, *Portrait of Carolus-Duran*, 1879

Sargent had not yet decided that he would specialize in that arena. The year after his success with his portrait of Fanny Watts, he sent to the Salon a sparkling genre scene of fisher girls on the beach in Brittany, *En route pour la pêche* (*Setting Out to Fish*) (1878, Corcoran Gallery of Art). In 1879, he displayed both his portrait of Carolus-Duran and a sensuous image of a peasant girl in a field in Capri. He also showed his work at smaller, more experimental venues. Sargent consciously demonstrated his versatility as a painter through the variety of his

contributions, calculating them to appeal to a broad group of potential critics and patrons. It was a tactic he continued almost every year to increasing acclaim. By the fall of 1881, Sargent was working on one of his largest and most dramatic genre scenes, *El Jaleo* (plate 2.1). Ideas for the picture had been percolating in his mind since 1879, when he had visited Spain and sketched the gypsy dancers there. Over the next two years, most likely working in his Paris studio, Sargent made numerous studies in oil of musicians and dancers, experimenting with poses for his finished composition, as well as two smaller paintings showing swirling dancers under a night sky. However, when it came time to craft his final version, which he planned to display at the 1882 Salon, Sargent painted with great speed and assurance. He ignored contemporary studio practice, which called for the creation of a finished sketch at a smaller scale that would be transferred to the large canvas by a grid system or through tracings or projections. Instead, Sargent started afresh, moving rapidly across the surface of the enormous canvas and rarely going back to correct his figures or to rework the details. Once his ideas were set in his mind, they flew from his head to his hands. *El Jaleo* is a tour de force of sheer painterly bravura.[11]

Of course *El Jaleo* was not a portrait, and thus Sargent was able to work freely, painting for his satisfaction alone without worrying about creating a likeness or pleasing a client. But he had not set portraiture aside, for at the same time that he was finishing *El Jaleo*, Sargent was painting a large portrait of a close friend, Louise Burckhardt, today known familiarly as *Lady with the Rose* (plate 2.2). Sargent had known her for a number of years; their families traveled in the same social circles and some friends even suspected a romance between the two,

Elizabeth (known as Lizzie); another daughter, Julia, died in infancy. Ned Boit's early life echoed his father's: he studied at Boston Latin School, graduated from Harvard in 1863, and went on to Harvard Law. According to some of his friends, Ned was well suited for a career in the law and would have excelled in the profession, but the field did not hold his interest for long, and soon he would be spending more time looking at (and thinking about) art than reviewing legal briefs. Quite athletic during his college years, Ned was a refined and courtly man, cultivated and kind, a reader of books and a consummate host. His brother Bob described him as "a large, strong man, nearly six feet tall" and recalled his elegant deportment and dress, his distinguished bearing, and his democratic taste. Olivia Cushing Andersen, a relative by marriage, found him "a very attractive man, good-looking, well dressed, a thorough gentleman, a man of the world, and a good painter."[14]

Despite the current title of Sargent's painting, the daughters of Edward Darley Boit were not their father's children alone. Their mother, Mary Louisa Cushing Boit, was a lively, vivacious woman who enjoyed people and society. Known all her life as Isa, she was born in 1845 to John Perkins Cushing of Watertown, Massachusetts, and his wife Mary Louisa Gardiner. Like many upper-class Bostonians, Isa Boit was related by blood or marriage to almost everyone in town. Her great-uncle was Thomas Handasyd Perkins, Boston's wealthiest merchant and an early patron of the arts; her maternal grandfather was John Sylvester Gardiner, the rector of Trinity Church; her uncle was Henry Higginson, the founder of the Boston Symphony Orchestra. She was characterized by her friend Henry James as "brilliantly friendly" and "eternally juvenile."[15]

Isa Boit may have inherited some of her energy and verve from

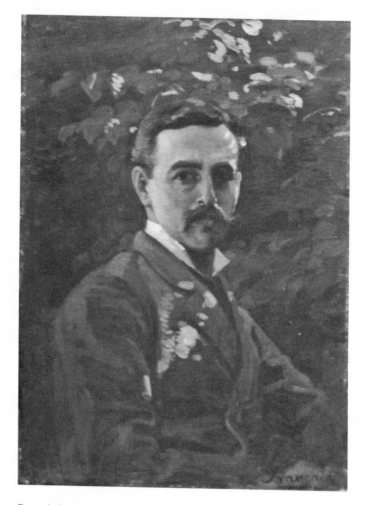

François-Louis Français, *Portrait of Edward Boit*, about 1880

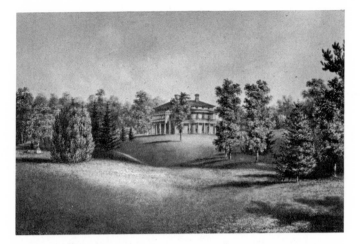

Bellmont, the Cushing family estate, 1837

her father, who had been a seaman, a trader, a smuggler, and a philanthropist. Cushing, whose mother had died when he was ten, had been raised by his uncle, Thomas Handasyd Perkins. At age sixteen, he sailed for China on one of his uncle's ships and soon became the sole agent for Perkins's lucrative China trade. Cushing stayed in China for almost twenty-five years, becoming a skillful manager and a full partner in the business. By 1827, at age forty, he was ready to retire and return to the United States, but it took several years for him to arrange for the disposition of the firm, which by then traded not only in fabric and tea but also opium. Eventually Cushing consolidated Perkins and Company with the business of another Bostonian, Samuel Russell, and left Canton to settle in Boston in 1831. A very wealthy and most eligible bachelor, he soon married Mary Louisa Gardiner. After the birth of their first child, a son, they moved from the city to their country estate in nearby Watertown, Massachusetts. Called Bellmont, the house was designed in 1840 by New England architect Asher Benjamin (with Cushing's concentrated involvement),

sparing no expense and including such innovations as double brick walls for superior insulation, indoor plumbing, and bathrooms heated by hot air ducts. There, according to all accounts, Cushing lived the life of an eastern potentate replete with Chinese servants, spending his days cultivating a lavish garden and extensive greenhouses, supporting civic causes, and encouraging the redistricting of Watertown to establish a new town to be named Belmont.[16]

The Cushings had five children – four sons (one of whom, William, died young of scarlet fever) and one daughter, Mary Louisa, born in 1845 and named for her mother. Isa was the baby of the family, seven years younger than her youngest surviving brother. It is easy to think that she might have had an opulent upbringing, and her niece Olivia Cushing Andersen later recounted that the children

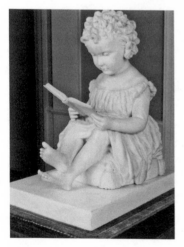

Henry Dexter, *Mary Louisa Cushing* [*Boit*] *as a Child* (*The First Lesson*), 1848

grew up at Bellmont "with every desire satisfied." Bostonians fondly remembered "the wonderful children's parties given by Mr. Cushing, to which the boys and girls of Boston looked forward with joy, – of the haystacks; of the ponies for the children to ride; of the music; of the fire-balloons; of the dancing on the lawn, with the well-known dancing-teacher Papanti in charge; and of the procession of the children to the supper table."[17]

When Isa was just three years old, her parents commissioned an image of her in marble from one of the most popular recorders of Boston society, sculptor Henry Dexter. Dexter was best known for his portrait busts and was particularly sought after for his images of children,

some of which were full length. He made six pieces for the Cushings: busts of Mrs. Cushing and her three eldest sons, and "portrait-statues" of her youngest children, William and Isa. Isa's was originally entitled *The First Lesson*, and it shows a small barefoot girl with tousled curls, serious and unselfconscious, seated on a floor cushion reading a book. The informality of her pose and her apparent self-possession reappeared many years later, when Sargent painted Isa's own youngest child, Julia, sitting on the floor with her doll.

Isa Cushing and Ned Boit married on June 16, 1864, in the middle of the Civil War. Abraham Lincoln had just been nominated for a second term as president with a platform that called for the abolition of slavery. The Battle of Petersburg was underway; Union general Ulysses S. Grant would be forced into retreat the following day. The warships USS *Kearsarge* and CSS *Alabama* were lined up off the coast of France before engaging, three days later, in a battle that was painted by Edouard Manet. Isa was nineteen; she had already lost both her parents and was under the guardianship of her brothers. Ned was respectable and promising; he had avoided the army and was currently studying law. Their wedding was a grand occasion: they were married in an Episcopal ceremony at Christ Church in Harvard Square, attended by eight groomsmen and eight bridesmaids, and an elaborate reception was held at Bellmont. "It was a wonderful day," Ned's brother, Bob Boit, fondly reminisced. "We had a grand time with dancing all the afternoon in the long drawing-rooms . . . the gardens near the house were in their June beauty, and at that time no gardens near Boston equaled them. Over the centre of the garden was a large marquee covering the fountain. Here refreshments were served." Bob added that the charming Isa, "the very loveliest of brides," became "one of the best friends I ever had." [18]

Together, Ned and Isa Boit lived a deliberately peripatetic life. They began their marriage by dividing their time between Boston and Newport, Rhode Island, where both of them had many connections through family and friends. They built a summer home in Newport, The Rocks, which sat above Bailey's Beach on property adjacent to that of the bride's brother, Robert Cushing. Children came quickly, and not only daughters. Their first child, a son, was born in April 1865; he was named Edward after his father and was always known as Neddie. But even with the excitement of the baby, the prospect of keeping to a routine of winters in Boston and summers in Newport or Cotuit, on Cape Cod, apparently seemed dreary. The Civil War had ended and traveling was now much less hazardous. In 1866, just after Ned was admitted to the Massachusetts Bar and while Isa was pregnant for the second time, the Boits sailed for Europe, appropriately enough on a vessel named the *China*.

Their itinerary was structured around Ned's interest in art, an avocation that his wife's comfortable inheritance would soon allow him to pursue. The first stop on their ambitious itinerary was Dublin, where Ned inspected William Frith's detailed study of the varied crowds in the train shed at Paddington, *The Railway Station* (1862, Royal Holloway and Bedford New College); Boit proclaimed it to be "by far the best painting I [have] ever seen." They traveled on to London, where they stayed with Ned's aunt Julia and her husband Russell Sturgis, another Boston merchant related to the Cushings who had once been deeply involved in the China Trade, but who was now an important partner at the banking firm Baring Brothers in London. There, Ned visited the annual exhibition at the Royal Academy of Arts, the show of British Water Color Painters, various art galleries and museums, and the panoply of exhibitions on display at the Crystal

Palace, the great iron and glass hall devoted to shows about science, exploration, art, and industry. He found the setting, Joseph Paxton's industrial masterpiece, to be "an immense building of dingy glass, like a huge conservatory – but lacking ... the smell of flowers ... [it] is like the inside of a circus tent – redolent of animals, food, and above all of a crowd." [19] Mechanics fairs and technology were things Americans could see at home, and clearly Boit was unimpressed; he had come to Europe to see less familiar sights, especially paintings.

Boit was not an uncultured man, but simply an American who had had little opportunity at home to study the visual arts. It was a common problem, for there were few places to see great art in the United States before the Civil War. Boston's art scene in the 1850s and 1860s was haphazard. The Museum of Fine Arts did not yet exist, and the collections at the Boston Athenæum, a combination library and art gallery, then consisted largely of ambitious portraits and historical scenes by American painters; only the two grand Roman interiors by Giovanni Paolo Panini and a large still life by the seventeenth-century Flemish artist Pieter Boel stood out as European masterworks from the numerous copies of famous compositions by Guido Reni and others. [20] Boston's private collections, to which Boit had easy access, held some treasures, but most featured contemporary pieces, principally canvases by Gustave Courbet, Jean-François Millet, and other artists of the Barbizon School whose paintings were most favored by Boston's tastemakers. To appreciate the old masters, Boit needed to travel abroad.

Ned was attempting to instruct his eye, which he knew lacked the sophistication that studying Europe's masterpieces could provide. Like many Americans on tour, the Boits also went shopping, purchasing several paintings for the home they were making in Newport. The works they selected were, if unadventurous in spirit, typical

for the period – a Cairo sunset by Charles-Theodore Frère, two small paintings by Richard Ansdell (best known for his depictions of dogs), a rural landscape with cattle by William Shayer, a large landscape by Henry Bright. When Ned Boit visited the National Gallery in London in June, he remarked that he "was not yet educated up to Turner," adding that while he found the British landscapist J. M. W. Turner's earlier works beautiful, he felt that they all exhibited "a studied neglect of drawing – as if color were the only thing in which excellence was to be aimed at." He stated that he would "reserve [his] humble opinion" of the old masters "until I am able – by an inspection of many of their pictures – to really understand the peculiarities and peculiar merits of each," since, he admitted, he "was disappointed in the gallery – it was neither so large nor so choice as I had supposed – one room was devoted to paintings on gold in the Fra Angelico style – not one of which I – in my present uncultured state – would hang on my walls."[21]

From England in July 1866, the Boits traveled to Boulogne, Paris, and Dijon before heading through Switzerland and Germany. In the fall, they returned to England, where Isa bore their second son, John, in October. Isa did not make a quick recovery and the baby was sickly, but they continued their travels. By mid-December they were back in Paris, where Ned visited the Louvre and the exhibition rooms at Goupil's, the leading art dealer in the city. His appreciation of the French capital developed on this second visit, and he wrote that the more he "saw of Paris the more convinced I am that my first impressions of it were erroneous. Its grandeur grows on me daily."[22] Despite Ned's attraction to the city, he was determined to keep traveling toward the destination that had long been celebrated as the culmination of the grand tour: Italy.

The Boits passed through Genoa and Florence to Rome, where they spent the spring of 1867. A sizeable American community existed there in the 1860s, anchored in the picturesque Palazzo Barberini apartments of the famous American Neoclassical sculptor William Wetmore Story and his wife, Emelyn. The Storys, like the Boits, were well-connected Bostonians, with many friends and relatives in common (among them, Ned and Isa's recent hosts in London, the Sturgises). Ned and Isa joined their compatriots in rounds of social events and for sightseeing excursions to ancient monuments in the city and on the Campagna, where the classical ruins made a haunting and picturesque vista. Despite the illnesses of both Isa and their baby son John, who died in March 1867 and was buried in the Protestant Cemetery in Rome, Ned made sure to complete the artistic education he had planned. He visited the Vatican to see the famous works of Raphael and Michelangelo and traveled to Naples, Pompeii, and Venice; he especially enjoyed the paintings of Domenichino in Rome and Titian's *Assumption of the Virgin* at the Church of the Frari in Venice. But Isa's health remained fragile, and soon the Boits, with their young son Neddie, were on their way home to Boston and Newport. Ned resumed his legal career, opening an office in Pemberton Square, the headquarters of many of Boston's most prestigious law firms.

In 1868, Ned Boit's artistic epiphany came when he visited an exhibition of landscapes that included paintings by Jean-Baptiste-Camille Corot at Boston's Soule and Ward Gallery. The naturalism of Corot's imagery and his ability to capture light, air, and atmosphere astonished Boit, and he resolved to follow his heart and become an artist. Brother Bob later confessed that Ned seemed at "rather an advanced age to begin [a new career] – but for the first time in his life he has found something which is really absorbing to him + the only

occupation he has ever devoted himself to with zeal + industry."[23] Like so many aspiring American painters of the age, Ned planned to study art abroad. Isa Boit enthusiastically supported (both emotionally and financially) the idea of living in Europe, which she much preferred to Boston or Newport, and thus Ned was able to leave the law behind him.

By the time they began organizing their move, the family had grown again to three children. Florence was born in Newport on May 6, 1868, and Jane had arrived on January 17, 1870, also in Newport. But these joys were tempered, for Ned and Isa were now faced with the heartbreaking task of splitting up their family and leaving their firstborn son, Neddie, behind. It must have been a challenging period for all of them, despite the advice they received from the best physicians. Neddie clearly was not normal. "At the age of two he could talk," recalled Bob Boit. "Then he suddenly stopped, lost his intelligence, and became an idiot – and when [he was] 5 or 6 years old [he] had to be sent from home for the sake of the other children." The Boits found a place for him in Barre, Massachusetts, at a private boarding school for "feeble-minded" children established in 1851. The institution was run by Dr. George Brown according to the theories of the day; students were separated by sex and ability, as well as by income level, and teachers sought to improve their state through physical education and manual training.[24] Whatever schooling was provided for Neddie seems to have had little effect, and he never regained his ability to communicate. His illness preoccupied the family for years to come.

In the fall of 1871, without their son, the Boit family left for Europe. Ned was drawn first to Italy and then to the French countryside and ultimately to Paris, increasingly intrigued by the liberation from detail

and emphasis on overall effect that he saw in the paintings of the French school. Among the friends the Boits made at this time were Henry James and painter Frederic Crowninshield, two men with Boston connections who would be in and out of their society for the rest of their lives, as they intersected with one another in a variety of cities on the international circuit. Some sources indicate that James met the Boits in Rome, others in Boston, but they were certainly acquainted by the spring of 1873, when James mentioned them in a letter from Rome to his mother. The Boits and Crowninshields participated actively in Rome's whirl of expatriate social occasions and intrigue. In 1871, they attended a great Renaissance costume ball given by lawyer and diplomat Maitland Armstrong, who later remembered that "among the most beautiful American women [to attend] were Mrs. Frederick Crowninshield and Mrs. Edward Boyt [*sic*] of Boston," adding that "all the artists were there." During this same period, James chronicled exhilarating riding parties on the Roman Campagna, noting in confidence that he thought it best to "fight shy of Mrs. Boit who ... is an equestrian terror." [25]

In the same 1873 letter, James referred to Boit and Crowninshield as "a couple of young artists." Boit had taken a studio on the via Margutta, at the center of the American art community in Rome. Some scholars have suggested that he may have studied with William Stanley Haseltine, an American landscapist and fellow Harvard man who was much praised for his crystalline depictions of Italy's rocky coast. Soon thereafter, both Boit and Haseltine appeared in the correspondence of another American expatriate painter, Elihu Vedder. Vedder had apparently made a remark that had been taken amiss, as he wrote to a friend of Haseltine's in 1876, "I gather you reported my saying — I thought amateurs like Haseltine and Boit had no business to open

NED AND ISA BOIT

studios here in Rome. As to Haseltine it is utterly impossible that I should have called him an amateur when I have known him for years as a professional artist." But Vedder did not elevate Boit from his amateur status, a condition that would haunt Ned throughout his career. His comfortable economic circumstances and his high social position kept some individuals from fairly assessing his artistic accomplishments. Vedder continued to complain about Boit, noting that while he "had always praised [Boit's work] as far as it goes as very good," he was insulted by what he had heard about Boit's decision not to "mix with the artists in Rome." Vedder angrily proclaimed, "It makes me mad to see people who have grown up without a thought of art until the idea suddenly strikes them of taking it up, [who] after a few lessons from some French master . . . set up a studio and are classed among regular artists and turn up their noses at men who fought out the battle for themselves."[26] Vedder would later relent, and he enjoyed Boit's watercolors when he saw them on display in Boston in 1887. His initial quarrel with Ned may have been rooted in insult or jealousy, but it also seems likely that Vedder and Boit were on opposite sides of an artistic divide that opened during this period, when Rome had started to lose its luster and the art capital shifted north to Paris.

Boit had already begun to transfer his artistic allegiance to France, and the family spent more and more time there. At least by 1876, Ned had taken a studio at 139, boulevard Montparnasse, on the Left Bank in the heart of the city's artistic quarter. Sometime in the early 1870s, he had indeed become the pupil of "some French master," the French landscapist François-Louis Français, himself a student of Corot, the artist from whom Boit had received his initial inspiration. Français shared Boit's love for Corot's atmospheric approach and also for Italy; it is possible that the two men first met there, when Français

traveled to Italy in 1873. Boit acquired one of Français's dense forest scenes, painted near Plombières, Français's birthplace, as well as a highly finished ink drawing of trees in Brittany, both of which he would donate to the Museum of Fine Arts upon his return to Boston in 1879.

Boit's apprenticeship with Français drew to a close in 1876, when his painting *La Plage de Villers* (*Calvados*) was accepted by the jury for display at the Salon in Paris. The canvas has disappeared, but Ned's brother described it as a landscape of "Rocks, beach + ocean," implying that the scene was straightforward, with no heroic narrative or dramatic subject. Other early examples of Boit's work, along

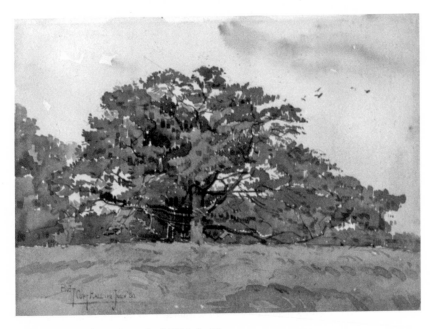

Edward Darley Boit, *Study of Old Oak*, 1880

with his interest in the Barbizon School, suggest that the painting employed the subdued palette and balanced composition favored by other popular landscapists at the 1876 Salon, Français among them.[27] Boit's subject, the beach at Villers, a village on the Normandy coast just west of Trouville, had been popular with French painters in the 1850s and 1860s when the town was first being developed as a seaside resort. Coastal scenes were quickly becoming a favored motif for a variety of French artists, from the academicians to the Impressionists. Ned certainly knew this, but his own family's maritime history and his upbringing in coastal New England would have given him a natural affinity for the subject.

Ned's painting must have been based on sketches he made in Villers the preceding summer, which he then would have worked up into a finished composition in his Paris studio. Like most artists (but enjoying the extra comforts money made available to him), Boit usually spent his summers with his family in the country, often near the sea. In 1876, after celebrating Ned's artistic success, the Boits traveled to Etretat, another popular coastal resort in Normandy. There, they kept company with Henry James, who talked about the scene in a letter to his brother William. "The quality of the air is delicious," he wrote, but "the company is rather low, and I have no one save Edward Boit and his wife (of Boston and Rome) who have taken a most charming old country house for the summer."[28] Ned used the family travels as an opportunity to paint, and their itinerary can be traced in pictures, although he may not have exhibited his work in chronological order. For example, in 1877, Boit showed a watercolor of the Piazza del Popolo at the Salon, but whether it documents a recent trip to Rome or was painted some years earlier is not clear. In that year's Salon cat-

alogue, he listed only his Paris studio as his address, dropping Rome from his record. None of Boit's work appeared in the 1878 Salon, although whether or not he submitted anything to the jury is unknown. The family spent at least part of the next summer at Dinard, in Brittany, another favorite seaside resort. Boit exhibited an oil painting of the banks of the Rance estuary between Dinard and St. Malo (along with watercolors of Mont St. Michel and of St. Peter's in Rome) at the Salon in 1879 (locations unknown). Soon after that show ended, flush with success, Ned and his family embarked for Boston. The trip was their first return to the United States in eight years.[29]

Ned and Isa now had two more daughters to bring home, along with Florence and Jane. Mary Louisa, nicknamed Isa like her mother, was born in Paris on June 5, 1874, and Julia, the youngest, on November 15, 1878, in Soisy, a community north of Paris near Enghiens-le-Bain, a spa town boasting mineral baths and a casino. The Boits were planning an extended trip home, at least in part to introduce baby Julia, whom her grandparents and uncle had never seen, to the family. "Mama & pater," wrote Bob Boit in 1879, referring to his parents, had hastened from Boston to Newport to prepare their house for "the coming of Ned + Isa, four children, nurses, maids, + governesses – who were expected early in June – + were coming directly to Mama's to pass the summer . . . As they had been abroad for eight years Mama & pater were specially anxious to have them pleased on their return with all their surroundings – in hopes, I think, of keeping them on this side of the water." The family was close-knit, and it was hard for them to be separated. Ned's parents had spent a year in Europe in 1874–75, arriving there just before Mary Louisa's birth. Bob was immensely sad that his brother had never met his own

beloved wife, Georgia Mercer Boit, who died of a fever in 1878, four years after their marriage. He eagerly anticipated his brother's visit. Ned arrived in New York with his family on the SS *Bothnia* in mid-June 1879, and soon Bob announced that he had "seen Ned + Isa + their children. The two former have changed very little in the last eight years – with the exception that Ned is a little grayer + Isa is a little stouter + not *quite* so young looking ... I looked over Ned's water color sketches – many of them lovely – which I had not seen before. [I] heard Isa's Florie play her violin to Isa's accompaniment + altogether enjoyed being with the family again."[30] Florie was now eleven years old; her youngest sister, Julia, was an infant of seven months. The girls would have spent most of their time that summer in the care of the European nurses and governesses who had accompanied the family on their journey, providing them not only with assistance and education but also with continuity and a personal connection to their more familiar Parisian world.

The summer passed with a merry round of activities, but despite Ned's parents' hopes that he would stay in the United States through the winter, he returned to Europe with his family in early October 1879. The American experiment had failed, as brother Bob related:

> *Just* [at] *this time Ned + Isa who had been passing quite a gay summer at Newport staying with all their family at Pater's, decided to gather up their belongings + return to Europe + to Paris at once – taking passage on the 8th Oct. This quite upset me. I had looked forward so much to Ned's companionship this winter ... making me feel very blue. However Ned explained all his reasons – pecuniary + otherwise – to me, and on the whole I thought he could not do better, or that to say the least it was natural he should have done as he did.*[31]

Wanderlust was certainly among the reasons the Boits refused to stay in America, along with the luxurious apartments and entertainments that they enjoyed more easily and affordably in France than in the United States. But the appeal of the French capital was more than economic; the lure of Paris's cultural scene, especially for an artist like Boit, was simply too strong. Ned felt that Paris was the only appropriate place for him to earn his credentials as a painter. He arranged for a group of his watercolors to be sold at auction at the Boston gallery Williams and Everett after his departure. The catalogue discussed the works as "original studies from nature," and the titles summarized the Boits' travels throughout the preceding period, from Brittany to Mont St. Michel to the outskirts of Paris, from Florence to Rome to Sorrento. The progression from place to place became a lifelong pattern, but Paris became the Boits' real home.

Paris

*I*N FRANCE, the Boits joined an international community. Expatriates from the United States, South America, and throughout Europe found professional and social opportunities in Paris more attractive than anywhere else in the world. This stylish and sophisticated city had become a magnet for artists lured by its many opportunities for training and display; for intellectuals excited by its urbane and often witty exchange of ideas; for physicians and scientists seeking the latest experimental developments in their field; for statesmen engaged in diplomacy, at this time always conducted in French; and for entrepreneurs eager to provide shoppers at home with the latest luxury goods. People came from around the world to settle in Paris, but the most numerous, and the wealthiest, expatriate residents of the city were Americans. Some of them had discovered that an address in the most cosmopolitan of capitals was advantageous for business; others were drawn to its position at the center of the world of art, society, fashion, and entertainment; many discovered that their money bought more there than it did in the United States. Paris was also one of the world's most modern cities; since midcentury, the French government had created a new metropolis of broad avenues and luxurious apartments punctuated by historic sites, relentlessly demolishing parts of the old capital, with its maze of twisting dark streets. The disruptions and unrest of the early 1870s had quickly been overcome; by the time the Boits settled in Paris, the city had easily re-established itself as the acknowledged center of shopping, dining,

and artistic pursuits of all kinds. This elixir, with its mix of nationalities and entertainments, was addictive. As American portraitist Cecilia Beaux reported of one Mrs. Green, who lived in the Americans' favorite quarter near the Etoile, "I never knew why [she] chose to spend her life in Paris . . . perhaps, though she was a Shaw of Boston, and a 'loyal subject,' she found that, having once tasted, she could not do without the 'milk of Paradise' which many feel is to be found where she elected to remain."[32]

When Bob Boit visited his brother and sister-in-law in Paris, he tasted that milk of paradise, keeping a diary of his daily activities. No doubt some special efforts were made to introduce him to the city's many diversions, but the events the brothers experienced together that summer were not so different from the family's regular routine and thus reveal many of the things the Boits enjoyed about life in

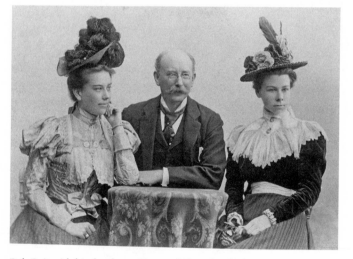

Bob Boit with his daughters, Mary and Georgia, 1896

Paris. One day, the brothers went shopping and took a drive through the Latin Quarter, stopping at the Luxembourg Gardens for a stroll before a late lunch at the fashionable Café de la Paix, on the boulevard des Capucines. The rest of the afternoon was spent at home and the evening at the new Opéra, where they heard the famed American soprano Emma Eames, a friend of Ned and Isa's, sing her celebrated leading role in Charles Gounod's *Roméo et Juliette* (plate 2.3). After the performance, they returned to the Café de la Paix for a beer, taking pleasure in watching the bustle of the passing crowd. The next day, they went shopping again and then to the Louvre, where Bob Boit was particularly impressed with the paintings of Van Dyck, Rubens, Rembrandt, Velázquez, and Titian. Lunch followed at the Café d'Orleans in the Palais Royale, and then the brothers played billiards before returning home. In the evening, they dined at the renowned Café Anglais on the boulevard des Italiens and went to the theater at the Comédie Français.[33]

Among the many pleasures the Boits savored in Paris was the food, which Bob, like so many visitors, enumerated in rapturous detail. Of one meal at the famous Maison Dorée, a restaurant popular with a bourgeois and artistic clientele (and the location of the eighth and final Impressionist exhibition in 1886), Bob exclaimed, "Who would have supposed that the simple, vulgar turnip contained hidden from all but these blessed Frenchmen such a delicate aromatic flavor! What is the telegraph to such a discovery as that!... thine be the palm, Oh, paper-capped chef, for taking a miserable common thing that has been served to swine for thousands of years + extracting there[from] a god-like essence to be treated with respect for ever + never to be forgotten. Place the turnip on top of the heap!" By the end of his visit, sated with food, wine, music, and art, Bob had converted completely

to Ned's point of view, becoming a champion of the beauties and pleasures of Paris. "So ends [my] journal of Paris," he concluded. "It is the best city that I have come to yet in the World, + with a moderate fortune I should like to pass my life here . . . I should be willing to be forced to pass the rest of my life there. I believe it the city of the world best suited to a man of artistic disposition + seems to me to contain all that is necessary for man's happiness."[34] At last he understood his brother's firm commitment to expatriate life.

While the Boit men clearly relished the many public pleasures of their surroundings, the women and children of the family would have inhabited a somewhat more circumscribed world. But women found happiness in Paris as well, and their entertainments consisted of much more than fittings at the couture salons of Worth or Doucet and shopping at the city's many new luxurious department stores. Isa Boit was sociable and lively, and she delighted in what her friend James characterized as "the great Parisian hubbub," which seemed to him, then at home in Boston, a "carnival of dissipation."[35] Like her husband, Isa enjoyed the opera, music, and theater, and she participated enthusiastically in the rounds of afternoon calls, teas, receptions, and dinners required of a woman of her class. She went riding and driving in the Bois de Boulogne and also entertained at home, putting the many elegant rooms in her apartment to good use.

The writer Edith Wharton reminded herself of an exceptional evening there in the 1880s when she met, for the first time, Henry James: "The encounter took place at the house of Edward Boit, the brilliant water-colour painter whose talent Sargent so much admired. Boit and his wife, both Bostonians, and old friends of my husband's, had lived for many years in Paris, and it was there that one day they asked us to dine with Henry James. I could hardly believe that such

a privilege could befall me, and I could think of only one way of deserving it – to put on my newest Doucet dress, and try to look my prettiest!" But the evening did not turn out as Wharton had hoped; her rose-pink dress failed to give her the assurance she needed. "Alas," she said, the gown "neither gave me the courage to speak, nor attracted the attention of the great man. The evening was a failure, and I went home humbled and discouraged." It was only later in her life, when she "had found" herself and "was no longer afraid to talk," that she became one of James's close friends, but she always remembered the sparkling evening of conversation that had tantalized her at the Boits.[36]

Although Wharton found herself mute in James's company, Isa Boit did not. She adored him, as he did her; James thought of her as "always social, always irresponsible, always expansive, always amused and amusing." Fond of people and of fun, she flourished in a continual round of engagements. Bob Boit assessed her as "strong, fascinating, full of grace, + with an extraordinarily penetrating mind – full of likes + dislikes – but never in any way or at any time small or spiteful – great-hearted – generous, exacting, loving, coquettish, humorous + with quick keen insight + appreciation of the thoughts and motives of others. She delighted in everything but the commonplace."[37] She must have hoped that her four daughters would grow up to enjoy society as much as she did.

At the time Sargent painted them, the girls were still young and would not yet have participated in all of the activities of their parents, although they would have played in the park, gone for drives, and attended daytime concerts. Like Edith Wharton's childhood, the Boits' "little-girl life" was probably "safe, guarded, [and] monotonous."[38] Their world was more clearly centered on the apartment, where

they had a nursemaid and received their education from a private tutor. To reconstruct the lives of the Boit girls before they were immortalized in Sargent's portrait, one must cobble together the sparse factual information with descriptions by other women of their age and social class who chronicled their own experiences growing up.

The earliest chapters in the Boit daughters' lives presumably matched those of many other upper-class girls of their time. Wharton, for example, who was just six years older than Florie, remembered her "tall splendid father who was always so kind, and whose strong arms lifted one so high, and held one so safely," as well as her "mother, who wore such beautiful flounced dresses, and had painted and carved fans in sandalwood boxes." Mother and father were background figures for her, however, for she had "one rich all-permeating presence": her nurse, Doyley, who was "as established as the sky and as warm as the sun." Wharton, like the Boit girls, had been taken to Europe at a young age, but she realized that "the transition woke no surprise, for almost everything that constituted my world was still about me: my handsome father, my beautifully dressed mother, and the warmth and sunshine that were Doyley." This semblance of stability was important for children like the Boits, and it was something that many families who were frequently on the move had in common. It created security within the family unit; as William James remarked of his brother Henry, "He's really, I won't say a Yankee, but a native of the James family, and has no other country." [39] This sense of place, of belonging to the family instead of (or in addition to) the state, served as the glue that kept families together despite constant travel. It also provided common ground for many expatriates, perhaps encouraging friendships among people who shared similar experiences, like the Boits, James, and Sargent.

Outside their home, the Boit girls probably enjoyed the city's parks, where they would have been taken by their nurses to "[dodge] in and out among old stone benches, racing, rolling hoops, whirling through skipping ropes, or pausing out of breath to watch the toy procession of stately barouches and glossy saddle horses which . . . carried the flower of [society] . . . round and round." Wharton's parents went on from Rome to Paris, and she reminisced that they "were always trying to establish relations for me with 'nice' children, and I was willing enough to play in the Champs Elysées with such specimens as were produced or (more reluctantly) to meet them at little parties or dancing classes; but I did not want them to intrude upon my privacy." She also recalled indoor activities, mainly kept separate from the adults but "led in with the dessert, my red hair rolled into sausages, and the sleeves of my best frock looped up with pink coral" to greet the guests at Sunday dinner, providing her with a glimpse into a grown-up world that was equal to the one Florie Boit received each time her parents asked her to entertain their own guests with her violin. Wharton, already demonstrating her own preferences, most often chose to read and to make up stories, apparently feeling no remorse or resentment about her insulated life.[40] Like her, the Boit girls read, both together and alone, probably becoming familiar with the ever-growing selection of novels and articles written specifically for children. Their lives followed an established pattern, well protected from adult concerns and cares.

There is no indication that the young Boit girls sought any independence from this routine, and the impression given by the sparse notes in most of the existing adult diaries and letters is that they were rather passive. Yet a charming illustrated letter from ten-year-old Julia to her eleven-year-old cousin Mary, Bob's daughter, con-

firms that their lives were not confined to the house and were also full of activities and fun:

> *I have still got my doll but its head broke and it has got a new head, with brown hair. I have been to lots of places this spring, twice to the grand Opéra to see "Romeo and Juliet," to the Hippodrome, and to the Chatelet to see "Le Tour du Monde en 80 jours." And I have also been to the Circus and to the Exhibition [the 1889 world's fair]. There're lots of funny things at the exhibition ... I think you would like it very much. Have you ever seen "Buffalo Bill's Wild West"? I have been to see it and think it is great fun. You see lots of Indians and "Cowboys" and "Buck jumpers" that are awfully naughty and the Cowboys can hardly ride them ... it is so funny. We have got some canaries that Mama [got] us and I think they are cunning.*[41]

Of course the girls also played at home, as evidenced by the doll Julia holds in Sargent's portrait – perhaps even the same one she mentioned in her letter. The toy is of a new and modern type, the baby doll, first created in the mid-nineteenth century and manufactured in both France and Germany. Julia's appears to be of the German variety, made out of molded composition (a mixture of pulped paper and other materials) and fabric. Immensely popular and relatively inexpensive, such dolls were distributed throughout Europe.[42] Whether or not it was meant to be a baby, and no doubt to the amusement of others, Julia had named her doll Popau – the nickname of Paul de Cassagnac, a contemporary right-wing politician, journalist, and renowned duelist with sword and pistol who figured in the recently opened displays at Grévin's popular waxworks.

Ned's diaries show that he and his wife shared in their daughters'

45

activities, both indoors and out. Isa took them driving and to concerts; Ned accompanied them on long walks and read to them in the evenings. In summer, at whatever resort they inhabited, he often went swimming with them. In an age before antibiotics and systematic inoculations, the girls were frequently ill; their father mentions their various colds and other ailments with concern. In 1881, Henry James wrote to their mutual friend Etta Reubell in response to her report that the girls had the measles: "I should fear that those white little maidens were not suited to struggle with physical ills – their vitality is not sufficiently exuberant." He added that he hoped the worst was over, for "it can't have amused Mrs. Boit and it didn't amuse me either, not to be able to see her." Three years later, James heard that "Mrs. Boit has scarlet fever among her long white progeny."[43] James's characterization of the girls – little, long, white – suggests that they were passive and weak, lacking the physical energy and high spirits of many children of their age; but perhaps in James's mind, the little girls' personalities were overshadowed by the brilliancy of their vivacious mother.

Like most expatriate girls of their age and class, the Boit daughters were schooled at home under the guidance of a governess or tutor. But academic excellence was not the goal; Wharton later claimed that she "had been taught only two things in [her] childhood: the modern languages and good manners."[44] The girls would have learned languages – certainly French, in which they were all fluent, but also German and Italian. They would have been enrolled in dancing classes, a necessary part of their social education, probably starting their lessons in Paris. The Boits also loved music and each played an instrument, a typical accomplishment for young ladies and a necessary one for domestic entertainment. All of the girls were skilled performers,

and they often joined together to present private evening musicales, sometimes with proper programs carefully illustrated by Julia, who had a talent for drawing. They favored pieces by contemporary French and German composers – elegies and nocturnes written for their chosen instruments. Music served as both a pastime and a consolation throughout their lives.

Julia Boit's illustrated program for a concert given by
"Les Mademoiselles Boit," 1891

When their portrait was painted in 1882, the Boit sisters would still have been perceived as children. Even the eldest, fourteen-year-old Florie, who leans against the vase in the background, still wears her hair down and her skirt at midcalf, only a bit longer than that of her younger sister Isa, whose skirt falls just below her knee. Some etiquette advisors suggested that girls of thirteen should wear ankle-length dresses, indicating their progression toward adulthood. Then, as now, many girls sought to speed up the process, wearing their hair up and their skirts long – and even adopting corsets – as soon as they could get away with it. How the Boit girls felt about such things is unknown; their cousin Mary was eager to lengthen her skirts when she turned thirteen, as other girls of her age had done, despite (or perhaps because of) the objections of her stepmother.[45] If the girls or their mother had kept diaries (and if so, had their journals survived), such questions might be more easily answered. As it is, their father and uncle recorded few such intimate and feminine details. In April 1885, Ned noted that Florie and Jeanie "had their hair done up by Maxine," presumably in an adult style. In July 1886, he wrote that Isa (mère) had allowed eighteen-year-old Florie to drive after lunch; his entry is marked with an exclamation point, as if the event were a momentous occasion.[46] Despite these signs of maturity, the four girls remain forever young in Sargent's portrait.

The Boits, Sargent, and Children

B y the time Sargent's work on their daughters' portrait began,
Ned and Isa Boit must have known the artist quite well. Unless
Sargent had been thinking about it for some time (and no evidence
suggests that he did), the painting sprang into being very quickly. It
is equally a portrait and an interior, an homage to modern painting
and to the art of the past, and one of Sargent's greatest works. The
exact circumstances surrounding its genesis are unknown; nothing
chronicles a formal agreement between painter and patron. Sargent
clearly was given considerable artistic freedom with the composition.
His portrait was entirely unorthodox, for it is very unusual in a com-
missioned likeness to obscure the features of two of the sitters. It was
made for people who understood both Sargent's aesthetic sensibility
and his artistic ambitions, individuals who had more of a connection
to him than clients undertaking a business transaction. The relation-
ship between Sargent and the Boits provides one clue to the paint-
ing's unconventionality.

Ned and Isa had probably first met Sargent in France in the late
1870s. Their social and artistic circles intersected broadly, but it could
have been Ned's teacher François-Louis Français who provided the
network that first drew them together. One of Français's close friends
was Carolus-Duran, Sargent's instructor. Français and Carolus had
met when they were both young art students in Paris in the late 1850s;
they traveled together in Italy in 1864 and remained good friends
for the rest of their lives.[47] It seems likely that the path between

9

their two American students, both of whom had Boston connections, would have been a short one. Sargent may also have met the Boits through mutual American friends, among them the Paris-based hostess Etta Reubell, either in the city or in one of a number of summer places, including St. Enogat and St. Malo, where all of them circulated in the 1870s. "Sargent was a great friend of us all," Julia later explained.[48]

Before starting the portrait, and since the time he had completed *El Jaleo* and the *Lady with the Rose* (*Charlotte Louise Burckhardt*), Sargent had undertaken two other artistic campaigns that would affect his conception for his large and unusual painting of the Boits. One was a series of Venetian interiors that he created in 1880 and 1882, and the other was a small portrait of Louise Escudier, the wife of a prominent Parisian lawyer. Both had offered Sargent the opportunity to experiment with the placement of figures within a large interior space and to play with the effects of filtered and reflecting light. Many scholars have even suggested that *The Daughters of Edward Darley Boit*, although painted in Paris, was the culmination of Sargent's Venetian experience.[49]

The artist made two working trips to Venice in the early 1880s, the first during the fall and winter of 1880–81 and the second during the summer of 1882, after displaying *El Jaleo* at the Salon and just before starting the Boit portrait. His activities in Venice and the exact chronology of the works he made there remain somewhat obscure, but it is likely that he went with the intention of finding a subject he could work up into a Salon picture, as he had done on many other occasions.[50] His 1877 trip to Brittany, for example, resulted in his important oil *En route pour la pêche*, which he displayed at the 1878 Salon. In the summer of 1878, Sargent went to Capri, a journey that

inspired his next Salon picture, *Dans les oliviers, à Capri* (1879, private collection); in 1879, he went to Spain and Morocco, later producing the exotic North African–inspired *Fumée d'ambre gris* (1880, Sterling and Francine Clark Art Institute) and *El Jaleo*, shown at the Salon in 1880 and 1882, respectively. There is every reason to believe that Sargent had in mind to paint a Venetian subject for the Salon.

In September 1880, Sargent refused an invitation from Matilda Paget (the mother of his friend Violet Paget, better known as Vernon Lee), explaining to her that "there may be only a few more weeks of pleasant season here [in Venice] and I must make the most of them . . . I must do something for the Salon and have determined to stay as late as possible." In the summer of 1882, he again wrote to Mrs. Paget from Venice, apologizing that he was unable to visit her in Siena because he was "really bound to stay another month or better two in this place so as not to return to Paris with empty hands."[51] Sargent did not return to Paris entirely empty-handed, but neither did he ever display a major Venetian painting at the Salon. For that traditional venue, he would have needed to paint a large canvas, something worked up in the studio from the smaller paintings and drawings he had completed on-site. The sultry street scenes and shadowy interiors he had finished in Venice were too small, sketchy, and informal for the Salon, although he did show them at other more liberal and forward-thinking venues in both Paris and London.

Sargent's Venetian paintings were unusual in their concentration on the city's narrow back streets and its decrepit palaces – shabby interiors that betray few hints of their former richness – and in their deliberate avoidance of familiar tourist vistas. Martin Brimmer, a Boston art patron and one of the founders of the Museum of Fine Arts, called them "half finished . . . inspired by the desire of finding

what no one else has sought here – unpicturesque subjects, absence of color, absence of sunlight."[52] In part, Sargent's refusal to record conventional scenes must have come from his search for an unusual subject to build into a Salon painting, one that would capture attention in the way that *El Jaleo* had done. If *The Daughters of Edward Darley Boit* can be read as the culmination of his Venetian studies, then the interiors he made there disclose some of the artistic problems he hoped to resolve.

Sargent completed about eight paintings in Venice that show interiors with multiple figures (plate 2.4). Most of them depict large open rooms, the upper floors of canal-side palaces that by the 1880s served a variety of purposes, from artists' studios to literary retreats to working-class apartments. Sargent used the long shadowy spaces as stage sets, moving his models around in intricately choreographed groupings. The figures do not always relate to one another, nor do they necessarily engage the viewer. In all of them, light filters through the area indirectly and often from the back, reflecting the polished pavement of the floor, glinting from furnishings and picture frames, and bathing the scene in a pearly opalescence that disguises as much as it reveals. The rooms and the activities that take place within them remain obscure and enigmatic, and Sargent deliberately avoids a clear narrative.

These Venetian interiors call to mind some of the more modern paintings Sargent might have seen in Paris, particularly the work of Edgar Degas. Sargent's personal relationship with Degas, if any, is unclear. No known evidence documents more than a passing acquaintance between the two men, although Sargent's name and his rue Notre Dame des Champs address do appear in one of Degas's notebooks. Degas used the book for sketches and reminders during the

period 1877–83, at just the moment when Sargent seems to have been most affected by the French master's work. Both men were friendly with composer Emmanuel Chabrier and bassoonist Desiré Dihau, the main figures in Degas's *Orchestra of the Opéra* (about 1870, Musée d'Orsay); Dihau also sometimes played with the Pasdeloup Orchestra, which Sargent depicted in 1879. Contemporary sketchbooks of both artists include lively drawings of the gaily dressed clowns who entertained between acts at the Cirque d'Hiver, where Pasdeloup performed, and also at the Cirque Fernando, where Degas painted. Sargent was well acquainted with a number of other artists and writers in Paris who could have brought him into contact with Degas – among them Jacques-Emile Blanche, Mary Cassatt, George Moore, Claude Monet, Auguste Rodin, and of course Carolus-Duran (although Degas disparaged him for his slick style) – but there is no record that any of them ever did. While Degas reportedly dismissed Sargent as "a facile painter but not an artist," Sargent admired Degas: when he visited the third Impressionist exhibition in 1877, he made a pencil sketch after Degas's pastel of a ballerina, *L'Etoile*, one of the few copies Sargent made after a contemporary work (Worcester Art Museum).[53]

Whether or not the two men knew or liked each other, the French master's art became part of Sargent's visual vocabulary. Echoes of Degas's subjects and compositions reverberate in his paintings of the late 1870s and early 1880s. Sargent's interest in subjects from modern life – the Luxembourg Gardens, the Pasdeloup Orchestra – reveal his awareness of the themes explored by Degas and his colleagues, among them the Italian painters active in Paris, such as Giuseppe de Nittis and Giovanni Boldini. The almost monochromatic palette and swirling design of *Rehearsal of the Pasdeloup Orchestra at the Cirque*

d'Hiver (1879, private collection on loan to the Art Institute of Chicago) betray Sargent's fascination with some of the unconventional formal qualities of Degas's work. Sargent would never fully develop these avant-garde tendencies, preferring instead to maintain a more conservative profile; as Mary Cassatt snidely remarked, he cared too much what other people thought.[54] But in his less formal paintings, including his Venetian interiors, he toyed with some of Degas's motifs – the tipped-up floors, the oblique sources of filtered light, and the arbitrary arrangement of figures (plate 2.5).

Sargent incorporated some of these ingredients into the portraits he was making during the same period. He posed Louise Escudier, for example, next to the tall windows of a Parisian interior, depicting her as a figure within a room rather than as a sitter standing before a backdrop (plate 2.6). This conceit allowed him to experiment with the effects of half-lights and shadows as they fell across her features from the side. Madame Escudier and the windows are reflected in the small mirror hanging in the background, further expanding the space and diffusing the silvery light. While the portrait is reminiscent of the fashionable French interiors with female figures painted by Sargent's friend Alfred Stevens, a Belgian artist active in Paris, Sargent did not aspire to Stevens's polish or to his fascination with the details of decoration and the luster of fabric. His canvas is roughly worked, with some areas barely sketched in and others thickly brushed. The painting relates equally well to his own Venetian interiors, particularly his studies of single figures, some small and some large, which seem to be the remnants of his abandoned ideas for a Salon picture.[55]

These same properties are apparent in Sargent's portrait of the Boit daughters. *Madame Paul Escudier* may even have served as a sort

of rehearsal for the Boits, giving Sargent an occasion to experiment with the placement of a figure within a domestic interior, a composition that combines elements of portraiture with an intensive study of light and shadow. The uneven paint surface of *Madame Paul Escudier* provides evidence of the numerous slight changes Sargent made to the locations of various objects in the room and suggests that he was working out those relationships as he went along. There are no such signs in the Boit portrait; the only areas showing pentimenti are Julia's lap, where the position of the doll was changed (plate 1.7), and the minor repositioning of the figure of Mary Louisa, which moved a bit further down in the picture (plate 1.4). *The Daughters of Edward Darley Boit* (like *El Jaleo*) was painted directly and quickly, brush and palette knife employed with supreme assurance, all of its artistic problems solved in advance.[56]

John Singer Sargent, *Robert de Cévrieux*, 1879

Sargent had gained experience with painting children before he rendered the Boit girls; in fact, of all the early portraits he made that might be counted as commissions, fully one-third of them depict young sitters.[57] Like any artist at the beginning of his career, he would have been glad to receive genuine orders for portraits, and in response he created engaging likenesses that often reveal the lively personalities of his subjects. Robert de Cévrieux, for example, posed for Sargent with his pet dog. Standing on an oriental rug before a curtained backdrop, the little boy, not yet breeched, is dressed in a fashionable skirted suit with a red bow. He appears to be a polite and dutiful child; his hair is brushed and shiny, his red socks are taut and even, and he presents a shy half smile to the viewer. The child's restrained energy is made clear through his attribute, the small dog he squeezes tightly under his arm. The animal is alert and animated, squirming to be released, longing to enjoy a freedom that his owner would perhaps also prefer. Sargent borrowed the basic compositional format of *Robert de Cévrieux* from his teacher Carolus-Duran, who had exhibited portraits of his own children with their dogs at the Salons of 1874 and 1875. But the dashing facility with paint and the sense of contained action and movement were Sargent's alone.

Sargent does not seem to have exhibited his portrait of Robert de Cévrieux in public, but he never regarded his images of young sitters as minor works, as some artists did. Two years later, in 1881, one of the two paintings that he selected to display at the prestigious Salon was a double portrait of children, then titled *Portrait de M. E. P. et de Mlle L. P.* (plate 2.7). It depicted sixteen-year-old Edouard Pailleron and his young sister Marie-Louise, the children of Marie and Edouard Pailleron, a prominent Parisian couple whom Sargent had painted (in separate portraits) in 1879. Sargent had shown his striking image

of Madame Pailleron, dressed in black and crossing a spring green lawn, at the Salon of 1880. The following year, he returned to the exhibition with this likeness of her children seated together on a low divan strewn with oriental carpets. Although it incorporated similar props, this painting was a more complicated composition than *Robert de Cévrieux*. It proved to be a critical success for Sargent and served as an important precursor for his portrait of the Boits.

The story of the Pailleron commission enhances our understanding of the difficulties faced by any portrait painter, but it also reveals the particular vicissitudes of dealing with young sitters, who were often bored and sometimes uncooperative. Sargent posed the two Pailleron children in the controlled environment of his studio on the rue Notre Dame des Champs. However, the ability to manage the props and lighting did not mean that Sargent had power over his human subjects. In her later years, Marie-Louise wrote that her sittings had been interminable and fraught with tension. For any child, posing for long intervals of time would have been a trial. To gather more than one child together – two Paillerons or four Boits – and expect them each to behave in accordance with one another, to follow the painter's wishes, and to keep still, was not an easy task.

The battle lines between the artist and Marie-Louise Pailleron had perhaps been drawn a year or two before. During the summer of 1879, when Sargent was with the family at their country home in Savoy, he often played with the children. It was a season not only of painting but also of butterfly hunting, and Marie-Louise later recalled Sargent searching out desirable specimens for his collection. After capturing the colorful insects, he acted "like an assassin," she wrote, "asphyxiating his victims" under a glass with the smoke of his cigar. That Marie-Louise summoned up the event with such fascination

and horror almost seventy years after the fact might demonstrate the lingering effect it had upon her, and it may explain some of her reluctance as a model, pinned, as it were, to the canvas. Frequent appointments with a young girl who had been characterized by her own grandmother as "spoiled too much by her father and ... too forward" cannot have been easy, nor were the two siblings the best of friends. Marie-Louise defined her sittings for Sargent as "a veritable state of war" and herself as a "rebel" who posed badly, fidgeted and chattered constantly, and refused to obey the painter's requests. Her arguments with Sargent, which began with the details of her costume and her hairstyle and escalated over his desire to have her sit for extended periods, continued for some time. She was only convinced to settle down to pose by a visit from the dashing painter Carolus-Duran, who appeared in his protégé's studio, explained that her father would be unhappy if Marie-Louise's portrait was not a success, and disappeared again "like Jupiter in his storm cloud."[58]

Uncooperative as she was, Marie-Louise's descriptions of her sittings offer one of the few early records of Sargent's studio on the rue Notre Dame des Champs and of his portrait practice in the early 1880s. The artist had, she said, "a large studio, very bright, but very untidy, in which the principal attraction, aside from the studies that hung on the wall, drifted over the furniture and even onto the floor (I remember a head of a Capri girl, a marvelous profile . . .), was for me a grubby harmonium, whose keyboard I undertook to clean on my arrival." As if she were trying to distance herself from her own misbehavior, Marie-Louise's account shifts between the first and third person as she relates her own recalcitrance and the difficulties Sargent faced when trying to paint her. She was well aware of the tension in the studio and Sargent's attempts to relieve it:

Of course . . . my painter was unable to get his model to resume her
pose, thence ensued a lively chase, leaping over obstacles, etc. From this
harmonium, gray with dust, J. S. Sargent could, when he so desired,
produce agreeable sounds; he was a good musician, and he also sang
and played the guitar; when he was happy with his work he sang min-
strel songs that amused me a great deal. To sing, he perched himself on
the harmonium or on one of the ladders, long legs dangling — but that
only happened in peaceful moments, and generally war reigned on the
rue Notre Dame des Champs.

Vacillating between admitting her guilt and justifying her discomfort,
she talked about the portrait:

[Sargent] painted me and my brother (he . . . was always obedient
to the artist's instructions) seated on a divan, the little girl facing the
front, the boy in three-quarters view, legs hidden by the divan. One
knows that complete and prolonged immobility is torture for a child
of 9 years. I don't say this to excuse the child, whose rebellion appar-
ently became intolerable to the artist, who had dedicated to her his
time and his talent. But still, when one considers that I posed for him
83 times, in all truth that is difficult for one still at a tender age.

Finally the day arrived when Sargent declared that the portrait was fin-
ished, and Marie-Louise was at last released from her confinement:

I greeted the news with jumps for joy, and Sargent, as much a child
as me and no doubt equally delighted to be released . . . straightaway
began to dance a giddy jig alongside his new work, then suddenly, with-
out saying a thing, he quickly began to throw pieces of furniture out

THE BOITS, SARGENT, AND CHILDREN

the window of his studio; I can still see today the free flight of his stool, table, easel, mahl-stick, brushes, and rags ... naturally, for these airborne activities, he found in me a willing accomplice.

Sargent later good-naturedly dedicated a drawing to "the terrible Marie-Louise," but the simmering tension of their time together can be read in his portrait.[59]

There is no equivalent report of the Boit girls' sittings with Sargent; no diary has been discovered that reveals any contretemps between the children and the artist or between one girl or another, although one suspects that assembling four sisters of such varying ages and attempting to bind them to a common purpose – the painting – may have been a challenge. The Boit portrait also shares certain emotional attributes with the likeness of the Pailleron children. Both representations lack the sentimentality and sugary charm that characterize most contemporary images of young sitters, making Sargent's pictures an exception to the commonly accepted formulae for depicting children. The Pailleron children look out imperiously at the viewer. Marie-Louise appears as if she were enthroned, an eastern princess on a pile of exotic carpets. Her entirely frontal pose, the tension of her pointed toes and splayed right hand, and the North African brooch and bracelet she wears enhance the impression.[60] She is regal and self-possessed and seems entirely separate from her elder brother, to whom she is deliberately disconnected by both gaze and gesture. The siblings do not embrace or hold hands; they are aloof from one another, united only in the direct stares they present to the viewer. Neither Edouard nor Marie-Louise holds a pet, a book, or a toy; they do not engage in childhood games, nor do they display any semblance of innocence or affection.

Sargent's avoidance of any touch of sentimentality is remarkable. Compared to such explosively popular paintings of children as John Everett Millais's *Cherry Ripe* of 1879, which was reproduced as a color print in 1880 and sold to half a million subscribers, or even to portrait commissions awarded to more modern artists like Renoir, whose portrait of Madame Charpentier and her children was displayed in a place of honor in the 1879 Salon, the Paillerons seem solemn and almost stern. To varying degrees, both Millais and Renoir employed the usual conventions of childhood, often expressing (in different ways) innocence, happiness, pleasure, and charm.[61] Sargent showed none of these. Instead, he demanded something new from his audience, asking his viewers to consider each of the Pailleron children (and also the Boits) separately and seriously, as unique and independent individuals.

Sargent's critics were not always able to live up to his requirements, either holding the artist accountable to convention or, more often, analyzing his work through their own expectations about images of children. A. Genevay, for example, in his review of the 1881 Salon exhibition, described Marie-Louise as a young girl eager to please her elders by sitting so still for her portrait, adding that she seemed "very well-behaved, very vivid and serious,

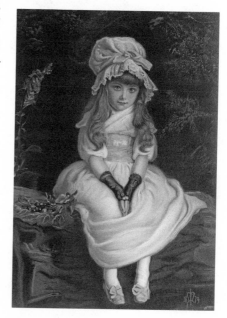

Chromolithograph after Sir John Everett Millais, *Cherry Ripe*, 1880

THE BOITS, SARGENT, AND CHILDREN

Pierre-Auguste Renoir, *Madame Georges Charpentier and Her Children,
Georgette-Berthe and Paul-Émile-Charles*, 1878

as befits a brave little model." Olivier Merson called Marie-Louise
a "charming little girl."[62] But these comments, seemingly so anti-
thetical to the facts of the commission and the personalities as we
know them (and also so different from modern interpretations of
the portrait), must have been welcomed by Sargent. He was, after
all, hoping to develop a portrait business, and he doubtless would
have preferred that the critics point out aspects of his work that
future clients would find appealing. No one would commission
an artist to paint their daughter to look as if she had unusual tele-
pathic powers, as even Edouard Pailleron had noted at one point
in the process, remarking that his daughter "look[ed] like Joan of Arc
hearing the voices."[63]

The temptation to read a narrative into the Pailleron portrait was

in part the result of Sargent's success at creating such a lifelike image, something he achieved again with the Boits. The French critic Maurice du Seigneur wrote about the banality of most of the other portraits on display in the 1881 Salon, which seemed to him to be uninteresting records of forced studio interactions in which all aspects of the sitters' characters were subsumed by the artist's need for them to sit still. Sargent's portrait of the Pailleron children was different, he wrote, for his works had "the very rare gift of drawing you in when you walk by them, they fascinate and interest you as much as any history painting ... they have life, movement, [and] ease."[64] But with his praise, it is evident that the critic missed one crucial aspect of Sargent's modernism: his very resistance to "history painting" and clear reluctance to tell specific stories – his avoidance of what James had discussed in 1877 as "the anecdotal class" of pictures, the "unimaginative and unaesthetic" views of "some comfortable incident of the daily life of our period."[65] Sargent included none of those usual elements of a narrative in his work. But his efforts did not keep viewers, then or now, from creating tales of their own, their imaginations freely substituting a concrete plot in place of the artist's ambiguity.

Many attributes of Sargent's portrait of the Pailleron children reappeared when he painted the Boits. Here, too, viewers past and present have taken the initiative to construct a narrative in the scene, choosing their dramas based perhaps more upon their own experiences than on the minimal ingredients the artist provided. Sargent does not present any specific scenario. Save for Julia's doll, the girls have no props to characterize their personalities, no toys or pets that reveal their interests or inform the relationships between them. Little information is given that would form the basis of any story. Also like Marie-Louise and her brother Edouard, each of the Boit children is treated

as an individual and seems quite separate from her companions; visually the girls do not depend on one another. Yet the two paintings are also strikingly dissimilar, for *The Daughters of Edward Darley Boit* is much more than a portrait. In this composition, the figures are not the sole subject of interest; the vaguely defined room, with its mirrors and vases, and the range of lights and half-lights are given as much attention as the girls themselves. *Portrait of Edouard and Marie-Louise Pailleron* may have provided Sargent with practice in arranging more than one figure on his canvas, but it does not foretell the complexity of the Boit image.

Nothing is known about the circumstances surrounding Sargent's creation, even whether the painting was made at his initiative or at the Boits' request. No letters survive from Sargent, the Boits, or their eloquent friend Henry James conferring about its genesis; no descriptions of the girls' sittings or the painting as it took shape; no photographs, extant bills of sale, or records of transport; no recollections published by one of the girls in later days. The girls' uncle Bob does not mention it in his early diary entries, voluminous as they are, and their father's surviving accounts do not begin until 1885. No pencil sketches or oil studies have been found either for the composition as a whole or for any of the girls, individually or together, although such preparatory works would be expected for a painting of this scale and ambition and they exist for most of Sargent's other important canvases of this period. If one surmises that Sargent tossed them out when he moved his studio in the winter of 1882–83 from the rue Notre Dame des Champs to the boulevard Berthier, why then did his numerous studies for earlier works like *El Jaleo* or *En route pour la pêche* survive? If he gave them to the Boits, where have they gone? The genesis of the portrait remains as much a mystery as the painting itself.

The Daughters of Edward Darley Boit

THE SETTING

*S*ARGENT PAINTED his portrait of the Boit girls in the autumn of
1882. He probably began it in October, as soon as possible after his
return to Paris from Italy. Late that month, Sargent's father reported
that his son John was "busy in Paris" and therefore unable to join the
family in Nice.[66] Sargent must have worked quickly, finishing the paint-
ing no later than December 20, when it appeared in Georges Petit's
Exposition de la Société Internationale. Thus it took about six weeks
for him to complete the large canvas from start to finish. That was
more than enough time for an artist with Sargent's technical gifts, but
it was very fast, nevertheless.[67] The paint seems almost effortlessly
applied: each girl is defined by thick, confident strokes made with a
fairly large brush and a palette knife, while the background and the
floor are suggested with extremely thin, broad washes of color. The
variations in the medium – the different thicknesses and opacity of
the paint – echo the themes and variations of the canvas as a whole,
in which Sargent played opposites against one another: presence and
absence, substance and shadow, light and dark.

Sargent may have been inspired to paint the four girls in this way
after actually seeing them playing in their apartment; one envisions
them active, laughing, dancing in and out of the shadows. Perhaps
he joined them in their horseplay, as he had done with Marie-Louise

three years before: one imagines him then suddenly struck by the artistic possibilities of the moment, stopping, taking charge, and asking the girls to move in, out, and around the room until he found a pleasing arrangement, a haunting and powerful composition. The record he made of the hall and its furnishings is truthful, but the setting was severely edited by Sargent's discerning eye.

One of the most striking things about the canvas is its austerity; aside from the girls and the vases, the scene seems empty. In this way it is not a precise reflection of the family, for the Boits enjoyed a comfortable life packed with friends and belongings. Their world moved with them as they traveled, providing a thread of continuity in a narrative of restlessness. Their baggage, both physical and emotional, was later illustrated in a letter from John Boit, Ned's youngest brother, who detailed the family's departure from Paris to the resort town of Pau, in southwestern France:

> Isa left for Pau last Tuesday with the big girls and the big luggage and Ned Thursday with the smaller specimens of each. The Boit household transported to Pau themselves – 6 in number, 9 servants, forty trunks, about 30 boxes and bags, two or three bird cages, two carriages, several cases of silver, linen etc, 1 harp, 1 violoncello – The French RR's allow about 60 lbs of luggage per ticket. You can form some mild idea of what it costs these curious people to move. Ned tells me Isa is extravagant + Isa says Ned is. I don't believe there is much to choose. As far as "we Boits" are concerned, I am quite convinced we are all extravagant.[68]

The Boits' tastes and comforts may have been luxurious, but these indulgences do not show in Sargent's portrait, which seems dark and

View of the avenue de Friedland from the top
of the Arc de Triomphe, about 1900

rather somber. The girls wear plain clothes, and the room in which they
pose is barely furnished. When the painting was exhibited at the
Salon in 1883, it was caricatured in the magazine *Le Journal Amusant*
with the satiric caption, "grand unpacking of porcelains, Chinese
objects, children's toys, etc., etc." (see p. 106). With these words, the
author joked about the itinerant lifestyle of the rich and their pos-
sessions as well as about the seemingly random placement of objects
and children in the composition. He also referred to the great empti-
ness of the space, which he interpreted as a situation in transition.
But as James would later put it, Sargent had "done nothing more
felicitous and interesting than this view of a rich, dim, rather gener-
alized French interior." [69]

The enigmatic interior Sargent depicted was simply one of the
rooms in the Boits' spacious quarters on the avenue de Friedland.
Ned, Isa, and their daughters had moved into the apartment in 1879
after returning to Paris from their summer in Newport; they stayed

Edward Darley Boit, *Arc de Triomphe, Paris,* 1883

there until 1886. The building was situated on one of the several large boulevards that radiate out from the Place d'Etoile in the eighth arrondissement, an elegant and expensive district. This area had been substantially altered after 1850 during the grand civic reorganization of Paris planned by Baron Haussmann. The avenue de Friedland, which leads from the Arc de Triomphe toward the east, was not entirely new, but in 1864 the old boulevard Beaujon, once part of a suburb called the Faubourg du Roule, had been reconfigured and connected with the new boulevard Haussmann. It was renamed in commemoration of Napoleon's 1807 victory against Russia at Friedland, and it became a favorite residence for wealthy American expatriates.

"The American quarter of Paris is as sharply defined as is the English one," wrote the social critic and novelist Lucy Hamilton Hooper

in her 1874 account of the American colony. "American instincts cause their possessors to turn their backs on the antiquated grandeurs of the ancient and aristocratic quarters of Paris, and to prefer the freshly-built, airy mansions on the Boulevard Malesherbes or the Avenue Friedland, and the sunny sweep of the Champs Elysées." Ned Boit recorded the neighborhood himself in 1883, painting a vibrant water-color of the Place d'Etoile.[70] In Boit's image, the white light casts strong shadows, making the streets appear to be stark and austere; the broad expanse is barely relieved by the irregular shade of the scrawny, newly planted trees that line the avenues, and the scene seems raw and modern.

The American preference noted by Hooper for newly constructed buildings might seem antithetical to people like the Boits, who were so eager to enjoy the old world that they left kith and kin behind them in the new, but actually living in traditional splendor was different than marveling at it from a distance. Constructed in 1877–78, the Boits' apartment building was only a year old when the family moved in. It had been designed by the prolific Beaux-Arts-trained architect Auguste Tronquois, whose office was in the neighborhood and who was responsible for many similarly elegant houses in the exclusive eighth and sixteenth arrondissements.[71] The house had all the modern conveniences of gas lighting, ample plumbing, reliable heating, as well as an elevator. Henry James, less enamored of these advantages, had described such a place in his novel *The American* (1876–77), using it as the home of his buffoonish American expatriate Tom Tristram. "Mr. and Mrs. Tristram lived," James wrote, "behind one of those chalk-colored façades which decorate with their pompous sameness the broad avenues manufactured by Baron Haussmann in the neighborhood of the Arc de Triomphe. Their apartment was rich in the modern

69

THE SETTING

conveniences, and Tristram lost no time in bringing his visitor's attention to their principal household treasures, the gas-lamps and the furnace holes."[72] These amenities also played a prominent role in Emile Zola's 1882 *Pot-Bouille*, serialized stories about the residents of modern Parisian apartments, which had been transforming the way people lived with their odd juxtapositions of public and private worlds.

While James's fictional and tasteless Americans most relished their up-to-date utilities, many of the real expatriates who lived in the neighborhood, including the Boits, were more cosmopolitan and sensitive, desirous of different kinds of household treasures. Hooper remarked that "the American residents in Paris may be divided into several classes, first among which [are] those wealthy and aesthetic persons who have sought and found in this marvelous city that satisfaction for their artistic and social tastes which is scarcely yet to be obtained in their native land." Calling them "rich, cultivated, and refined," Hooper explained that these "American-Parisians" were "devoted lovers of art." Some of them were significant collectors, among them James H. Stebbins, a wealthy New Yorker who lived near the Boits in "a charming hotel on the avenue de Friedland."[73] Stebbins liked contemporary art by French academic painters, favoring works by Meissonier, Gérôme, Fortuny, and Bouguereau. His compatriot, the wealthy sugar heir William H. Stewart, who also lived in the eighth arrondissement, shared his conservative taste. Stewart held popular receptions every Sunday morning at his elegant home; art critic John C. Van Dyke later noted that "art and artists were almost always discussed, and very intelligently, from very different points of view."[74] With their patronage of Sargent, Ned and Isa revealed that their artistic preferences were somewhat more modern than those of Stebbins and Stewart, but the Boits may have frequented their

gatherings, as did many other Americans, including the avant-garde painter Mary Cassatt. The Stebbinses, Stewarts, and others like them were important knots in the city's social fabric; as Hooper noted, "In those charming salons are to be met not only the other members of the American society, but the literary and artistic lions of this great capital."[75] Here, Americans met and mingled with many of the important figures in the city's international cultural sphere – writers and painters, dramatists and critics, all brought together in an atmosphere of communal exchange.

John Singer Sargent, *Henrietta Reubell,* about 1884–85

In addition to figures like Stebbins and Stewart, important society hostesses also lived in the neighborhood. Isa Boit was a particularly close friend of Etta Reubell's, a woman mentioned by British artist William Rothenstein as "a maiden lady, with a shrewd and original mind." James told his brother William about her when they met in 1876, explaining that she was "extremely ugly, but with something very frank, intelligent, and agreeable about her." Reubell was an adventurous and active woman; she smoked cigarettes, an emblem of her bohemianism; and she

created her own artistic salon, enjoying and directing the conversation from her sofa in a paneled and gilded alcove. She regularly arranged interesting people at dinners and receptions at her home on the avenue Gabriel, a few blocks southeast of Ned and Isa. In addition to the Boits and James, she knew such avant-garde figures as James McNeill Whistler and Oscar Wilde, and she freely mixed and matched her guests and provided introductions to new arrivals. Rothenstein called her "a striking figure, with her bright red hair . . . in face and figure she reminded me of Queen Elizabeth – if one can imagine an Elizabeth with an American accent and a high, shrill voice like a parrot's. All that was distinguished in French, English and American society came at one time or another to her apartment . . . she was adept at bringing out the most entertaining qualities of the guests at her table. She would often ask us to meet people whom she felt we would like, or who she thought might be of use." James came to address her as "la grande Mademoiselle," corresponding with her for many years and using her as a model for Miss Barrace in his 1903 novel *The Ambassadors*. "She was one of my mother's best friends," remembered Julia Boit, "and we were often taken to see her on Sundays, my sisters and I. She was the most amazing person and we loved to go there." James dubbed Etta and Isa "the shepherdess[es] of the studios," and Sargent was among their flock.[76]

Both Isa Boit and Etta Reubell have been credited with introducing James to Sargent; most sources date their meeting to February 1884, the month that the novelist, in a letter to his Boston friend Grace Norton, outlined his affection and admiration for Sargent, saying he was talented, charming, and "civilized to his finger-tips." It seems quite evident from James's correspondence, however, that they had met one another much earlier. On December 5, 1882, James

wrote to Reubell from London to tell her that he was waiting for "Mrs. Boit à bras ouverts [with open arms]" and asking her to "give my blessing to tout votre pleine monde, + say in special something as friendly as possible for me to Sargent." Clearly the two men were already acquainted. James had been in Paris twice that fall, both before and after making a tour of southern France. Although Sargent

was not in the city when James was there in mid-September 1882, he certainly was in residence in early November, when he was in the midst of painting the Boit daughters. James wrote to his friend Isabella Stewart Gardner that he was seeing the "same rather threadbare little circle of our sweet compan-

ions" in Paris, but it seems these old friends had brought him together with someone new and exciting. Would he have seen the unfinished canvas that Isa and Ned Boit had undertaken with Sargent? It is tempting to think so, for by the time James began to write about the picture, he obviously knew it well and beheld it with affection.[77]

That November, James may have dined with his old friends the Boits on the avenue de Friedland, where Isa loved to entertain. The Boits' lives were somewhere between the fictional Tristrams James had imagined and real

John Singer Sargent, *Henry James*, 1913

figures like Stebbins and Stewart. More adventurous in their aesthetic tastes and chosen companions than many other American expatriates, the Boits nevertheless, like the Tristrams, enjoyed their modern luxuries. This is plain from descriptions not only of their home on the avenue de Friedland but also of the residence they leased on their return to Paris in 1888 after two years in the United States, a very similar apartment just a few blocks away on the avenue de Messine. Ned's brother Bob gave a picture of the latter, noting all of its comforts and conveniences:

> Ned's apartments [sic] . . . will be charming. It is two flights from the street, in a very handsome marble-halled house − + is practically fireproof throughout. It has an elevator that runs all night which is also a convenience especially in winter when the hours of these people are late. The arrangement is like this − and I occupy Jeanie's room. The rooms are about 13½ ft high and all thoroughly lighted − there are two fine rows of trees in the street − A cab stand at the door + a Post Office just across the Place Sheakspeare [sic] at the corner − all most convenient.[78]

The generous lodgings that Bob Boit diagrammed, with a large foyer, spacious public rooms, and separate bedrooms for each of the girls, were entirely equivalent to the apartment the Boits had occupied in 1882, where the great portrait was set.

The Boits' building on the avenue de Friedland has been razed, but the cadastral records of the city of Paris document their residence there. Characterized by the assessor as a "très belle maison," the house was square, with four wings arranged around a central court and stables. The records outline a luxurious plan: on the second floor above the

ground floor, in a stone building with an elevator, was an apartment consisting of a large antechamber, a morning room, drawing room, dining room, billiard room, separate bedrooms for everyone in the family, bathrooms, dressing rooms, five lavatories, and a full complement of service rooms.[79] From all of these possibilities, Sargent chose to paint the girls in the large paneled antechamber, the front hall, just inside the main door.

Extant rooms in an adjacent building on the avenue de Friedland, constructed at about the same time, make it clear that when Sargent used the Boits' residence as the setting for his portrait, he was faithful to the architecture of the space. In that neighboring apartment, looking through a doorway at the back of the front hall, one can glimpse a large drawing room (the "grand salon") with windows facing the street. Those tall windows reflect in a mirror over the fireplace. Identical features are visible in Sargent's painting. The two Japanese vases apparently flanked the passage from the foyer to the salon, and perhaps

Bob Boit's sketch of his brother Ned's apartment on the avenue de Messine, 1889

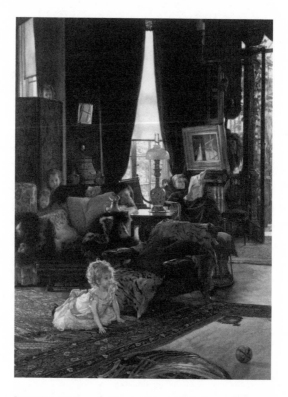

James Jacques Joseph Tissot, *Hide and Seek*, about 1877

the wobbly red screen could be moved to block drafts from the door. Aside from the few objects visible in Sargent's painting, the Boits' taste in interior furnishings is unknown. Their home was probably like those of other American residents in Paris. "Everything smacks of the pilgrim," wrote Earl Shinn of one such expatriate household. "The furniture and decorations are collected from half-a-dozen capitals ... the servants fill the halls with echoes of a varied and courier-like

assortment of languages; and the ladies of the house direct them in German, or in Brussels French, – conversing with each other, meanwhile, in the purest French of the Théâtre Français."[80] One suspects that the Boits' quarters were equally cosmopolitan and eclectic; their drawing room was likely similar to the crowded interior depicted by James Tissot in his painting *Hide and Seek*, in which three young girls play among an assortment of overstuffed furniture, carpets, Asian screens, and porcelains.

The only furnishings that have survived from the time of the portrait are the two giant vases that loom and glimmer in Sargent's composition. The vases were not studio props but beloved possessions of the Boits. Stuffed with excelsior, they were packed and repacked, moving back and forth across the Atlantic with the family, providing them with a constant symbol of home; relatives later recounted with amazement that the vases crossed the ocean more than a dozen times, suffering only relatively minor damage to their rims. Six feet tall and massive, their tops flare into scalloped ripples of porcelain, the delicacy of these frilled edges belying the great weight of the vessels. Their colossal proportions dwarfed the girls, making odd relationships between the animate and inanimate subjects of Sargent's portrait. Had the girls perhaps taken a draught of some magic potion, as Alice had done in Lewis Carroll's 1869 novel *Alice's Adventures in Wonderland*? In that story, the heroine, clad in her own starched white pinafore, sipped from a small bottle labeled "drink me":

> *This bottle was* not *marked "poison," so Alice ventured to taste it, and finding it very nice, (it had, in fact, a sort of mixed flavour of cherry-tart, custard, pine-apple, roast turkey, toffee, and hot buttered toast,) she very soon finished it off. "What a curious feeling!" said Alice; "I must*

be shutting up like a telescope." And so it was indeed: she was now only ten inches high, and her face brightened up at the thought that she was now the right size for going through the little door into that lovely garden. First, however, she waited for a few minutes to see if she was going to shrink any further: she felt a little nervous about this; "for it might end, you know," said Alice to herself, "in my going out altogether, like a candle. I wonder what I should be like then?" And she tried to fancy what the flame of a candle is like after the candle is blown out, for she could not remember ever having seen such a thing.[81]

Alice shrank so much in size that suddenly ordinary household furnishings took on enormous proportions. Girls and objects shifted their relative dimensions in her magical universe, and Sargent's subjects in their shadowy room evoke Carroll's fictive space. *Alice's Adventures in Wonderland* was deeply embedded in popular culture by 1882, and both the Boit daughters and Sargent (with two younger sisters) would have been familiar with the book. Transformations of scale and proportion – one of Carroll's recurring themes – seem a chief component of Sargent's unusual setting. But the vases he painted are real, and faithfully rendered.

Sargent used the very authenticity of the large porcelain pots to create a sense of fantasy. He knew better than to depict every detail of these elaborately decorated vessels (see plate 1.8). Instead, he subdued their color, using a grayer blue than the rich dark cobalt of the originals, and abbreviated their elaborate motifs, only hinting at the birds and flowers that ornament every inch of their surfaces. Sargent was aware that if he rendered all of their decoration, the vases would take too prominent a role in his composition. By toning them back, he made them recede and allowed the girls to come forward. Never-

theless, certain details – one bird in flight, the stylized rocks – can be identified in both ceramic and paint, proving that Sargent used the actual vases as models, not merely his imagination.

The Boits could have purchased these large-scale vessels on either side of the Atlantic. Beginning with the London International Exhibition of 1862, Japanese ceramics were displayed and sold at international art and trade exhibitions in both Europe and America. They became popular markers of the modish taste of their owners, for the collecting of blue-and-white ceramics from China and Japan was all the rage. But the Boits' vases were not the sort of fine Asian antiques to which Whistler had paid homage in his paintings of the 1860s. Nor were they the delicate porcelains associated with the tea ceremony that attracted sophisticated Japanophiles in Paris. Instead, they were colossal, brand new, and made specifically for the West according to Japanese ideas about what Europeans liked.[82]

The Meiji government of Japan took advantage of this taste for Japanese art, actively marketing Japanese goods at world's fairs and trade shows to finance a radical reorganization of the country's culture and society. The 1873 exposition in Vienna was one of the most significant, for its large display was the first to be organized by the Japanese government rather than by Western collectors.[83] With the advice of a German chemist who taught in Tokyo, the Japanese ensured that the goods they sent to Vienna were selected to meet Western standards of taste. Some European connoisseurs were disappointed, decrying the imitation of Western forms of porcelain manufacture. Jacob von Falke, for example, curator of the Austrian museum of art and industry, complained about the mammoth scale and European style of some of the pieces displayed at the Vienna fair. Asian scholar Francis Brinkley would later be much harsher, condemning

the "wretched products of this mercenary impulse." The chief offender, he complained, was "a vase, from three to six feet in height, in shape resembling a truncated soda-water bottle, with its neck spread out in the semblance of a scalloped trumpet." Brinkley recognized the difference between art and fashion, observing that "many an American or European amateur flatters himself that in the big, obtrusive vases which disfigure his vestibule he has genuine specimens of Japanese art, whereas he has, in truth, nothing more than a Japanese estimate of his own bad taste."[84] But the public loved the big pieces, and the Boits were among many enthusiastic patrons who disfigured their vestibules with such flamboyant modern wares.

Japanese gallery at the world's fair in Vienna, 1873

The Boits' large blue-and-white vases were made in Arita, Japan, and are characteristic of the region, with luminous dark blue cobalt oxide glazes (a modern innovation) and decorations that cover the whole surface of the vessel with landscape elements, flowers, and birds to create a unified narrative. They bear the mark of Hirabayashi Ihei, who was active in Arita as an exporter from about 1865 into the 1880s.[85] Arita had been one of the first Japanese ceramics centers to modernize, courting customers in Europe and America and even acquiring steam-powered production machinery manufactured in Limoges. Arita ceramics had appeared at the Centennial Exposition in Philadelphia in 1876, where the Fukagawa workshop offered an especially dramatic display of flower vases of various sizes, one of them ten feet tall, an enticement promoted in the official catalogue.[86] Thirty thousand objects, including two entire buildings, had been shipped from Japan to Pennsylvania, where Sargent was one of the many Americans to receive an introduction to Japan's art and culture. But exactly when and where Ned and Isa Boit bought their vases is unknown. Photographs of the Vienna fair also show vases of a style and scale similar to the ones the Boits owned. It seems most likely that they bought their vases in Europe, either at an international fair or perhaps in one of Paris's new retail shops or galleries that specialized in Japanese imports.

The Boits, like Sargent, would have been aware of the vogue for Japanese art in the modern aesthetic circles of Paris. Critics like Philippe Burty, Charles Ephrussi, Edmond de Goncourt, and Ernest Chesneau, who wrote about contemporary painting and the international art scene in the city's leading journals, also commented extensively on the Japanese works exhibited at the 1878 exposition in Paris, helping to establish the popularity of Japanese art in France.

But particularly American associations were also at play. Credit for "opening" Japan to the West in the early 1850s was given to the American naval commander Matthew Perry; he was awarded a medal for his accomplishment by merchants from the Boits' native Boston, who no doubt hoped to continue their long and lucrative history of Asian trade. The funds that had enabled the Boits to live in Paris came from Isa Boit's Cushing inheritance, a legacy of Boston's China Trade earlier in the century. One of its leaders had been Isa Boit's great-uncle Thomas Handasyd Perkins, who sits beside a large Chinese ewer – a symbol of his success in Eastern markets – in Thomas Sully's full-length portrait of him (1832, Boston Athenæum). Perhaps the Asian ceramics in Sargent's portrait of the Boits also summon up that profitable history.

The large blue-and-white vases remained treasured possessions of the Boits. When Ned commissioned a house in Brookline from the Boston architects Peabody and Stearns in 1903, the front hall was designed to accommodate them. There they stayed until the 1980s, their miscellaneous contents a document of mischief and the passage of time. When they first traveled to the Museum of Fine Arts for display in 1986, they contained – among handfuls of the excelsior with which they had been so carefully packed – a cigar stub, a paper airplane, a pink ribbon, a tennis ball, sheets of geography lessons, a letter about the repeal of Prohibition, an Arrow shirt collar, an old doughnut, an admission card to a dance at the Eastern Yacht Club in Marblehead, Massachusetts, three badminton shuttlecocks, many coins, and a feather. The vases now stand in the museum's gallery near the painting, mute witnesses to lost time.

If these silent sentinels could speak, they might reveal whether Sargent actually settled down to work in the Boits' apartment or

made the final painting in his own studio on the other side of the city. The shape and size of the canvas – a square measuring more than seven-by-seven feet – make it an unwieldy burden to move, especially in and out of a Parisian apartment. Contemporary artistic practice would have dictated that such a large work be crafted in the controlled environment of the studio, based upon sketches in pencil, watercolor, or oil of the room, the vases, and the girls. Although no such studies survive, Sargent could have brought the girls to his studio for individual modeling sessions, combining them on canvas with smaller compositional studies he had made in the apartment. Presumably he did not subject the Boits to eighty-three sittings, as he supposedly had done with Marie-Louise Pailleron. They may have been more willing subjects; they were doubtless much more familiar with the requirements, since their father was also an artist (albeit a landscape painter). The four sisters might simply have been better behaved. They would have needed to be, for Sargent was working quickly and did not have eighty-three days to devote to them. He seems to have taken only about a month and a half, forty-five days, to complete this masterful picture.

The Daughters of Edward Darley Boit

THE PAINTING

*D*ESPITE THE SPEED of its execution, *The Daughters of Edward Darley Boit* was not casually made. Its scale and formality, its combination of traditional and modern references, and its haunting presence are signs of a carefully considered and self-conscious piece of art. The painter's ambitions seem much larger than those required for a simple likeness of four relatively ordinary little girls, and the unusual conception seems purely Sargent. Perhaps the Boits had commissioned him to make a portrait of their daughters, and he proposed this unconventional image instead. Or possibly the whole idea was Sargent's, for at this time in his career he was known to have pursued the subjects that appealed to him. He did this most notably (and during this same season) with the legendary beauty Madame Pierre Gautreau, whom he actively petitioned to pose for him. The girls may also have triggered something in Sargent's artistic imagination, causing him to suggest a portrait to their parents.

Whatever the case, Sargent had sympathetic patrons in his friends Ned and Isa Boit, both of whom understood and appreciated the creativity of painters and writers and so were unlikely to insist that Sargent produce a more conservative image. Fond parents who had paid an artist for a likeness of each one of their children would have found Sargent's painting, which obscures the features of two of the

four girls, a dismal failure. But the Boits must have taken the advice that Henry James would later offer to one of Sargent's sitters. James recommended "the policy of self-surrender to the artist . . . trust him completely and ask no questions . . . leave him his ways, his variations, his mysteries . . . You can't collaborate except by sitting still." [87]

The Boits, who presumably did buy the canvas from Sargent (since they ended up with it), fortunately left the painter to his mysteries, allowing him the freedom to construct something that functioned as much more than a portrait. Perhaps they realized from the very beginning that he had something substantial in mind. Sargent's magic was not limited to his facility with a paintbrush. Here, in a scene of children at home in a contemporary Parisian apartment, he conjured together the old and the new, grasping the essence of a variety of sources and uniting them with the physical evidence before his eyes. He invented an image that was, all at once, faithful to actual appearance, reminiscent of the grand traditions of art, and completely novel and unusual. In this way, Sargent established himself (and by extension his clients) as a thoroughly modern heir to the old masters.

For his conception of *The Daughters of Edward Darley Boit*, Sargent's muse among the artists of the past was once again Velázquez. The Spaniard's well-known and much-admired masterpiece *Las Meninas* (1656, Museo Nacional del Prado) provided him with direction; it was one of ten paintings by Velázquez that Sargent had copied during a trip to Madrid in 1879. By making such a pilgrimage to see these famous works in the Prado, Sargent had followed not only contemporary French taste and admiration for Spanish painting but also the specific recommendation of his teacher Carolus-Duran, who had constantly reminded his students to study Velázquez. In Madrid, Sargent obtained

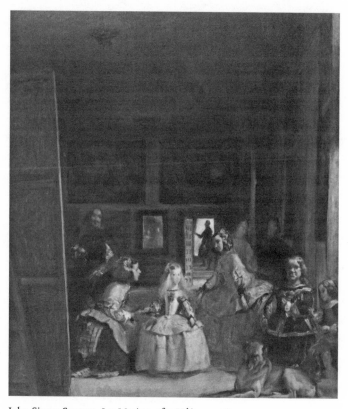

John Singer Sargent, *Las Meninas, after Velázquez,* 1879

the requisite permissions from the museum, and the Prado's record book lists him as beginning his copy of *Las Meninas* on October 27, 1879, and completing it on November 14.[88] The register also reveals that Sargent worked on several different copies simultaneously but spent the longest time on *Las Meninas*, perhaps finding it the most intriguing or difficult of the works he studied. The copy he made of it is much smaller than the original but captures its characteristics faithfully, albeit with a freer and looser brush. Sargent seems to have been

SARGENT'S DAUGHTERS

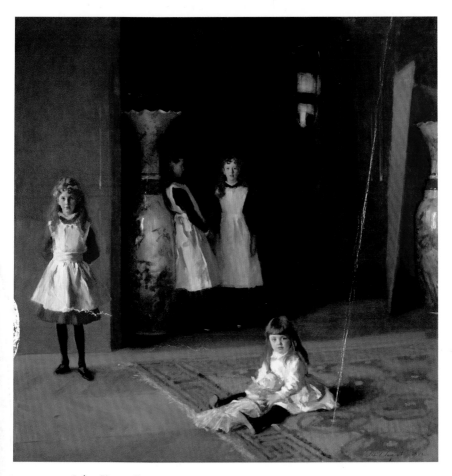

1.1 · John Singer Sargent
The Daughters of Edward Darley Boit
1882, oil on canvas

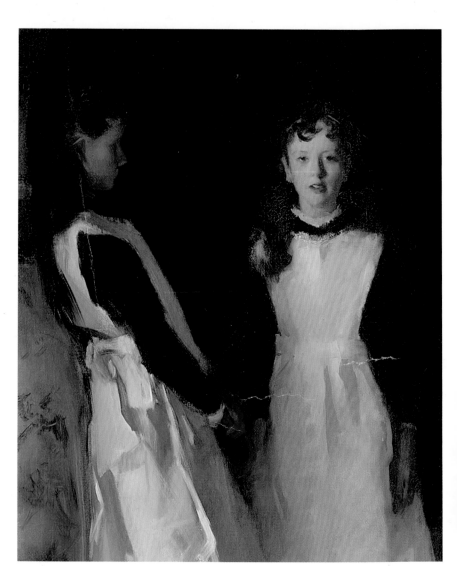

1.2 · Detail of Florence and Jane

1.3 · Detail of the fireplace, mantel, and mirror in the background

1.4 · Detail of Mary Louisa

1.5 · Mary Louisa's pinafore, showing Sargent's bold use of the brush

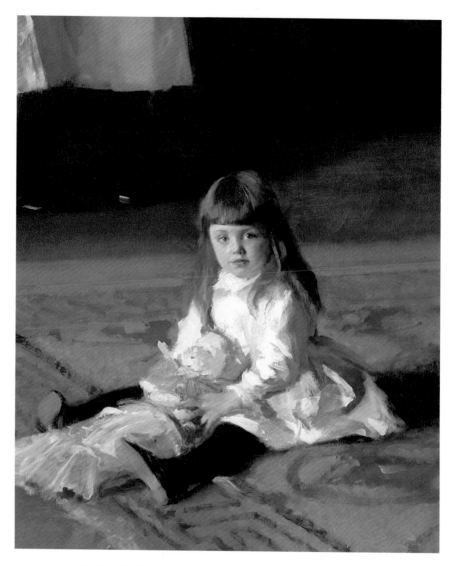

1.6 · Detail of Julia

1.7 · Julia's hand and doll: Sargent shifted the position of the doll, and traces of this change are evident in his loose flurry of brushstrokes.

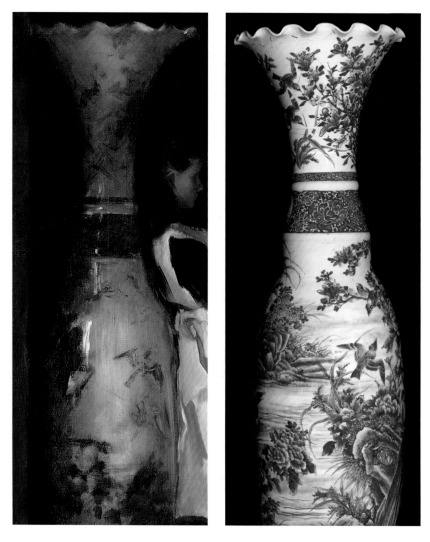

1.8 · Comparing Sargent's painted vase to the actual vase owned by the Boits (right) highlights the artist's skill: by leaving out much of thee vases' elaborate decoration, he made them appear to recede into the shadows.

most interested in Velázquez's underlying composition and structure, as well as in his placement and lighting of individual forms. The baffling relationships between the figures in *Las Meninas*, its shadows and half-lights, and the complex geometry of its space all reappear in *The Daughters of Edward Darley Boit.*

Other sources in Velázquez's art have also been suggested for the complicated space Sargent created in the Boit portrait – *Las Hilanderas* (*The Spinners*), for example, which Sargent also copied at the Prado, a painting whose foreground figures of spinners in a dark space are juxtaposed with a lighted alcove in the background where further action unfolds.[89] One might also bear in mind Sargent's oil studies of particular figures from group portraits by the seventeenth-century Dutch painter Frans Hals, which he made around the same time. In Hals's work, Sargent could explore the complexities of presenting on a single canvas both individual personalities and an image of a unified group. Yet even if Sargent made use of more than one historical source, there is something specifically appealing about the link between the Boit girls and *Las Meninas*. The two paintings share more than a formal resemblance; they are also bound together by a simple thematic connection: both paintings are centered on little girls.

The main character in Velázquez's composition is the five-year-old princess, the infanta Margarita Teresa of Spain, a self-assured child with shoulder-length blond hair who is almost the mirror image of four-year-old Julia Boit. The infanta is encircled by members of her court – two ladies-in-waiting (the *meninas* of the title), two dwarfs, and various other attendants, including a large dog – just as Julia's older sisters are arrayed around her. Along with Maria Barbola, the dwarf dressed in black in Velázquez's composition, the Spanish princess looks directly out of the canvas at the viewer, as do two of the

Diego Rodríguez de Silva y Velázquez, *Las Hilanderas* (*The Spinners*), 1657

Boit girls, while their sisters look away or recede into the background, recalling other figures in *Las Meninas*. In both compositions, the girls respond to something outside of the canvas. Velázquez implies that the infanta reacts to the presence of her parents, the king and queen, who appear reflected in the mirror at the back of the room and thus must be standing in front of their daughter, in the space of the viewer. Sargent's daughters also seem to react to an onlooker, in this case unseen, someone who has caused them to look up and out of the picture.

Some scholars have proposed that the connection between the two paintings is deeper than these formal similarities. For example, Barbara Gallati has argued that one common English translation of *Las Meninas*, "maids in waiting," can equally be applied to the meaning of Sargent's portrait.[90] In this way the Boit girls can be seen as maids-in-waiting too, either literally, as they stand in the entrance foyer of the family's apartment, perhaps waiting for an arrival or departure, or figuratively, as girls who attend their future role as

women. Velázquez's title can also be translated as "maids of honor," and by extension Sargent's portrait can be seen as honoring the Boit children, or perhaps their parents. But such verbal puns are rare in Sargent's work. When he exhibited the painting in Paris in December 1882 and again in March 1883, he did not force the viewer to note its relationship with the Velázquez and he called it simply *Portraits d'enfants* (Portraits of Children).

This title is not as easy as it first appears, for Sargent selected the plural "portraits," a term that might have been considered a typographical error in a hastily printed exhibition checklist but which becomes evidence of a conscious semantic choice when repeated in two catalogues on two separate occasions. Similarly, when Sargent's father mentioned the Boits' painting, he called it "a portrait, or rather 4 portraits of children in one picture," reinforcing its plurality.[91] With his *s*, Sargent emphasized that he had brought together the likenesses of four people, declining to fuse their individuality into a generalized image of a unified group. This tactic was a multiplication of his image of Edouard and Marie-Louise Pailleron, which had been described as "the portrait of M. E. P.... and his sister, on the same canvas."[92] In the Boit picture, each girl appears to have been painted separately, none of them linked to any of the others by pose, gaze, or gesture. Even the two oldest children, who stand so close to one another in the background that their white skirts overlap, seem entirely alone. Sargent's emphasis on the uniqueness of each of the girls, on their very self-possession, intentionally calls to mind Velázquez's assured, stoic infanta. It was a device that he would later repeat in a number of his portraits of young girls, giving them a presence and distinctiveness seldom accorded to children of their age and gender.

Reverence for Velázquez was only part of Sargent's artistic agenda.

His portrayal of the Boits – their individual personalities, their domestic setting – also reveals his desire to create something demonstrably new. Forward-thinking writers of the period had been asking for painters to respond to the world around them, to reflect upon the anonymity and immediacy of contemporary life. In his ambiguous domestic portrait, Sargent may have proposed an answer. One critic condemned his painting as "insolent in the American style," by which he likely meant that the picture lacked subtlety and grace and was entirely too raw, much like the new electric streetlights whose harsh glare had just begun to mar the Paris nights and were reviled as a symbol of the Americanization (a contemporary synonym for modernization) of Paris.[93] Set within a recognizably up-to-date interior, Sargent's young subjects play out an uncertain, random, or perhaps even nonexistent story. This ambiguity, together with the broad brushwork and uneven lighting effects the artist employed, makes the painting antithetical to the established conventions of academic art, with its emphasis on smooth surfaces, even illumination, and clear narrative. As much as it echoes the grand traditions of Velázquez, Sargent's picture also embodies "the new painting" that had been introduced in France.

Domestic interiors were one of the style's important subjects.[94] The avant-garde poet and critic Stéphane Mallarmé had observed in 1876 that "the chief part of modern existence is passed within doors," and thus he felt that the interior was a particularly appropriate subject for artists who sought to explore present-day life. Writer Edmond Duranty agreed, noting that interiors could offer as much optical interest as street scenes, for "in our homes, tonal values vary infinitely, depending upon whether one is on the first floor or the fourth, whether a home is heavily furnished and carpeted, or whether it is

sparsely furnished." In formal terms, an interior was as responsive to the changes in atmosphere – to the momentary effects of light and shadow – as a city scene or a landscape could be. "An atmosphere is created in every interior," wrote Duranty in his important 1876 essay *The New Painting*, "along with a certain personal character that is taken on by the objects that fill it . . . we will no longer separate the figure from the background of an apartment . . . the language of an empty apartment must be clear enough to enable us to deduce the character and habits of its occupant."[95] The light and shade, the furnishings, the books and the bibelots could all reveal as much as the humans who used them, and vice versa. Interiors – of the workplace, the café, the theater, and the apartment – were at the heart of modern life and art.

Duranty's text is often linked to Degas's distinctive interiors, and it is once again to Degas that one might turn to find insights into Sargent's unusual and disconnected composition. While the informal paintings of bead stringers and street life that Sargent had recently made in Venice bear the most resemblance to Degas's arbitrarily arranged scenes of dancers and laundresses, the Boit portrait still echoes those compositions. The painting has been enlarged, formalized, tightened up, and brought to a different level of society, but elements of the experimental nature of Sargent's Venetian scenes and Degas's interiors persist. The setting is one of the most obvious. Degas had frequently used contemporary rooms as a stage for his portraits, often employing the geometries of architecture and decoration to emphasize the disjunctions within families. In *Family Portrait* (plate 2.8), for example, Degas's large portrait of his aunt Laura Bellelli, her husband, and their two daughters, he divided the space unequally between the monumental form of the mother, whose wide

skirts and encircling arms fill the majority of the composition, and the cramped area given to her husband, Gennaro Bellelli, who is set distinctly apart from his family, virtually caged in a small space demarcated by moldings, chairs, and table legs. None of the four Bellellis look at one another; each figure is entirely absorbed in his or her own thoughts. Despite the similarities to Sargent's painting in the Bellellis' distant and disparate gazes and the stark whites of the girls' pinafores, it seems unlikely that Sargent ever saw Degas's portrait, which – aside from its display at the 1867 Salon – apparently sat neglected in the artist's studio for the rest of his life. But an echo of its disengaged relationships reverberated in several of Degas's later portraits and genre scenes, including a number that Sargent would have seen at the 1876 Impressionist exhibition.

Degas's Bellelli composition is only one of many examples of Impressionist group portraits that can be characterized, as the art historian Linda Nochlin has written, as fragmented, separate, and centrifugal, often including areas of empty space that hint of dislocation and anxiety.[96] Degas's *Place de la Concorde*, an unconventional portrait of the aristocratic painter Ludovic Lepic and his two daughters on the streets of Paris (1875, State Hermitage Museum), is one of the most extreme, with its summary background and cropped, disconnected figures, each of whom looks in a different direction, but there are many other examples by avant-garde French painters – Degas, Manet, Monet, Bazille – seeking to redefine the portrait. They experimented with unusual settings and poses, with lighting effects and angles, creating disjunctions and ambiguities that expressed the new tensions of life. Sargent's painting, with its emptiness, unusual disposition of figures, and deliberate lack of a relationship between the girls, also vibrates with this distinctly modern unease. In 1885,

Vernon Lee would call this quality in Sargent's work a "crispation de nerfs," a nervous anxiety, a certain high-strung apprehension that she found in many of his depictions.[97]

Sargent set his portrait in a specific space in the Boits' home: the "grande antichambre," or front hall, of the apartment. He may have found the space appealing simply for its light and reflections, or for the vases that were placed there, or for the fact that – especially if he did craft the painting there – it was large and empty. Nevertheless it was an interesting choice, for it was a threshold. The least intimate room within the house, the foyer was neither entirely within nor completely without the family's domain; it was both a public and a private room. It was an accessible social space, where callers were received, but also a transient one, for there an unwelcome visitor would be shown the door and an acceptable guest ushered further inside. While the room was clearly within the Boits' domestic sphere, it revealed little about the interior preoccupations of the family. The girls are balanced there, the viewer left uncertain whether he or she is to be invited in or warned away. The very awkwardness of this setting, clearly defined as a passage or vestibule by the placement of the vases, adds to the impenetrability of the scene.[98]

The girls themselves reiterate this sense of disorientation, for they neither advance in greeting nor retreat in apprehension; each in her own way stands her ground. As individual as they seem, the sisters echo and reinforce one another through their similar clothes. Dressing alike is a common conceit among siblings, but the Boits' costumes are unusual for their informality. While most girls would have worn their best outfits to pose for a portrait, the Boits are shown in simple everyday clothes – dark dresses and stockings, sturdy shoes, and stiff white pinafores that would have protected the clothing underneath.

They sport no frilled collars or ribbons or lace, no shiny smooth satin stockings of the type Marie-Louise Pailleron had begged to wear, no bows or ornamentation of any kind. Plain and casual, the dresses reinforce the quotidian nature of the setting. One suspects that the choice of costume was made by Sargent (records document many instances of this artist telling his sitters what to wear) – not only to reinforce the informality of his subject but also to demonstrate, in the pinafores, his remarkable abilities as a painter of white on white. It is in the whites that the painting comes alive, with a dazzling display of brushwork that both defines the forms of stiff skirts and wide sashes and stands apart from them, recording the deft action of the artist's touch (plate 1.5).

The sense of autonomy among the girls (and the vitality of Sargent's paint) has often made viewers feel as if by looking at the portrait, they have interrupted the children, who glance up in response. While today's audiences have sometimes assumed that the girls are engaged in some sort of clandestine activity, in Sargent's day the most frequent notion was that they had simply been playing. The pinafores were certainly appropriate garments for girls at play, and the majority of writers who discussed the painting when it was first displayed characterized it as an image of children participating in or having just finished a game. Henry James, who knew the Boits quite well, characterized it as a "happy play-world." Similarly the Boston writer Susan Hale, who most likely was also acquainted with the family, would describe it as a scene "of the Boit children playing."[99] It would be many years before the painting came to be interpreted as a penetrating essay on the psychology of childhood.

While Sargent was indeed an astute observer of character, and several viewers claimed that his paintings revealed more about his

sitters than either the artist or his model might have intended, it is likely that the problems he sought to explore in *The Daughters of Edward Darley Boit* were artistic rather than psychological. The curious arrangement of the figures, the studied asymmetry, and the concentrated exploration of chiaroscuro are too dominant to be discounted. The girls are not posed neatly – Florie, Jeanie, and Julia are all more or less in the center of the flat plane of the composition, while Isa draws the viewer's eye to the left. Her bright figure is balanced at right in two ways: by the shapes of the large vase and red screen, and by the shadowy depth of the room in the background. The scene is also precisely aligned from front to back – the captivating figure of Julia acts as a counterweight to the forms of her two sisters at middle ground, with the background anchored by the window reflected in the mirror over the fireplace, which provides a carefully calculated touch of light. In 1880, the milky incandescence of Sargent's painting *Fumée d'ambre gris* had been praised for its exploration of white upon white; here he investigated the same problem differently, choosing a single object – the uniform of starched white pinafores – and recording it in a progression, first as it appears in the bright light of the foreground (perhaps the stark glare of a modern gas fixture) and then, through a series of deliberate steps, as the skirts' glow fades in the increasingly dim interior behind. The girls in their pinafores and the modulations of the light inspired Sargent to put together a composition of theme and variation as balanced as a musical score.

Sargent created equilibrium in this composition through an unusual strategy of playing shapes and light and dark against one another. Its square format emphasizes these patterns. His canvas also rests upon another pivot: it falls midway between portrait and genre scene. In fact, the painting barely functions as a portrait, since only Julia appears

in the clear and even light that one expects in a commissioned like-ness. Isa and Jeanie are recognizable, although neither is rendered clearly – Isa's face is half in shadow, while Jeanie stands in the dim light at the back of the room, her features indistinctly defined. Florie is altogether lost in the darkness; she turns away from the viewer, her face completely obscured. James's later definition of the picture as a "rich, dim, rather generalized French interior" gives emphasis to the setting over the sitters. The placement of the girls in such a large space, along with the unspecified relationships between them, allows Sargent's viewers to construct a story around them; thus, his paint-ing leaves the realm of portraiture and becomes a genre scene. James even suggested another title for it, "The Hall with the Four Children," a designation in keeping with the names he chose for some of his short stories and one that encourages a narrative interpretation. "The naturalness of the composition, the loveliness of the complete effect, the light, free security of the execution, the sense it gives us as of assimilated secrets and instinct and knowledge playing together," wrote James, "makes the picture ... astonishing." [100]

James's text is as ambiguous as Sargent's painting. He may have been referring to attributes of Sargent's young models, who play to-gether and seemingly share a childhood world of secrets and knowl-edge. Or James may have been referring to Sargent himself, whose technical secrets, aesthetic instinct, and artistic knowledge play together on the canvas. Sargent's painting, with its unusual amalgam of art history and modernity, of portrait and genre scene, of formality and casualness, of mystery and specificity, of light and dark, was an intriguing puzzle, one that often perplexed the critics when it was first displayed.

"Four Corners and a Void"

Y MID-DECEMBER 1882, Sargent's painting was finished and ready to be presented to the public. One might have expected him to hold such a major canvas for the annual Salon, but Sargent chose instead to show it for the first time in the well-appointed rue de Sèze galleries of the Parisian art dealer Georges Petit. Exactly Sargent's age, Petit had inherited his father's prosperous business in the late 1870s. By that time art dealership had taken on modern form, with firms promoting a stable of artists, acting as experts and appraisers, and organizing exhibitions that served to mark their territory and to garner attention from both the press and the public. Petit had already invested in modern art, serving as the expert at the 1878 bankruptcy sale of Ernest Hoschedé, an important early collector of Monet's paintings, and eventually he would become a competitive rival to Paul Durand-Ruel, the chief dealer for many of the Impressionists. According to Emile Zola, Petit's motivation was financial rather than aesthetic. Zola commented that the dealer had created a luxurious store for art that replicated the commercial tactics of the city's elegant department stores, that he bought low and sold high, and that his chief customers were the Americans who arrived in Paris each May. Mercantile it may have been, but Petit's formula succeeded; in 1881, he expanded his gallery and moved it to a large house on the rue Godot de Mauroy (with an entrance on the rue de Sèze). There, in a smart neighborhood behind the Church of the

Madeleine in the ninth arrondissement, he outfitted lavish rooms at the heart of Haussmann's Paris.[101]

Modeling his efforts upon the commercial and critical success of the innovative shows presented by the Grosvenor Gallery in London, Petit organized his first independent annual exhibition, the Exposition de la Société Internationale, in 1882. He assembled an advisory committee of painters, but Petit alone made the final decisions about which artists would be invited to display their work. He promoted a young and international group, all active in Paris and considered distinctly modern, if not avant-garde. As the critic Paul Mantz noted in *Le Temps*, "The visitor can be assured in advance ... [that] he will find no academic work, no literary piece inspired by the cult of the ideal of ancient days ... all the painters ... are young ... and all are in the style of tomorrow."[102] While several of the Impressionists would come to display their canvases at Petit's, the dealer's first exposition, opening on December 20, 1882, included mostly men now characterized as members of the so-called *juste milieu* (the middle ground), artists who negotiated the boundary between tradition and innovation. Among them were the much-acclaimed French painters Jules Bastien-Lepage, Jean Béraud, Jean-Charles Cazin, and Pascal Dagnan-Bouveret; the Italian portraitist Giovanni Boldini; the Finnish and German artists Albert Edelfelt and Max Lieberman; the Briton William Stott; and two Americans, Julius Stewart, a painter of expatriate high society, and Sargent. Sargent displayed seven works in that first show, chief among them his new *Portraits of Children*.

Like most of his fellow exhibitors, Sargent had already won acclaim at the Salon. By agreeing to show with Petit, he consciously allied himself with the more progressive group of painters whom the dealer supported, and thus promoted his art as modern.[103] While the

large portrait of the Boits was the most ambitious of the canvases Sargent exhibited, he also showed two small and informal likenesses – one of his childhood friend Vernon Lee (1881, Tate Britain), and one of Madame Allouard Jouan, a writer and translator (about 1882, Musée du Petit Palais, Paris). Additionally, he displayed four of his moody Venetian views (two interiors and two street scenes). In that company, the Boit portrait would have seemed more finished and complete than any of the other paintings. In *Vernon Lee*, Sargent had left areas of canvas blank and had given his model a fleeting, momentary expression, sketchlike qualities that did not appear in his *Portraits of Children*. Similarly, he might have expected that in comparison to his small Venetian interiors, his large composition would seem very carefully planned. However, the juxtaposition of these seemingly disparate works would also have revealed many similarities. The casual appearance of Vernon Lee is replicated in the informal outfits the Boit girls wear, and both paintings convey the sense that the sitters have been interrupted. The dark palette, boxlike setting, and apparently random positions of the figures seen in the Venetian paintings are echoed in *Portraits of Children*; viewed together, the depiction of the Boit girls may indeed have appeared as if it were the culminating expression of Sargent's Venetian studies, or an amalgamation of those pictures with portraiture.

Many critics discussed Petit's exhibition and Sargent's paintings, some dismissing the works as "unformed sketches" and characterizing Sargent as a "disputed master." [104] But the influential writer Paul Mantz proclaimed *Portraits of Children* a "véritable tableau," a true painting (in the sense of a complete and finished piece), and he analyzed it at length. As a genre scene he found its subject unusual, for the girls "do nothing." Sargent's composition was similarly unconventional,

but Mantz recognized that it possessed an underlying structure built around color and shades of light rather than upon lines, and he understood that the painter had learned many lessons from the art of the past:

> *From the point of view of the linear arrangement, the composition is audacious and disjointed, it is organized instead around color and chiaroscuro . . . In the foreground, the waif in the white dress plays with a doll whose pasteboard face is whisked with lively reds, and she sits on a greenish rug, but one worn, faded, pale, and there we have — with this white, this rose, and this green — a bouquet that shows us that Mr. Sargent did not study the great harmonist Velázquez in vain.*

Mantz figured out that Sargent's main subject was not likeness, but light and its infinite variations:

> *The three standing girls are not less distinguished by the choice of tints and by the delicacy of the lighting: one is in the middle ground, the two others at the back of the room; they thus receive, contrary to the laws of Mr. Boldini* [whose painting Mantz disliked], *a touch modulated by the dimmer light. Each of them wears a white, fitted apron over her blue or red dress. The problem is one of painting whites in light, whites in half-light, and whites in shadow. This charming obstacle is resolved with the greatest delicacy in the world. That which Mr. Sargent has wanted to do, he has done.*

He concluded his remarks by observing that Sargent's previous work in Spain and in Italy, along with his study of past masters, had shaped his eye:

And we are truly delighted that this subtle painter has seen Madrid and Venice. That double voyage clearly showed him things he had suspected with a sort of vague intuition. He does not know how to group his figures, he composes by chance, but he has a gift for fine coloration and he has learned much in the museums.[105]

Sargent, according to Mantz, was a bold innovator with deep roots in the past.

Mantz had found fault with Sargent's challenging composition but appreciated his daring. Similarly, critic Arthur Bagnères enthusiastically noted the artist's delight in his craft, in the manner in which he left the evidence of his brush across the surface of his canvas. Writing in the *Gazette des Beaux-Arts*, Bagnères even questioned whether Sargent must be counted as an American, since his work had brought such honor to Paris and to his French teachers. Bagnères praised the unusual portrait of the "vase family," although he found the anatomy of the girls' thin legs and ankles defective, adding that even in this dark composition there were "not enough blacks" to hide them. "The vases however," he continued, "having neither legs nor ankles, are carried off with irreproachable brio." More dismissive was G. Dargenty, who declared in the journal *L'Art* that Sargent put too much effort into making his viewers believe he painted effortlessly, adding that he "knew of nothing as irritating as this laborious search for spontaneity." Olivier Merson, on the other hand, writing in *Le Monde Illustré*, praised Sargent's stunning originality.[106]

After the close of the exhibition at Petit's, the large canvas was presumably shipped to the Boits' apartment on the avenue de Friedland or perhaps to Sargent's studio. At some point, Sargent arranged to have the painting photographed. It was soon to make another public

appearance, this time at the Salon. The exhibition was no longer organized by the French state (which had relinquished control of it to the Société Nationale des Artistes Français in 1881), and the display had already begun to lose its hegemony in the face of the ever-increasing numbers of art exhibitions in Paris, but despite these changes, the Salon was still the most attended and widely publicized art show in the world. According to one American journal, it was "amusing to note how much importance is attached in this country [the United States] to the fact that a picture has been hung in the Paris Salon. Almost as many bad pictures are hung there every year as at our Academy, but the Salon number on the frame of an American painting will often sell it, while without this Parisian flavor, the artist's work would go begging."[107] The Salon remained, particularly for Americans, the most important conduit for artists to establish – and to maintain – their reputations and their market.

After his success the previous year with *El Jaleo* and the *Lady with the Rose* (*Charlotte Louise Burckhardt*), Sargent could not afford to miss the 1883 Salon, nor could he send something small or too casually conceived. He needed a dramatic and bold painting (or two) that would capture attention and be perceived as a suitable sequel (and a definitive variation) to the works he had shown before. He did not intend to display his portrait of the Boits. Instead, he was planning to show a pair of canvases depicting well-known American women living in Paris. One was Margaret "Daisy" White, the wife of a prominent diplomat (*Mrs. Henry White* [*Margaret Stuyvesant Rutherfurd*], 1883, Corcoran Gallery of Art), and the other Virginie Gautreau, a controversial society beauty originally from New Orleans (*Madame X* [*Madame Pierre Gautreau*], 1883–84, Metropolitan Museum of Art). The presentation of two such radically different images – one woman

dressed in white and one in black, one traditionally formulated and one daringly modern – was intended to enhance and solidify Sargent's reputation as a painter of women.[108] But neither of the paintings was completed in time. Works that were to be exhibited at the Salon had to be submitted in mid-March, as Sargent's friend the American artist Henry Bacon reported in his book *A Parisian Year*: "The twentieth of March is the final day for the reception (termed *l'envoi*) of the paintings for the Salon, the annual art exhibition of Paris, which opens to the public on the first of May ... the painters have been hard at work, for although the work destined for the exhibition may have been begun many months before, the twentieth approaches slowly but surely, and not infrequently finds the artist with brush and pallet [*sic*] still in hand."[109] Sargent still had his brush and palette in hand. "I have been brushing away at both of you for the last three weeks in a horrid state of anxiety," wrote Sargent to Mrs. White on March 15, 1883, just at the last moment before artists had to submit their works to the Salon. He confessed to her that he had failed to finish her portrait, that he was still making changes to the background, and that he hoped it was true that she would not mind if it were not shown. In a postscript he added, "I send the Boit children to the Salon."[110]

That Sargent's decision to exhibit his Boit portrait at the Salon was a hasty one is confirmed in the weekly newsletter *Courrier de l'Art*, which announced in its March 29 issue what paintings would be sent to the Salon that year.[111] Under Sargent's name is listed *Portrait de Mme G.*, presumably the full-length Madame Gautreau that Sargent had recently abandoned; it would take him another year to finish it. But the Boit painting was complete, and it belonged to sympathetic friends. Many years later, Sargent referred to "the very old obliga-

103

tions" that he owed to Ned Boit, duties "that date from when I was starting out."[112] Sargent never seems to have explained the nature of that debt, but it may have had something to do with this display. Whether carefully planned or quickly substituted, the portrait of the Boit girls offered all of the right ingredients for the Salon: it was big, bold, and unusual.

The Salon opened at the Palace of Industry on May 1, 1883, and, even surrounded by the 2,480 other paintings on view, Sargent's portrait garnered much attention. Its large size and square format were well suited to attract notice and helped to dictate where the canvas could be installed. Too big to "sky" (hang out of sight at the top of a densely packed wall), the painting was more likely to be placed "on the line," in the prime viewing area. One could not expect to find paintings arranged harmoniously at the Salon. In 1883, as in previous years, the rooms were set up alphabetically; Sargent's canvas, number 2165, was juxtaposed with works of all sizes, shapes, and subjects by the other artists whose last name began with S. Among them were two other group portraits of children, Dutch painter Thérèse Schwartze's *Children of the Burgomeister Tjalling van Eysinga* (current location unknown) and William Stott's *Ronde d'enfants* (now known as *The Kissing Ring* [plate 2.9]). Whether these three paintings hung in proximity to one another is not known, but the disparate styles of Schwartze and Stott serve to bracket Sargent's. Schwartze worked within an academic vocabulary, creating tightly finished group portraits in which sitters are linked by pose and gesture (plate 2.10). Stott's unusual rhythmic and melancholy outdoor portrait, with its sinuous, stark setting and spare depiction of the figures, was much more modern.

As had been the case at Petit's, the reception of *Portraits of Chil-*

dren at the Salon was mixed. French critics espoused both negative and positive reviews. Dargenty, who four months earlier had complained about Sargent's studied cleverness, now faulted his grasp of anatomy and described Sargent's four little girls "as dolls joined with ultra-thin legs," a notion carried into the satiric caricature of the painting that had appeared in *Le Journal Amusant*, which depicted the girls as mannequins dangling on stands. Novelist Edmond About claimed that Sargent had never equaled his portrait of Carolus-Duran (shown in 1879; see page 17) and that now he was "entirely inferior . . . in this too-large canvas in which two vases and four young girls, only vaguely sketched in, are badly arranged and seem thrown together at random." Taking a more moderate tone in the influential *Gazette des Beaux-Arts*, Charles Bigot (whose father-in-law was the American painter G. P. A. Healy) remarked that Sargent's "pretty little girls" were brought together on a canvas that was "a bit too large and at times a little empty." Nevertheless, Bigot cautioned his countrymen that France would need to stay alert, for the country was in danger of losing its artistic supremacy to the talented foreigners who had studied at French schools, among them Mr. Sargent. In a "conversation" between artist and critic published in *La Nouvelle Revue*, the academic painter Guillaume Dubufe admitted that Sargent was extremely talented, but declared that he abused his gifts and endangered his reputation by showing canvases that seemed like brilliant sketches rather than finished works. "There are excellent passages," he admitted, "in his quadruple portrait of young girls doing penance in an overly large hall; there, four white aprons, each variously illuminated and skillfully painted are worn by four pretty redheads in a vague gray uninhabitable space," but, the writer continued, the painting was "bizarre" and its peculiarities set a bad example.[113]

105

"FOUR CORNERS AND A VOID"

The seemingly disparate assemblage of figures was one of the most striking aspects of Sargent's painting. Henry Houssaye, a distinguished French critic and historian, questioned whether the canvas was meant to be one picture or four separate portraits. "The portraits no doubt are likenesses," he wrote, "but the painting is composed according to new rules: the rules of the four corners game." With this comparison, Houssaye linked Sargent's apparently arbitrary arrangement of figures to a popular children's pastime related to musical chairs, in which each participant moves silently from one corner of a room to another in response to a random call. Houssaye added: "There are further merits in this compartmentalized picture. The physiognomy of the sitters is marvelously captured, striking in its vivacity and truthfulness; the expressions are varied and natural. The color is fine, agreeable, distinctive, and the understanding of the light is remarkable. The misfortune is that the execution is sloppy. Nothing is finished, everything is merely suggested, but, one must recognize, suggested with masterful certainty. At least one can't fault

SARGENT.

41654
"'Grand déballage de porcelaines, objets chinois, jouets d'enfants, etc., etc.

Caricature of Sargent's portrait in the magazine *Le Journal Amusant*, 1883

Mr. Sargent for overworking his pictures."[114] The painting intrigued the French writer, although he remained troubled by Sargent's casual composition and unconstrained brush. It was the only non-French portrait that Houssaye discussed at length.

One might have expected the critic and collector Philippe Burty to have responded favorably to Sargent's painting, since he often promoted the modern works of the Impressionists and was fascinated with Japanese art, especially porcelain. But Burty was ambivalent, suspended between his preference for Whistler and his distaste for the success of foreign artists at the Salon, and he offered a chilling opinion about the Sargent, which he found eccentric and odd:

> *The portraits . . . have something about them that is false and insolent in the American style, cold and cruel. They disturb me. Four young girls in white aprons are scattered in a vague space where one can make out a very tall blue and white vase. Is it a hallway? The nursery? Each girl plays on her own. That's admissible. But what is not acceptable is that the diffused light of this interior does not relate at all to the crude dry colors that define the clothes or flesh. The wall is yellowish in tone, and there, where it ends, there is an abrupt black hole . . . the one charming part is the young girl sitting on a rug, darling and radiant. One would like to cut out this morsel, and cut out the others too, who, each alone, are bold and striking; the big vase would sell for a lot to an enthusiast of blue and white.*

Burty's vandalistic comments echo those Sargent's own father had made about the painting a few weeks earlier, when he wrote to his brother Tom that his son had "sent to the Salon a portrait, or rather 4 portraits of children in one picture – which is well reported of

by the newspapers." The lack of any relationship between the girls, emotionally, physically, or visually, was Sargent's most radical choice. One critic apparently dismissed the painting as "four corners and a void."[115]

While many of the French writers commented on Sargent's American origins and some offered disparaging remarks out of jealousy or national pride, European audiences were by no means united in their response to Sargent's unusual composition. Avant-garde authors, in particular, welcomed the painting's unconventional characteristics, seeing them as a refreshing excursion into modernity. For example, the Brussels journal *L'Art Moderne*, a literary review that favored modern art and Symbolism, printed an animated account of the painting in its anonymously penned review of the Salon show. The writer was likely either Octave Maus or Edmond Picard; both Brussels lawyers and advocates of the new, they had founded the magazine in 1881. The article commended Sargent, along with the French painter Albert Besnard and the Swede Richard Bergh, for going beyond the glorification of the "pretentious vanities" of the sitters that seemed so evident among the other portraits in the exhibition. In addition, the author appreciated Sargent's unusual composition, characterization, and sense of spontaneity, remarking that the painter "did not dream of arranging the girls he painted. He surprised them at their games, at the foot of the big Japanese vases around which they frolic; the serious demeanor of the two eldest girls is excellently rendered, as are the rosy carefree aspects of the two younger ones." Calling Sargent's work one of the highlights of the Salon, the reviewer nevertheless noted that the painting had some faults, particularly the deep darkness of the background. "And yet," he continued, seemingly haunted by the image, "these small

figures of the children, slender, with a worldly elegance that is completely modern, truly impressionist, remain with you." Based in part on his attraction to the informality and contemporaneity of the Boit portrait, Maus would invite Sargent to participate in the adventurous Belgian exhibition society Les XX, which he founded the following year.[116]

In a like manner, Joséphin Péladan, another Belgian art critic and also a novelist known for his interest in mysticism and the occult, singled out Sargent's painting among the many images of women and of children included at the Salon. He wrote, "Mr. Sargent, a student of Goya ... shows us four 'little girls' who have finished their games in a grand entrance hall with large Chinese vases. They have fine aprons over their lovely dresses and a serious air of tedium ... it has taken centuries of idleness and luxury to create these charming and pedigreed dolls; Mr. Sargent's brush is most effective in rendering these four aristocratic flowers." The very qualities that the Parisian critics had found so strange seemed especially interesting to the Belgian reviewers; they also appealed to the poet Hippolyte Devillers, who expressed high regard for the painting in his article about the Salon for *La Jeune Belgique*.[117]

British commentators were divided. Some were noticeably untroubled by Sargent's unusual painting and took it at face value. The critic for the *Saturday Review* described it as a "delightful picture, full of freshness and life" and went on to commend its informality, adding that "the children are playing in a large room; anything more happily unlike the 'official' portraits of the day cannot be imagined. Here there is no 'posing' of the figures, no straining after the violent contrasts of light and shade which are only obtainable in a studio, and which are never seen in the surroundings in which people

live." The *London Morning Post* declared it was a "happy Eldorado of childhood," where the smaller vases just visible in the background were "probably filled with jams." But the writer for the *Athenæum* found Sargent's painting less than ideal, "half-studied" and "half-finished." He added a carefully wrought and censorious conclusion: "A magnificent Chinese vase is the one fine element of a big picture which was apparently begun without a defined purpose, and is a congeries of parts without a *raison d'être*. Mr. Sargent would fain paint like Velazquez without Velazquez's pains." In contrast, the *London Illustrated News* found Sargent's painting as "impressive and original" as *El Jaleo* had been the year before, and the writer commented favorably on the unusual arrangement and depiction of the figures:

> *Of grouping in the ordinary sense there is none. The youngest, a mere child, sits with her doll in a large room, which opens into a dark apartment behind, and the other three stand apart. The canvas is large beyond precedent, considering that the portraits are those, not of four reverend signors, but of four little girls; and when examined closely it has, in many parts, the appearance of being covered with unmeaningful smudges. But let the spectator retire six or eight paces, and everything, by an almost Velasquez-like magic, takes its place, and he is simply looking into a spacious room, tenanted by four little girls.*

British reviews were often quickly republished in American newspapers. Although the *Boston Daily Advertiser* failed to identify the local connections of Sargent's young sitters (or refrained from doing so) when it reprinted the *Illustrated News*'s text, it clearly demonstrated the speed by which information about the Salon exhibitions was transferred from Europe to the United States.[118]

The Salon was given ample coverage by American critics, and Sargent's canvas was among the works that received special attention. The *American Register*, based in Paris, criticized the artist for displaying a painting at the Salon that had already been shown, saying the picture was well done "but too stiff to be graceful." The *Art Amateur* gave an early report in its June issue, drawing upon the notices printed in the *New York Herald* and remarking that Sargent's painting had been "warmly praised."[119] However, in the magazine's own assessment of the Salon the following month, its European correspondent Margaret Bertha Wright offered a sarcastic and cutting account. In an exhibition that included not only Sargent's portrait of the Boits but also William Merritt Chase's *Portrait of Dora Wheeler* (1883, Cleveland Museum of Art) and Whistler's *Portrait de ma mère* (1871, Musée d'Orsay, Paris), Wright thought "the most sensational American picture in the salon" was Julius Stewart's luxurious full-length portrait of a blond woman with diamond earrings in a white dress (*Portrait of Mme ****, unlocated). Wright compared Sargent's painting to his Salon entries of the preceding year, finding his portrait of the Boits "less refined" than his *Lady with the Rose* but "vastly more so" than *El Jaleo*. She felt, as had many of her French colleagues, that Sargent's new painting suffered from the artist's cleverness, his desire to create an artistic effect:

> It is almost as large as the latter [El Jaleo] *and represents a little girl, a baby, half a girl, about five-eighths of a girl, and two tall Japanese vases, spotted about in a vast expanse of canvas. The background is probably an artistic interior, but the vista is so tremendously receding, and the artist's passion for sharp effects of light and dark so assertive, that the spectator is forced to take for granted that this "Portraits*

d'enfants" is not backed by a "batterie de cuisine" [array of kitchen utensils]. *Sargent's taste for stiff, wooden forms is shown once again by the fact that three of these "portraits" are full-length figures in the stiffest of starched and most rectangular of white pinafores, while the baby playing with her doll has as much starch in her opaque white dress as cambric can possibly hold.*

Wright found Sargent's spectral effects particularly disturbing in a painting that had been advertised as a portrait. The girls had been made expendable:

> *This artist chooses to do startling things rather than beautiful ones, "tours de force" of glare and gloom: therefore, while presumably painting the portrait of four sisters, he has put one of them in a vivid streak of radiance, one in diffused and therefore milder light, and one in as dusky an atmosphere as if she were midway in a tunnel, while the fourth is utterly lost in gloom, from which merely the vague lines of a human form in a stiff pinafore show without a glimpse of features. In the diffused light of the foreground the baby, sitting upon a dull blue rug, is modeled in the round, and shows us as complete a human being as human beings usually are who do not live in tunnels. The little girl in the "streak" — with long thin legs cut squarely off by a sharp line of terra-cotta dress, shows one side of her face sharp, strong, and brilliant, while the other one is in Rembrandt shadow. As for the others, one is spectral, the other null. All this is very well as showing the artist's clever manipulation of "effects," but what in the world had it to do with portraiture? One naturally considers the living objects the chief consideration in portraiture, and does not ask for a portrait of fantastic light or for ostentatious proof of the painter's cleverness.*[120]

Wright decried the fact that the viewer's expectation that a portrait would capture the actual appearance of the four girls had been subverted and its value questioned. For her, the sitter should take precedence over the painter; Sargent clearly had failed.

The next month, the *Art Amateur*'s editor Montague Marks retreated from Wright's position. "Despite harsh criticism," he wrote, "Sargent's picture in the Paris Salon of four beautiful American children is, in my opinion, admirable in almost everything but composition." Trying to turn the French writer Philippe Burty's negative comments about the centrifugal arrangement into a positive one, Marks continued, "The figures might almost be cut out and framed separately." Yet he could not help adding one unenthusiastic remark, noting that "the elaborately decorated jars introduced to help out the composition are used, however, without sufficient regard to values." By September, though, Marks was taking patriotic pride in the good notices Sargent had been receiving. He reprinted in its entirety the favorable text about the Boit portrait that had appeared in London's *Saturday Review* in May. Along with it, Marks cautioned that Sargent's success was overshadowing that of Carolus-Duran, and that if he continued to outshine his teacher, Sargent might "get himself disliked." [121] His comments reveal his understanding of the politics of display and eerily forecast the events of the 1884 Salon, when Sargent exhibited *Madame X* and was censured for his – and her – success.

If the *Art Amateur*, a "practical" journal dedicated to "the illustration and encouragement of American art" in all media, was of two minds about Sargent's painting, the *Magazine of Art*, which offered illustrated monthly accounts from Europe on contemporary trends in art, was unreserved in its accolade.[122] William C. Brownell, a cosmopolitan and scholarly man of letters who also wrote for *Scribner's Monthly*,

was the magazine's critic. His review of American art at the 1883 Salon was lengthy and erudite and included six engraved illustrations, among them Sargent's *Portraits of Children*, the first time the painting was reproduced. Brownell wrote thoughtfully about the position of the American artists at the Salon, praising their ability to compete on this most international of stages. The artists he singled out for extended discussion combine those well known today with forgotten masters: Chase; William Dannat, whose medal-winning *Aragonese Smuggler* (1883, Musée National de Coopération Franco-américaine, Blérincourt) captivated many critics; Sargent; Whistler; figurative genre painters Thomas Harrison, Charles Sprague Pearce, and Frank Penfold; and landscapist Frank Boggs. Brownell, a man later characterized by novelist Edith Wharton as "exquisite," "aloof," and "elusive," someone "shy and crepuscular, as though his real self dwelt in a closely-guarded recess of contemplation from which it emerged more easily and freely in writing than in speech," was captivated by Sargent's unusual, shadowy painting.[123]

Brownell acknowledged that "the first necessity of a portrait from the point of view of art is, of course, not that it should be a resemblance, but that it should be agreeable." He was referring to Chase, but his comment would have applied to Sargent's likeness as well. But Brownell saw Sargent's painting as more than a portrait, and he respected it for its artistic qualities rather than for its usefulness as a precise record of the girls' appearances. He applauded Sargent's "indisputable originality," calling attention to his technical skills and to his marked trajectory from a patently capable painter to one displaying clear intelligence and imagination. "He is," Brownell declared, "Velasquez come to life again."[124]

Brownell was the first to write at any length about the relation-

ship of the Boit portrait to Velázquez's *Las Meninas*:[125] "There is the same absolute naturalness and unconsciousness in the children; the same intimate differentiation of characters without a shock to the *ensemble* of either character, interpretation, or artistic presentation; the same grave and decorous, almost grandiose pictorial treatment; with nothing in the accessories which is not happily subordinated to the main idea of the canvas; the whole resulting in a subtle fusion of the pictorial with the purely intellectual." Despite these carefully considered words of praise, Brownell was not unreserved in his tribute to Sargent. Writing of the dangers of both too much detail in a composition and too little, Brownell, like many of the other critics, noted Sargent's "vacant and loose" foreground and his "obscure" background. He asked that the painter not neglect the complete "realization" of his subject, challenging him to reach the superlative balance of the actual and the ideal that had been achieved by Velázquez.[126] The comparison to the Spanish master – and the very concept that (with some further attention to detail) Sargent could achieve something similar – was indeed a high honor.

The Salon exhibition closed on June 20, 1883, and Sargent's large canvas disappeared from sight. During the previous winter, the painter had moved his studio from the artistic milieu of the rue Notre Dame des Champs to the tony boulevard Berthier, and now he left Paris for Brittany. He traveled to Paramé, on the northern coast near Saint-Malo, to struggle, as he put it in a letter to Vernon Lee, "with the unpaintable beauty and hopeless laziness of Madame Gautreau."[127] The Boit family probably also left Paris. Their itinerary is unknown, although they spent part of the summer in England, at the spa at Tunbridge Wells (where they went several times in the 1880s) and in the Surrey countryside at Grove Farm, the estate of Ned's

uncle Russell Sturgis at Givons, Leatherhead. Boit exhibited a water-color of the terrace of Grove Farm at the Salon the following year.

In the autumn of 1885, Ned Boit made a short entry in his diary: "Poggi [?] brought back Sargent's picture." [128] Presumably he referred to Sargent's large portrait of his daughters, since he is not known to have owned any other Sargents at this time, but where the painting had been is a matter of mystery; no public exhibitions are recorded after the close of the 1883 Salon. Perhaps the canvas had been sitting in Sargent's studio or in storage. Ned and his family had been travel-ing constantly over the course of 1884–85 – from Paris to Surrey, to Tunbridge Wells and back to France, to Nice and Monte Carlo, to Boston, to Trouville, to London, and again to Paris. The painting of Ned and Isa's daughters would not reappear in public until 1888, when it was shown in the Boits' native Boston in Sargent's first-ever solo exhibition.

Sargent's Excursions

ARGENT TOOK NO TIME to savor his achievements after the Salon exhibition opened in May 1883, but instead moved ahead, both literally and artistically. He had already packed up and left behind his studio on the rue Notre Dame des Champs, quitting the cramped streets of the artists' quarter for gracious rooms on the boulevard Berthier, a modern and more exclusive neighborhood in the northwest corner of Paris. Here, as the writer Jules Claretie explained it, lived "the artist in white tie, painting in tails, the businessman who makes as much commerce in the salons [of fashion] he attends as in the Salon [of art] where he exhibits."[129] Sargent's new address reflected his ambitions, and in that spirit he started to rework the painting that he hoped would make a dramatic statement for him at the following year's Salon, his portrait of Madame Gautreau.

That likeness, now known as *Madame X*, marked the zenith of Sargent's engagement with Paris and French fashionability. Even before he had finished it, however, Sargent (encouraged by Henry James) had started to look away from France, toward England, for new artistic ideas and opportunities. He had by now become intrigued with the Pre-Raphaelite painters and with the British Aesthetic Movement, which united Asian objects and motifs with modern furnishings inspired by the preindustrial past. Vernon Lee noted that his boulevard Berthier studio was "extremely pretty, quite aesthetic and English, with a splendid big studio and a pretty garden with roses and all done up with Morris papers and rugs and matting."[130] Later

that summer, Sargent left his new studio to travel to Brittany to work on his portrait of Madame Gautreau. He spent the fall in Italy and in southern France, returning to Paris by February 1884. That month, he received his first important English commission, a request to paint the three daughters of Thomas E. Vickers of Sheffield, the first of several portraits he undertook for the family. In March 1884, just after sending his portrait of Madame Gautreau to the Salon (but before the exhibition opened), Sargent went to London. There, accompanied by James, he made a variety of contacts: he met the important British painters Edward Burne-Jones, Frederic Leighton, and John Everett Millais, and he formed close friendships with two expatriate artists active in England, the Dutch painter Lawrence Alma-Tadema and the American Edwin Austin Abbey. He may also have investigated the availability of studio accommodations, laying the advance groundwork for his move from Paris to London in early June 1884.

Sargent had been planning to relocate to England for the duration of his commissions from the Vickers family, but one catalyst for his decision to remain there was the extraordinary reception accorded to *Madame X* when the Salon opened at the beginning of May. Although he would continue to engage with the Parisian art world and to exhibit at the Salon for many years, the response to *Madame X* — critical and often cruel, perhaps calculated as a comeuppance for these two successful Americans — had come as a shock to him. In the words of his cousin and friend Ralph Curtis, Sargent, shy by nature, was "navré" (cut to the heart) by the uproar. In his full-length portrait, the artist had represented Virginie Avegno Gautreau as she wanted to be seen, replicating in paint the attention-getting role she had played in Parisian society. She was beautiful and dramatic, a woman who cultivated an audience, and Sargent showed her as a quintessen-

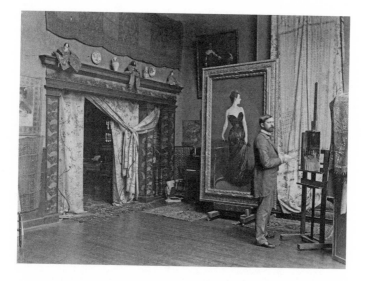

Sargent in his boulevard Berthier studio with *Madame X*, about 1884

tial *parisienne* – sophisticated, perfectly groomed, elegantly dressed, urban, and independent. But he may not have realized that Madame Gautreau was also a controversial figure, an American who earned as much disdain as approval for her forays into French society. Critics likely could not wait to say of her portrait what they would never say to her face, and the painting was ridiculed repeatedly. "He wants to get out of Paris for a time," wrote Curtis of Sargent. "He goes to Eng. in 3 weeks. I fear *là-bas* [there] he will fall into Pre-R. influence wh. has got a strange hold of him he says *since Siena*." [131]

Sargent did indeed fall into the Pre-Raphaelite influence, partly from his natural interest in the style but also, within the year, as a tactic to reinvent himself as a British painter. [132] He may have felt that pressure in reaction to the critical response garnered by his portrait

of Evelyn, Mildred, and Mabel Vickers, which he had finished in the summer of 1884 (plate 2.11). As he had done in his portrait of the Boits, Sargent arranged the Vickers sisters in a darkened interior, placing two of them in the foreground and the third behind them. Each of the young women looks in a different direction, but Sargent linked them together much more closely than he did the Boits, using the graceful curves of their arms and the direction of their gestures to lead the viewer's eye from one sister to the next and back again, giving an impression of affection and connection between them. Evelyn and Mabel, at left, are brightly lit, while Mildred, in the background, is more dimly illuminated; but in comparison to the Boits' portrait, the visages of all three Vickers sisters are clearly defined. Nevertheless, Sargent maintained the sense of mystery and interiority that so pervades the portrait of the Boit daughters.

According to Sargent, the portrait of the Misses Vickers "rather retrieved" his reputation in Paris when it was exhibited at the Salon in 1885, but British audiences considered it to be "beastly french."[133] The natural antagonism between the two countries and the distinction between their aesthetic preferences became clear when Londoners voted Sargent's portrait the worst painting of the year in a poll organized by the *Pall Mall Gazette*. Clearly, if he hoped to capture favorable attention in London, Sargent needed to create work that was more in alignment with English taste. This he would accomplish in spectacular fashion with another portrait of children, *Carnation, Lily, Lily, Rose* (plate 2.12).

Carnation, Lily, Lily, Rose had its genesis in a Vickers family portrait. In the summer of 1884, Sargent was in Sussex, painting a portrait of Edith Vickers (the aunt, by marriage, of the three Vickers sisters). In the course of his visit, he began a large portrait sketch of Edith's two

young children, Billy and Dorothy, standing outside in a garden with large stems of white lilies. Like the Boits, Billy and Dorothy pose in an indeterminate setting that suggests the singular realm of childhood.

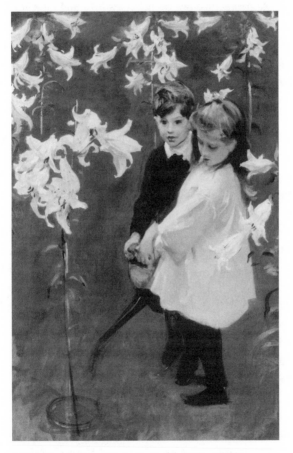

John Singer Sargent, *Garden Study of the Vickers Children*, about 1884

Sargent incorporated a similarly curious ambiguity of scale in the Vickers sketch, eliminating the horizon line and surrounding the children with blossoms as tall as they are. He presented them almost as a single figure: they overlap nearly entirely, and they grasp each other's hands in addition to the handle of the watering can they hold. Casually dressed, balanced upon black stalks that vaguely define their legs, the children seem lost in a world of their own.

Sargent refined his ideas in *Carnation, Lily, Lily, Rose*, his large and carefully planned composition of 1885–86. The painting took shape over time; preliminary sketches show Sargent exploring the garden setting with a variety of models in different formats and poses. Eventually he settled upon an image of two young girls, Polly and Dolly Barnard, the eleven- and seven-year-old daughters of his friend Frederick Barnard, a painter and illustrator. In many ways, his new painting is a translation of his portrait of the Boit girls from a French vocabulary into English terms. One image of children is set indoors and the other is situated outside, but both are ultimately studies of light. In the Boit portrait, Sargent explored the variations of lights and half-lights, the shadows and reflections, of a modern French interior; in *Carnation, Lily, Lily, Rose*, he investigated the effects of twilight and lamplight in a traditional English garden. Both paintings focus on little girls, their identities secondary to the paintings as a whole. Perhaps not coincidentally, all six of them were daughters of sympathetic artist friends of Sargent's. The girls are all dressed in white and arranged as if by accident; as Sargent said of his English canvas, "I am trying to paint a charming thing I saw the other evening," an effect he noticed by chance and sought to capture forever.[134]

Despite the fleeting effects of light that Sargent captured in *Carnation, Lily, Lily, Rose* (and it is useful to bear in mind that it was during

this exact same period that he made his most intensive exploration of Impressionism, including several visits with Claude Monet), the canvas was as carefully prepared as any academic performance. Sargent took two seasons to paint it, he made numerous drawings and oil sketches of his subjects, and he seems to have altered the format of his canvas from a rectangle to a square to emphasize its surface decoration and formal design. Various difficulties arose behind the scenes – the transient light, uncooperative weather, and shifts of season that caused the flowers to die – but the final painting is natural and graceful, a radiant exploration of a magical moment. It met with acclaim when it was first exhibited at the Royal Academy in London in the spring of 1887. Although it was loosely painted compared to some of the other works on view, and despite the fact that it recalled the French Impressionist school with its bright palette and its emphasis on the singular effects of light, *Carnation, Lily, Lily, Rose* was firmly rooted in an aesthetic English garden. The trustees of the Chantry Bequest immediately purchased it for the British national collections; Sargent had now successfully crossed the border.

The painter had conquered London in one way, but he had yet to revive the promising career as a portraitist that he had begun, and lost, in Paris. Despite the success of *Carnation, Lily, Lily, Rose* and his completion of a number of glamorous portraits of women, it would be several more years before his English career took off. In the meantime, there was another country to explore. In September 1887, armed with an order for a portrait of Mrs. Henry Marquand of New York and the expectation that other commissions would follow, Sargent set sail for the United States; it was his first working trip to his homeland. By the beginning of November he was in Boston, staying with his old friends Ned and Isa Boit and their four daughters.

Childe Hassam, *Boston Common at Twilight*, 1885–86, showing the city as it appeared when the Boits arrived for a two-year stay

A Boston Interlude, 1886–88

THE BOIT FAMILY had been back in America for about a year when Sargent arrived. Despite their enjoyment of life in Europe, they had not forgotten Boston. Ned had traveled back and forth on several occasions, and like many painters active abroad, he had always sought to keep his work in view of audiences at home. Following his successful exhibition and auction in December 1879 at Williams and Everett, Boit showed groups of his watercolors in Boston again in 1880 and in early 1881. That year, "Greta," the pseudonymous Boston correspondent for the journal the *Art Amateur*, singled out Boit's paintings for extensive praise. Boit was "the most marvelous worker in the thin, transparent kind of water-color," the writer declared. "Good judges who know the schools of Europe say that he is unexcelled by anybody that works or ever worked, in that style. I can well believe it. To me the blotting on of clean colors ... seems nothing short of magic ... so clean, so brilliant, so quick, sure, effective, that everything strikes the eye with the force of actual objects out of doors ... the subtlest effects of light and atmosphere are caught apparently with the utmost ease by this artist."[135]

Despite these favorable comments about his achievements, Ned Boit was not lured back to Massachusetts by his artistic accomplishments but by domestic concerns. The Boits returned to Boston in the spring of 1886 to attend to family affairs, chief among them the sale of the Cushing estate in Belmont, Bob Boit's marriage to his second wife Lilian, and the introduction of seventeen-year-old Florie to

125

Boston society. They spent that summer in Newport, where (according to Bob) "they were cut off by whooping cough from the gay world they had sought there."[136] Curtailed by that contagious (and then quite dangerous) illness, their social activities were limited, but by September 1886, Isa and the children had all recovered. Ned arranged to have their household effects shipped from Paris to Boston – including, presumably, Sargent's large canvas. In October, the family moved to Boston's Back Bay, taking an elegant and modern townhouse suitable for entertaining, for as Henry James noted, Isa had "great arrears to make up" after her "dismal quarantine."[137] Bob Boit described his brother and family in his diary: "They are passing the winter in Mrs. Tom Cushing's house No. 170 Beacon St. + have brought out their eldest girl Florie who is refreshingly sweet + simple – in striking contrast with most of the young society girls. Isa is in a round of gaiety and enjoys it – + Ned takes it philosophically though I do not doubt he longs for the more congenial Parisian life. This is no place yet for idle men – + he will not have a studio this winter, saying his entire time is occupied in 'catering' for his family."[138] While Ned dealt with the family's business affairs, Isa must have been planning for Florie's coming out.

As upper-class girls grew older, they marked their transition to adulthood by being formally presented to society. "Coming out" marked not only the age of responsibility and adulthood but also the point at which young women were considered eligible for courtship and marriage. A girl usually came out at age eighteen, and the occasion called for a number of events that most often began with a large tea party or an expensive ball that served to introduce the debutante. Even in Boston, where society supposedly kept to a strict and unostentatious standard, a formal dinner dance or an afternoon tea heralded

the occasion. Marian Lawrence, who came from a prominent Boston family whose fortune stemmed from textile mills, was slightly older than Florie Boit's sister Julia. She reminisced about her own "bud year" in 1893, remarking that all of her friends were "excited about 'coming out' and most of them devoted the entire year to it. Naturally," she added, "my father thought this a great waste of time." Noting that she was forced to abide by strict rules that were later relaxed for her younger sisters ("I was limited to three dances a week and the *hardest* rule to obey was to come home at 1:00 am!"), she created a vivid portrait of frequent dinner parties with regulated conversations between the young men and women, followed by carefully scripted dances and midnight suppers. Lawrence's own event was an afternoon tea, but the attendance figure she reported (720 guests) indicates that it was hardly a modest affair. She found the occasion, held both in her rose-filled house and under a marquee on the lawn, hard work.[139]

Marian Lawrence relished her new clothes and the dances and the company, but some women, less sociable and outgoing, remembered their debuts less fondly, characterizing them, for instance, as "a long cold agony of shyness . . . my brother's friends asked me to dance, but I was too much frightened to accept, and cowered beside my mother in speechless misery." Some parties were less elaborate; their ultimate purpose was a rite of passage rather than a concentrated search for a mate. "I don't think people got married so young then," wrote Lawrence. "It was not considered honorable for a man to propose unless he had enough to support a wife in comfort. Five thousand dollars a year was considered enough for this. Only one debutante [my year] became engaged."[140]

Florie was the first of the Boit girls to reach this milestone. Her mother would have prepared her by seeing that she was taught all of

the conventions of polite behavior. She certainly attended dancing classes, as her sisters did. Ned Boit later noted in his diary that his younger girls attended the Boston dancing school led by Mr. Papanti, which had attracted all of the city's upper-class youth for several generations (and more than one Mr. Papanti). As Marian Lawrence recollected, Papanti's classes had always been held in a hall on Tremont Street, "up two winding flights of stairs." The room had "a spring floor that gave an extra bounce to the dancing . . . and we went swooping and swinging around the hall in a delirium of delight." Ned wrote that his wife Isa accompanied their "two little girls" in 1888 when they "went to [their] last dancing class . . . Isa (2) danced cotillon with Amos Lawrence [Marian's uncle] and Julia with George Wheatland. Both enjoyed themselves tremendously." [141]

Few details are known about Florie's debut. Bob did not describe it and Ned, always more reticent in his diary entries than his brother, wrote only a few words on December 13, 1886: "A cold damp day . . . Florie had her first party in the evening. All passed off well. About 110 guests. Frank Loring led Cotillon. Mama was present and enjoyed herself." [142] Florie went on to attend numerous parties, dances, and concerts over the course of the winter. Her father recorded them in his diary, but his brief notes reveal nothing of the flavor these events must have had, nor do they indicate whether his daughter enjoyed them.

While Isa had been preparing for her eldest daughter's social debut in Boston, Ned was getting ready for a public display of a different sort, organizing a solo show at a local art gallery. He had been doing serious work, primarily in watercolor, and he began to exhibit more frequently; his April 1887 display at Noyes and Cobb Gallery followed one held there by another innovative local painter, Childe

Hassam.[143] Critics either congratulated or castigated Boit's work according to their position on Impressionism. He disappointed a more conservative writer: "Mr. Boit's exhibition is brilliant, refreshing, and interesting [but] it is not art," remarked the critic for the *Boston Evening Transcript*. "Mr. Boit has above all things a power of clear seeing that is astonishing," he continued. "He looks at a thing and seizes at once its central fact – flashing sun, hot color, wet air, violent contrasts of light and shade ... you get the sudden fleeting impression that is left on the retina after a single careless glance. Beyond this the value of the work does not go."[144] Although a number of important Boston collectors had already begun to embrace the momentary effects explored in Impressionist landscapes, which they purchased in large numbers over the course of the 1880s, many members of the press had yet to catch up.

In the summer of 1887, the Boits returned to Newport. Ned painted there and in Cotuit, as well as on excursions to Massachusetts' North Shore and other picturesque locations. For the next fall and winter season, the family moved to Boston's Beacon Hill neighborhood, taking a house at 65 Mount Vernon Street, next door to Samuel and Susan Warren, who had a significant collection of French art. The Boits rented the townhouse from Henry Cabot Lodge, who was serving in the United States House of Representatives and thus was absent from Boston for the season. The family resumed their city habits, a constant round of social engagements and entertainments, chiefly musical or dramatic in character. That fall they reconnected with Sargent, who arrived in Boston, as Ned noted in his diary, on November 8 with his sister, "poor Emily."[145]

Henry James had already introduced Sargent to an American audience in the October 1887 issue of *Harper's New Monthly Maga-*

zine, and his flattering prose helped the painter to establish the desirability of his art in the United States. Among the paintings James discussed at length in his article was the Boits' portrait, which was now in Boston and was illustrated in the text with the caption "The Hall of the Four Children." James identified the sitters, noting that "the superb group of the children of Mr. Edward Boit," along with Sargent's portrait of Charlotte Louise Burckhardt (*Lady with the Rose*), were proof of the painter's "uncanny" talent. James relished the picture of the four girls:

> The artist has done nothing more felicitous and interesting than this view of a rich, dim, rather generalized French interior (the perspective of a hall with a shining floor, where screens and tall Japanese vases shimmer and loom) ... The treatment is eminently unconventional, and there is none of the usual symmetrical balancing of the figures in the foreground. The place is regarded as a whole; it is a scene, a comprehensive impression; yet none the less do the little figures in their white pinafores (when was the pinafore ever painted with that power and made so poetic?) detach themselves, and live with a personal life ... a pair of immensely tall emblazoned jars ... seem also to partake of the life of the picture; the splendid porcelain and the aprons of the children shine together, and a mirror in the brown depth behind them catches the light ... The naturalness of the composition, the loveliness of the complete effect, the light, free security of the execution, the sense it gives us as of assimilated secrets and instinct and knowledge playing together — all this makes the picture as astonishing a work on the part of a young man of twenty-six as the portrait of 1881 [Lady with the Rose] was on the part of a young man of twenty-four.

James went on, addressing some of the concerns that had been leveled against Sargent's painting when it had been shown at the Salon: "Mr. Sargent is sometimes accused of a want of 'finish' but if finish means the last word of expressiveness of touch, 'The Hall of the Four Children,' as we may call it, may stand as a permanent reference on this point. If the picture of the Spanish dancer [*El Jaleo*] illustrates, as it seems to me to do, the latent dangers of the Impressionist practice, so this finer performance shows what victories may achieve." [146] He was clever in his remarks. Aside from issues of finish, many of the negative remarks that had been directed toward Sargent's painting were related to its function as a portrait. By understanding and categorizing the picture as a genre scene – as an interior that included four children – rather than as a proper portrait, James suggested to his readers a way of looking at the canvas that precluded arguments about issues of likeness and the traditional conventions of portraiture. He helped a new audience to see Sargent's work in a favorable light.

If anyone had missed James's article in *Harper's*, parts of it were immediately excerpted in various newspapers. For example in Chicago, a city that provided many patrons and consumers of cosmopolitan culture and kept up-to-date with Eastern trends, the *Chicago Inter Ocean* included an occasional column called "Life at the Hub," which reported on Boston events and society. Sargent's visit to the United States was noted, he was identified as "the guest of a brother artist, Mr. Edward Boit," and bits of James's prose reappeared along with a summary of the painter's current projects. [147]

Sargent's arrival in Boston was celebrated in the *Boston Evening Transcript*, which called him "one of the most famous of living American artists." [148] The painter and his sister joined the Boits in their

temporary home on Beacon Hill; they had likely already seen one another in Newport, where Sargent had been painting Mrs. Marquand's portrait.[149] Many of Sargent's activities in Boston (artistic and otherwise) are detailed in Ned's and Bob's diaries. "John Sargent the Artist has been staying with Ned + Isa at 65 Mt. Vernon St. (the Cabot Lodge house which they have taken for the winter)," wrote Bob, adding:

> He is a most charming man – simple, chatty, + humorous. Six feet tall + with fine physique. Brown hair, beard + moustache – fine dark eyes, rather dark florid complexion, large white hands nose slightly aquiline, but not very well formed, too thin on top + too thick at the base – but altogether a handsome man – Full of energy and Artistic fire – Musical + a great lover of Wagner whom he strums on the piano by the hour – A most agreeable companion full of thoughts and quaint ideas. He was born abroad (I think in Florence) of American parents + was brought up + educated in Europe – He was never in America but once before + knows little of it. He is [sic] much trouble at our money and cannot get the difference between dollars and pounds into his head.[150]

The Boits praised and promoted Sargent; they had immediately commissioned a portrait of Isa, and they actively encouraged other Boston friends and relatives to place similar orders. Ned and Bob Boit's cousin, Charles Inches, hired Sargent to paint a portrait of his glamorous wife, Louise, that would be finished in time for Christmas (1887, Museum of Fine Arts, Boston). Meanwhile, on the afternoon of November 12, Sargent began to paint Isa Boit; each sitting was carefully recorded in Ned's diary.

Once again, Sargent's friendship with the Boits allowed him the freedom to create an inventive and unusual likeness. Isa was, in the words of Bob Boit, "a great, noble-hearted woman, whose foibles and eccentricities added to her charms." She loved music, particularly Wagner; her family found her a woman of "great charm, but rather spoilt," "always charming, always capricious with a heart of gold, much artistic insight and a little laugh like a musical scale."[151] Sargent captured Isa's lively spirit when he painted her in the drawing room of 65 Mount Vernon Street, dressed, according to one source, in the gown she had worn for Florie's debut (plate 2.13).[152]

In Sargent's portrait, Isa is poised to laugh; her lips are parted, her head tilts, and she delivers a sidelong glance with a flash of her eye. Her pink and black outfit, with its bold polka-dotted skirt and pert feathered headpiece, speaks to her jovial personality. Bob Boit wrote about the painting in detail, noting that it was "a grand picture, and a strong + cheerfully flattered likeness – A portrait that will live with the old masters. Sargent is very fond of [Isa] – + evidently loves the task. He has done much work upon it, painting out the head already half a dozen times. He said to me while painting it the other day, 'It is *pretty* enough? Ah! I fear it is not *pretty* enough! I don't say it for flattery you know, but it is impossible to paint a woman's face as pretty as it really is!' In it spoke the true spirit of the Artist. He is a most charming man."[153]

Bob Boit approved of the portrait, which received favorable reviews when it was exhibited in Boston in January 1888. But Henry James feared that Isa's likeness would be considered crude when the portrait was displayed in London at the Royal Academy in May. He wrote to their mutual friend Etta Reubell of his reservations, remarking, "Our dear Iza [*sic*] won't do him [Sargent] good – though she

is wonderful and of a living! But she not only speaks – she *winks* – and the philistine will find her vulgar. Poor dear Iza!" James knew his audience; the critic for the London weekly journal the *Athenæum* said the portrait was "a Velasquez vulgarized," although surely to be compared to the Spanish master was not an entirely unfavorable remark.[154]

Sargent stayed with the Boits until January 19, 1888, when he left for New York. Ned Boit joined him there and returned with him to Boston on January 29 for the opening of Sargent's first solo exhibition. The show ran for two weeks; it was held at 4 Newbury Street in the new quarters of the St. Botolph Club, an organization founded in 1880 to bring together men interested in the arts and to serve as sponsor for exhibitions, lectures, and concerts. The twenty-one paintings by Sargent on view included both of his Boit portraits; the one of the four girls garnered enthusiastic commentary. The critic for the *Boston Evening Transcript*, for example, stated that "nothing more delicious, nothing more distinguished, could be conceived than the big square canvas portraying the four children in the Hall of the Great Vases ... though it violates impudently all the conventional laws of composition – it is a superb masterpiece of modern painting, nearer like a modernized Velasquez than anything this country has produced." Susan Hale, an artist who wrote for the *Boston Daily Globe*, called Sargent's work "perfectly delightful," adding that "the large one, of the Boit children playing in that ample room among great vases, is wonderfully lifelike and luminous." "Greta," in the *Art Amateur*, described it as "that other Salon triumph, the large family portrait, taken in a hallway decorated with huge vases, of four girls in pinafores, only one of whom is not bashfully half hiding from their

painter in girlish, unconstrained attitudes, and this attentive and obedient one *so* consciously resolved to stand just as she was told in a dancing-class 'position' – who would dare deny to that picture high qualities of truest art?"[155] No one in Boston seems to have found the painting awkward and off-balance, as had so many of the critics five years before. Instead, *The Daughters of Edward Darley Boit* helped to establish Sargent's reputation as a dashing and unconventional artist, desirable and exciting for his audacity.

While Sargent was enjoying his success, the Boits were struggling with family concerns. Henry James had reported in February 1888 to Etta Reubell that he had heard "an account of the Boits (the impracticality of their daughters, etc.) which points apparently to an early return to these unmatrimonial shores [Europe]," adding, "The sooner the better," evidently pleased that he might see his friends again soon.[156] But there was more to the situation than any daughter's mere impracticality. In the privacy of his journal, Bob Boit reported that his sister-in-law Isa had experienced "a great disappointment" with Florie, who apparently had begun to express her keen dislike for what her mother most enjoyed:

> *Florie is most unsatisfactory. A clever enough girl – by no means stupid – but with an affectation of indifference for all that is interesting to most young girls of her age and without intelligence or conversation in other directions to render her superiority bearable – Without grace or manners or conversation – Rude and ungrateful to her mother – unsympathetic to her parents – In fact no comfort or amusement to her family – Most reserved and difficult – Large, fine looking and with a substratum of honesty and directness and kindliness with others of her*

own age that makes them like her. Very retiring + with few friends +
Ignorant in most things as a child. A strange combination with noth-
ing apparent in her character to account for her brusque indifference
+ sneering way with her mother.

Bob sympathized with Isa, noting that it was "a great trial ... to a woman of Isa's disposition — who is fond of society and would like to have her daughters hold some such position [therein] as she herself has held." He had daughters of his own and suspected that the "trouble with Florie may come partly from her foreign Education + partly from her dislike for her mother's fondness for society. Whatever the cause, the result is disappointing enough." Whether Florie's insubordination was based in shyness, disinterest, or was an expression of rebellion against her mother (or had some other cause entirely) remains unknown. Isa apparently never understood her daughter, as Henry James later implied in a letter to Etta Reubell: "Poor Mrs. Boit – she has as much business with daughters as she has with elephants." The struggle took its toll on Isa as the girls grew up, for as James related, "Her elephants grow bigger and bigger all the while and she doesn't; but only grows older and sadder and further away from her happy laughing irresponsible years." [157]

Florie Boit's debut failed to launch her into Boston society in the way her parents had anticipated. She may simply have been entirely apathetic toward the preoccupations with fashion, flirtation, and romance of most girls her age; her desires may have been slow to mature or directed in other ways. No documented hints at any stage of her life indicate consideration on Florie's part of men or of marriage. But that spring, Florie's intransigence faded from discussion when her sister Jane's health became precarious. Nicknamed Jeanie and some-

times called Hub (for Hubbard, her middle name), Jane had shared the various childhood illnesses of her sisters; but when she became a teenager, she began to suffer from more severe physical and psychological problems. Her parents, whose only surviving son was still immured in a home for feeble-minded youth, must have been terrified.

Ned revealed little, although it is possible that a brief and cryptic note in his diary in October 1886 may already refer to Jeanie. "Fine weather but one of the darkest days of my life," Ned wrote. "An undutiful disrespectful child! I see no hope." Bob Boit related Jeanie's situation in March 1888 with his characteristic candor: "Jeanie must be taken to Aix La Chapelle this summer for the baths by order of the physician — Poor girl — she is fading rapidly away. Womb troubles — the curse of women. She is about 18 — and appeared well + pretty strong until about two or three years ago when every thing seemed to go wrong + now she looks like a skeleton + is in a nervous state bordering on insanity. If it were not for her intense love of music and practicing, I think she would before this have broken down completely." Bob later added, "Ned + family are to go abroad again in May — They do not like American life or climate," giving more socially acceptable reasons for their departure and glossing over their personal and unhappy ones.[158]

As if the two older girls' problems were not enough, Ned and Isa Boit's household was further wounded early in April 1888, when their son Neddie died at the age of twenty-three. "The end of an unhappy life," wrote Ned. He traveled with his brother to Barre to see the boy laid to rest, an event Bob reported with tender sadness:

The country around Barre is high + healthy + the establishment appeared to be well conducted. I was there several hours and talked

with the attendants as well as Dr. Brown ... they all seemed much attached to poor Neddie – whose only happiness for 18 years has been twisting + twiddling a stick between his fingers ... He died of consumption of the bowels + as he grew weaker [he] *wanted a smaller + smaller stick. This was the sum of his intelligence. It was hard to conceive of all the years passed in that plain little room without apparently a thought beyond his animal desires + the love of his sticks. The service was very simple in the parlor of the Asylum + the attendants who had watched him from the time he came there as a pretty little boy of five seemed to be much affected. His grave is on the southern slope of a knoll in a deep valley between the hills about a mile from the village. Trees are near + in the summer time it must be very lovely there – tho' so solitary + alone from all his family ... He had a fine clear cut face with a high forehead + handsome teeth – and as he lay there with his eyes shut it was hard to believe that they had wanted the light of intelligence – It was a strikingly strong + refined face – + it seemed as if his death had rent the veil that had hung so long between him + his fellow man. It was a speaking face in death – tho' dumb for so many years of his life.*[159]

The Boits' sorrow was no doubt amplified by considerable fear about the future, for they must have been nervous that Neddie's mental instabilities might prove to be hereditary traits that had already affected Jane, and maybe Florie.

By April 21, just a few weeks after his son's death, Ned Boit noted that they were having a "frightful time with Jeanie." Four days later he wrote, "Jeanie is in one of her moods and I am worn out." He visited with Dr. C. F. Folsom, a prominent Boston physician who specialized in nervous diseases, to ask for advice and to

arrange for a nurse for Jeanie who could accompany them on their return abroad. In France, they felt, they could give Jeanie the treatment that would be best for her; apparently they had no thought of leaving her behind in an institution as they had done with young Neddie. "Isa had a hard evening with Jeanie," Ned wrote in early May. They made their plans to return to Paris, Bob confessing their parents' disappointment at Ned and Isa's departure. "It is a terrible blow to [mother] + pater to have them go back to Europe to live. To have them come home was the hope of their lives + to feel that they would be near in their declining years. It is sad enough, + the cause of their going the saddest part of all."[160]

Jeanie's illness seems to have arrived with puberty, and contemporary medical practice was quick to link mental disorders and neuralgia with female physiology, particularly when menarche (or menopause) could be assigned as a cause. The mental state of the mother during her pregnancy was often also carefully examined, for prevailing opinion held that a mother's emotional trauma could be passed directly to her child. Bob outlined Jeanie's state in further detail, explaining that she was "practically insane." Her problems, he said, had "come on gradually with some internal disarrangement + there is little or no hope of her recovery. The Doctors have ordered that she shall be separated from the family, as her only possible chance, + this will be done when they reach Paris – tho' as yet it is a profound secret." He added that Jeanie had at times been "quite violent + has struck her mother + has frequently threatened to kill herself. It has been a terrible struggle and sorrow to poor Isa, who is utterly unnerved + unstrung by it."[161]

Sargent's painting of the girls became a surrogate for the family in Boston, staying on in the city while they fled. The Boits' removal

139

A BOSTON INTERLUDE, 1886–88

to France was not carefully planned; they had given up their apartment on the avenue de Friedland before returning to the United States, and apparently they had no address in Paris where they could send the canvas. The family packed up their belongings once again. On April 27, 1888, the portrait was delivered to the Museum of Fine Arts in Copley Square. The museum's registration book recorded it as "Portrait of Four Sisters," but the poetic title "The Hall of the Vases" was used when the painting was published in a list of loans on display.

When Sargent set sail to England from New York on May 26, flush with the triumph of his painting campaign in the United States, the Boits were also on board. Their maneuvers in America had not met with the same success. Florie stayed behind for a summer in Newport with her grandparents, remaining in America until December. Ned, Isa, Jeanie, little Isa, Julia, and their attendants traveled back to Europe. They arrived in England on June 3. "The journey was not very bad + the Boits are all pretty well," reported Sargent.[162] The family stopped briefly in London, where they visited with the Sturgises, lunched at Sargent's with James, and saw the portrait of Isa at the Royal Academy. Sargent would spend the summer of 1888 in the British countryside at Calcot Mill, exploring Impressionism with Dennis Bunker, a young painter he had met in Boston. The Boits were back in Paris by mid-June, living in temporary quarters while they sought medical advice about Jeanie's condition. Sargent's portrait of the girls stayed in Boston at the MFA for almost a year. It was packed up and shipped out from the museum on February 15, 1889, presumably to be sent directly to Paris.

Afterlife

NED AND ISA

THE BOITS HAD initially thought to send their daughter Jeanie to be treated at Aix-la-Chapelle (Aachen) on the Belgian/German border, where famous sulfurous hot springs were believed to be therapeutic for a variety of disorders, including those of the nervous system. They were loath to send her so far from home, however, and Jeanie seemed to have improved slightly upon her return to France. Ned began to consult with physicians in Paris, in particular a Dr. Sanne and Jean-Martin Charcot, a renowned neurologist who counted Sigmund Freud among his students. Ned wrote that "there was no doubt in Charcot's mind about sending Jeanie to the water cure at Auteuil."[163]

Hydrotherapy was an advanced, fashionable, and costly treatment. The clinic at Auteuil (just outside of Paris) was run by Dr. Alfred Béni-Barde, one of the cure's preeminent practitioners. In 1880, the newspaper *Le Figaro* reported that the list of illustrious patients one might encounter in Béni-Barde's waiting rooms included Prince Napoleon of France, the queen of Spain, the famous Théâtre Français actor Benoît-Constant Coquelin, and painter Edouard Manet, who had repeatedly undertaken the shower cures there.[164] Ned Boit consulted with Béni-Barde about his daughter's case, and on July 2,

1888, Isa took Jeanie to Auteuil, parting with her "calmly," according to Ned, on July 4. Jeanie stayed at the clinic until October 20, undergoing a regimen of cold showers that were intended to "tame" her and restore her equilibrium.[165] The doctors were encouraged with Jeanie's progress, and she had begun to eat more normally. Ned wrote to Bob that they hoped to take her home again soon. "She has been at a retreat for nervous invalids near Paris for several months past," Bob stated bluntly, "but [she] does not improve in health tho' mentally she is calmer than she was. I do not believe she will live long. She appears to be fading away." The news was better with Ned's next letters. In November, Bob noted that "Ned writes me that his daughter Jeanie has returned from the retreat near Paris where she was sent by the doctors – an altered girl – Sweet and gentle and obedient in every way – but a mere shadow of her former self. He thinks now the chances of her entire recovery good. I trust this joy is in store for them." Jeanie remained under Béni-Barde's supervision for several months and then seems to have suffered a relapse. Her father begged her to give up playing the piano, an obsessive activity that he felt contributed to her damaged emotional state. In February 1889, following the advice of Dr. Charles Richet, another eminent physician and specialist in nervous disorders, Jeanie was taken for electrotherapy. By the fall, still at home with her family in Paris, she was once again being characterized as "on the road to recovery."[166]

In the meantime, Ned and Isa had slowly attempted to get themselves and their girls more permanently settled. Ned inspected apartments throughout the fall of 1888, apparently delaying a decision in the hope that the family would be able to move back to their former quarters on the avenue de Friedland. He looked at another apartment on the avenue Kleber, south of the Etoile, and seems to have agreed

to rent it; but in February 1889, having received final news that their old home would not be available, he decided to take a new apartment on the elegant avenue de Messine, in the eighth arrondissement just south of the Parc Monceau. James had mentioned the street in his 1877 novel *The American*, calling it "one of the prettiest corners of Paris" and adding that "the quarter has an air of modern opulence and convenience," qualities that would have appealed to Ned and Isa.[167]

Soon after moving into their new apartment, which they finally accomplished in May 1889, Ned and Florie made a quick trip back to Newport in June to help the family celebrate Ned's parents' golden wedding anniversary. After the festivities, Bob returned to France with his brother, staying in Europe through the summer. Ned made another visit to the United States in 1890, the year both his parents died. He was unable to attend to his mother, whose last illness and death in May 1890 passed quickly, but he came to Newport with Florie in mid-June for her burial and to spend time with the family. It would be his father's last summer, and Bob Boit was pleased that the elder Edward Boit, despite his poor health, could enjoy the hours he spent on Cape Cod watching his son Ned paint a large seascape in an improvised studio he had converted from a seaside shanty.

Ned's new oil painting depicted the bay and cliffs at Cotuit; it was substantial in scale (reportedly four and a half feet tall and six feet wide) and clearly intended for exhibition. After his father's death in the fall of 1890, Ned returned to France without it, but Bob arranged to send it to him early the next year. "I have ordered Ned's great picture painted at Cotuit last summer shipped to him in Paris for exhibition this Spring at the Salon," he recorded in his diary. But the results were not expected: "Ned's beautiful Cotuit picture was refused at the Salon greatly to his surprise and mortification," wrote

Bob. "It is practically the first time he has been refused and this by far the best picture he ever painted. He writes he does not really care much so long as papa and mama are no longer here to be disappointed. I heard that only two American Artists were admitted – no doubt on account of the heavy duties imposed by our government upon French works of Art which causes great + just dissatisfaction on the part of France." The tariffs imposed by the United States on French art during the late nineteenth century affected many painters and collectors, but by 1891 these issues were less contentious than they had been in many years, and they seem an unlikely explanation for Boit's rejection by the Salon jury. This was the second year in a row that Ned's submissions had been refused. It was his last known encounter with that important exhibition, the venue through which so many American painters, including Sargent, would continue to uphold their reputations in the 1890s.[168]

At about this time, Boit turned away from oil painting, concentrating his attention on his watercolors. His decision may have been based not only upon a new disenchantment with oil painting but also in practicality, for watercolor was an easily portable medium and the Boits were constantly on the move. Ned's youngest brother John, who had now decided that he wanted to become an artist (and who was also pleased to accept his brother's financial hospitality), joined the expatriates in May 1891. The two brothers traveled to southern France and northern Italy to paint, and then returned to Paris in mid-June. "[John] proposes to pass the summer at Dinard near or with Ned and Isa who will take a house there," wrote Bob. "Probably Ned will find him more of an expense than he had bargained for. Isa wrote Jeanie [Jane Boit Hunnewell, her sister-in law] to the effect she had asked John to pass the summer with them. She said 'I know

Photograph of Edward Boit's lost painting *Cliffs at Cotuit*

he will smoke all Ned's cigars but I must have him.'" By July, the extended family was ensconced in Dinard at the engagingly named Villa Bric-a-Brac, which John told Bob was "the prettiest place at Dinard, [it] overhangs the cliffs + water with charming terraces."[169]

Despite their high hopes, the summer was unproductive and stormy, in both meteorological and familial terms. The events of the season were not spectacular, but they reveal a constant cycle of activity, complaint, demand, and distraction that do much to explain Ned Boit's inability to achieve more distinction as a painter. Unlike his friend Sargent, Boit lacked the concentrated focus and single-minded force necessary to place his career over and above all the other demands of his life. Letters sent that summer from each of the brothers in Dinard to Bob Boit in Boston disclose the details, leaving Bob amused by "the views of two somewhat idle brothers of each

other – One rich and independent – the other poor and independent. One always giving – the other always ready to receive. One ponderous, sound and didactic – the other witty, lazy, and humorous, and something of a philosopher ... each reading the other thoroughly – Neither reading themselves." Ned called John indolent and completely happy in his idleness, with no interest in applying himself to anything. For his part, John humorously described the family dynamic, which he had the good sense to find amusing:

Ned's girls ... already show beneficial effects of the sea air and bathing. Hub [Jane] is no better nor worse ... she is always pitiably overstrung and nervous. Isa mère is a bundle of nerves, + when Ned, by some unhappy chance, finds himself bilious at the same moment that Isa's nervous centre is upset by a coming storm or some such disturbing event – comedy is plentiful! As Isa's suggestions become more unreasonable and her conclusions more illogical, Ned grows coldly dignified and ponderously scathing – The children sit round looking a little grave and frightened, while I contain my mirth as long as I can, but generally end by giggling, which not infrequently brings them all down from the sublime to the ridiculous. They are delightful people and their affectionateness towards myself – touches me deeply. The troubles of both Ned and Isa arise from that simple cause – want of regular occupation.

The insular world of the Boits, unburdened by the necessity of employment or the compulsion to make art, had perils as well as pleasures.

Ned and his family returned to Paris in September, giving up Dinard after a spate of cold weather. "Cold storm after storm!" noted Bob in his diary, "till neuralgia stuck its fangs into Isa – biliousness

146

seized Ned + general discontent drove them discomfited back to town." They stayed in Paris for only two months before heading to Pau, a resort in southwestern France long favored by the British and famously home to the first eighteen-hole golf course in Europe, which both Ned and Florie particularly enjoyed. "Ned writes me they are much pleased with their surroundings at Pau," wrote Bob. "They have a place of about 20 Acres of land – large house – gardens trees etc. – good stables within about 10 minutes walk from the centre of the town and for an annual rental of $2500. It is called 'Les Chênes.' He talks as though they might remain there several years – and really economize." Bob, always the practical brother with financial matters, doubted their resolve: "They have not got rid of their Paris Apartments for which they are paying rent at the rate of about $3500 per annum + which within two years they fitted up at an expense of eight to twelve thousand dollars." [170]



This pattern of travel from resort to resort, with occasional landings in Paris, continued. The Boits stayed in Pau from October 1891 until April 1892, stopped in Paris, and then went on to England and Switzerland for the summer. They returned to Paris in September 1892, spent the autumn there, and then went back to Pau in January. The next year was much the same, but the routine broke when Isa became ill during the summer of 1894. The family had left Paris in June for Dinard, where they took the picturesque seaside house they had enjoyed once before, the Villa Bric-a-Brac. But Isa was ailing. She had started to complain over the past two years of various weaknesses, which the family blamed on her "change of life" (menopause), the stress caused by the illnesses of her children, and her "overwrought – + sensitive organization." By September, Ned had reported to Bob that over the past month Isa had grown increasingly



debilitated, eventually losing the use of her legs, then her arms. She became paralyzed and delirious, and quite soon her heart and lungs failed. She died on September 29, 1894, at the age of forty-eight, and was buried in Paris.[171] Ned was devastated. Henry James, who learned the sad news from Etta Reubell on October 10, was horrified. "I am very sorry indeed for poor Boit and his crazy children, and I have tried to tell him so," he confessed, later writing that he hoped Etta could offer Ned "some comfort and especially that those dumb [mute] daughters rally to him a little + people his bereavement with something else than their shyness." But Ned clung to his children. "Were it not for them," he wrote in his diary, "I should be glad to think I was to follow my darling into eternity."[172]

While both of his brothers tried to convince Ned to return to America, he refused, partly out of loyalty to Isa, whom he claimed had hated life in Boston, and partly in deference to his children, particularly Jeanie, whose life he feared to uproot yet again. The family stayed in Paris for almost two years, traveling only once, to Biarritz, where they spent the summer of 1895. There, Ned Boit renewed his friendship with a young woman he had first met in Newport, Florence McCarty Little, daughter of naval lieutenant William McCarty Little. She was twenty, had been living abroad with her mother, and was a friend of Ned's twenty-one-year-old daughter Isa. By January 1896, the couple began to talk about marriage, which shocked many of their friends. Bob thought it was a terrible mistake, an unfortunate romantic entanglement that Ned had started out of grief for his late wife, but Ned was not to be dissuaded. Bob was furious and Florence's family was upset. The wedding, first scheduled for June 1896, was postponed to October. Ned sent his daughters (along with their maid and their dog) back to Boston, where they were to spend the

summer with their aunt Jane Boit Hunnewell in Wellesley. He "continues to write and behave like a selfish, infatuated, silly school-boy," exclaimed Bob, appalled that his brother seemed to be abandoning his children, "no doubt that he might the better devote himself to the pursuit of his twenty year old inamorata − + be absolutely free from care or responsibility." In October 1896, Ned's daughters returned to Paris along with their cousins Mary and Georgia Boit and Jane Patten, who were to study in Dresden. "I think he seems quite preoccupied," noted Mary in her journal, "and now we are over here Uncle Ned says he is going to marry Florence Little next month. Well it is a very strange thing and I am more sorry for the girls than anything. Poor dears + it seems so queer to look at Uncle Ned + then think he is in love with someone my age." She later relented, remarking, "Uncle Ned is the youngest man I ever saw of his age. I don't think he looks one day over 45 . . . [he] is very nice and I love him very much indeed and as for the girls there is no use saying any more. Florie is a perfect queen." [173] The family was getting used to the idea of Ned's

149

"Uncle Ned," 1896,
in a snapshot taken
by his niece Mary Boit

AFTERLIFE: NED AND ISA

romance, and after months of delay and indecision, Ned Boit and Florence Little were married in Biarritz on January 5, 1897.

The sons of Edward Darley Boit, Julian and Edward, about 1910

"Ned has grown much of a philosopher," admitted Bob the next year. He "appears content to drift along with his young wife + take things as they come for the rest of a life which he apparently does not expect to be long." The new family divided their time between Paris and Newport. In January 1900, Florence Little Boit gave birth to a son, Julian. That year, Ned renewed ancient affections when he returned to live in Italy, purchasing a villa near Vallombrosa, called Cernitoio. It seemed that their lives would now settle into a graceful rhythm, a stately progress from Paris to Newport to Italy and back again. In April 1902, their second son was born in Paris; he was named Edward after his father, further allaying old sorrows.

But Florence contracted a severe fever after the birth, and she died two weeks later. "Poor Ned," wrote Bob. "Left with two baby boys and four rather inefficient girls – and he sixty-two in May ... What will they do without her? We were all opposed to his marriage and yet within a year recognized the fact that he had done a wise thing – for she was just the woman for his girls and gave them a new + happier life." Florence's mother was there to take care of the boys, but Ned Boit, widowed once again, sadly confessed, "[My] light has gone out."[174]

He kept going for the sake of his children. Yielding to family pressure to live in America, Ned joined his brother Bob in purchasing

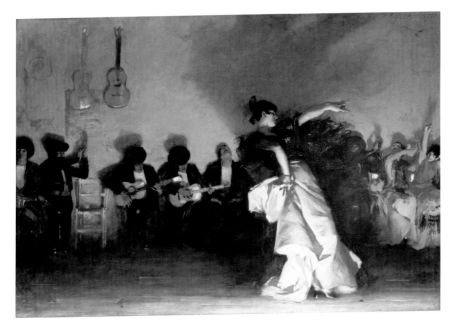

2.1 · John Singer Sargent
El Jaleo
1882, oil on canvas

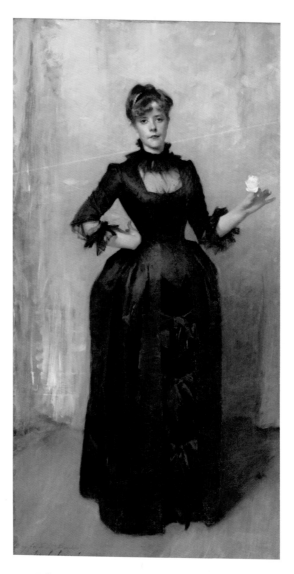

2.2 · John Singer Sargent
Lady with the Rose (Charlotte Louise Burckhardt),
1882, oil on canvas

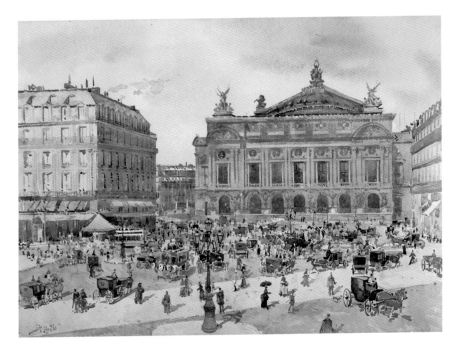

2.3 · Edward Darley Boit
Place de l'Opéra, Paris
1883, watercolor on paper

2.4 · John Singer Sargent
Venetian Interior
about 1880–82, oil on canvas

2.5 · Edgar Degas
Dancers in the Classroom
about 1880, oil on canvas

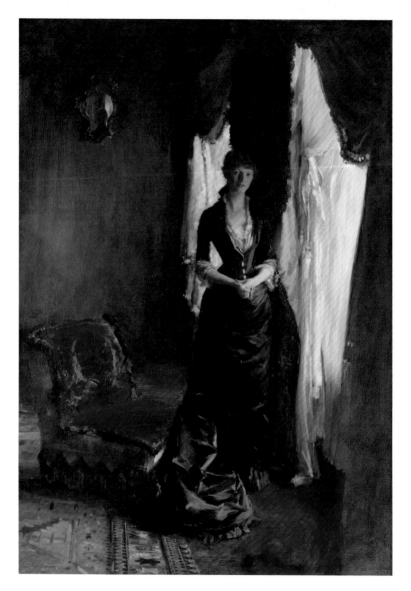

2.6 · John Singer Sargent

Madame Paul Escudier (*Louise Lefevre*)

1882, oil on canvas

2.7 · John Singer Sargent
Portrait of Edouard and Marie-Louise Pailleron
1881, oil on canvas

2.8 · Edgar Degas
Family Portrait
1858–69, oil on canvas

2.9 · William Stott of Oldham
The Kissing Ring (*Ronde d'enfants*)
1882, oil on canvas

2.10 · Thérèse Schwartze
Three Girls from an Amsterdam Orphanage
1885, oil on canvas

2.11 · John Singer Sargent
The Misses Vickers
1884, oil on canvas

2.12 · John Singer Sargent
Carnation, Lily, Lily, Rose
1885–86, oil on canvas

2.13 · John Singer Sargent
Mrs. Edward Darley Boit (Mary Louisa Cushing)
1887, oil on canvas

2.14 · Edward Darley Boit
Poppi in the Casentino, Tuscany
1910, watercolor on paper

2.15 · John Singer Sargent
Edward Darley Boit
1908, oil on canvas

2.16 · Julia Overing Boit
Sketchbook – Girls Playing Golf
about 1890–95, watercolor on paper

View of the house at Cernitoio, about 1912

property on Colchester Street in Brookline, Massachusetts, in 1903. He commissioned the Boston architects Peabody and Stearns to build him a large house there, requesting a colonial revival design of red brick with white trim. The plans were carefully calculated to include a large hall to accommodate Sargent's painting and the Japanese vases depicted in it. But life in the United States was no more appealing in 1903 than it had been in 1883, and by 1906 Boit had moved back to Europe, leaving his sons in the care of their grandparents, the Littles, in Newport. He made frequent and sometimes lengthy visits to Boston, but now spent most of his time with his daughters in the two places he had always loved the most, Paris (in a new apartment overlooking the city behind the Trocadéro on the avenue de Camoëns) and Italy, either at Cernitoio or in Rome.

Cernitoio was a refuge from worldly concerns, an "enchanting

View of the gardens at Cernitoio, about 1912

place," as Bob Boit's wife Lilian described it. It had once been a convent under the direction of the Benedictine monastery at Vallombrosa, but Ned had hired an Italian architect to transform it into a gracious villa with terraced gardens and fountains. It became a sanctuary and a retreat for Boit, his family, and his friends; Henry James found it a "quite divine" eyrie and "a dream of Tuscan loveliness," enjoying the hilltop location and the companionship of old friends, among them "the quite charming daughters." Boston artist Margarett Sargent remembered a fancy-dress tea there, when guests strolled through the gardens. Lilian Boit rhapsodized:

> *We have dined on the terrace nearly every night . . . and now the sun sets before we sit down to dinner and we have candlelight and the fading western glow behind the mountains across the valley — and just now the moonlight before we rise from the table . . . the view from Ned's terrace — looking down into the valley and over it to these Tus-*

can hills — tier upon tier — and at one point the Carraras looking with
their ragged out-line like pale broken clouds against the sky! Such
sunsets! . . . And then the moon rises over the house back of the terrace
— and at last floods the valley and the hills until we can see the houses
on the distant hillsides. On moonlight nights we study the stars.[175]

These visual enchantments inspired Boit to paint again, both in water-
color and in oil. Many of his late compositions depict the shim-
mering light of the Tuscan hills as seen from the vantage point of
Cernitoio (plate 2.14).

Henry James at Cernitoio with Ned Boit and Howard Sturgis, 1907

AFTERLIFE: NED AND ISA

Boit also continued to depict the landscapes of his travels, most often now in Italy but also in the United States. He did not shy away from modern subjects, painting in 1911, for example, several panoramic vistas of New York's rooftops, their geometric configuration enlivened by billows of steam and smoke. His style became more pointillist, with forms loosely defined by quick flickers of the brush. The Boston painter and critic Philip Hale described it as "a Morse alphabet, staccato, two dots and a dash," and while he found the results a little too uneasy and mechanical, he admired Boit's personal vision. The French critic Albert Dubuisson praised Boit's work at length for its brilliant color, "unanticipated invention," and firm design, finding his watercolors especially appealing to artists. "His

154

Edward Darley Boit, *East River, New York,* 1911

SARGENT'S DAUGHTERS

is a remarkable example," Dubuisson wrote, "of what persistence can achieve for an artist who would not let himself be deterred by failure and prejudice." [176]

Boit's renewed interest in his painting career was focused not only on the creation of art but also on its display and reception, and he began to show his work again with an energy and ambition that he had not demonstrated in years. Now with no wife, his children either grown or in the care of others, Ned's family responsibilities and demands were reduced, and perhaps he felt able to devote himself to his long-deferred vocation. In March 1906, he participated in a show at the Boston Water Color Club, causing brother Bob to remark, "He uses water colors as they should be used – for the purposes for which they are best adapted – and in this direction – sketchy effects out of door feeling – atmosphere – and drawing he is unequalled." Later that same year Ned exhibited in Philadelphia, where his work was favorably received, but Bob reported that the lack of subsequent sales "discouraged" his brother, who said that "hereafter he should paint only for his own amusement." [177] However, Ned was not disillusioned for long, and he soon began plotting an attention-getting display of his work, an exhibition of his watercolors alongside those of his well-known friend Sargent.

These plans may have been laid in April 1908, when the two men met up in England. Sargent agreed to paint Boit's portrait when Ned was passing through London on his way from Brookline to Cernitoio (plate 2.15). By then, Sargent had largely given up formal portrait commissions, but as Bob explained, "When the question arose of painting Ned, he said he should be delighted." The likeness was completed in just four sittings, and Ned was pleased with it, saying it was "full of snap" and adding, "Sargent thinks very well of it, +

hopes it is not inferior to the two canvasses already in my possession." His daughters liked it, and he paid Sargent £400.[178] He brought the painting back with him when he returned to Brookline at the end of November 1908. Two months later, in February 1909, Boit and Sargent displayed their watercolors together at M. Knoedler & Company, a prestigious art gallery in New York.

"The idea of these exhibitions is entirely his," wrote Sargent, "as is the idea of my participation." He said he had agreed to them on the basis of his long-standing friendship with Boit and certain "old obligations."[179] Sargent's debt to Boit, perhaps incurred early in his career when he had displayed the portrait of the Boit girls, may have been a pact to make a joint exhibition, as an anonymous writer for the bulletin of the Brooklyn Institute of Arts and Sciences reported in February 1909. "The Exhibition of the works of these two artists," noted the correspondent, "was in fulfillment of a compact entered into between Mr. Sargent and Mr. Boit many years ago when they were comparatively young artists. These two warm personal friends agreed at some time to exhibit collections of their paintings conjointly. This year for the first time has it been practicable for them to fulfill their pledges."[180]

If these joint exhibitions were, as Sargent said, "entirely" Boit's idea, they helped Sargent more than they did Boit, for the 1909 show marked the beginning of Sargent's successful campaign to place large groups of his paintings into the collections of American museums. He had been exhibiting his watercolors in London and winning critical acclaim for them, although he rarely sold them. In June 1908, he had held his largest display of watercolors to date, showing forty-eight of them at the Carfax Gallery in London. Sargent's accomplishments in watercolor were little known in the United States, however, and

seemingly he was more than ready to make his American debut in the medium. But rather than conceiving of an exhibition strategy for his watercolors on his own, he was backed into the plan by Ned Boit. While some scholars have credited Sargent for generously helping an old friend, lending his reputation and luster to the exhibition, it seems instead that Sargent's old friend was helping him.[181]

Ned and Bob Boit went to New York to hang the show – eighty-six watercolors by Sargent and sixty-three by Boit – at Knoedler's gallery. Bob tried to ascertain the differences between the works of the two painters, praising his brother's contributions. "[Ned's] work is free and full of color and light and air," he wrote. "Sargent's [is] rather lacking in atmosphere in which Ned's abound. Ned's [are] rather lacking in color when forced into contrast with the richness of Sargent's."[182] The exhibition opened to the public on February 15, 1909, and became a sensation, earning effusive approbation for Sargent from the press and crowds of attendees. Critical opinions about Boit's contributions were considerably more reserved. The prominent (and often conservative) critic Royal Cortissoz, who might have bolstered Boit's reputation, was brutal in his assessment, declaring, "In ordinary circumstances one might glance [at Boit's paintings] with mild interest. But placed in juxtaposition with what Mr. Sargent has done in the same medium, they simply crumple up and, in a figurative sense, disappear. The contrast is too cruelly vivid for its lesson to be ignored ... the dual character of this exhibition is particularly to be regretted, inasmuch as it has deprived Mr. Sargent of valuable space." The writer for *American Art News* was somewhat less harsh, noting that while Boit's work "naturally suffers in contrast with that of Sargent ... [it] has a charm all of its own, and he is especially happy in the rendition of light and air." The *New York Times* commended

Boit's "seriousness of feeling" and the "distinct charm" of his water-colors in a separate notice, diplomatically avoiding direct comparison with Sargent.[183]

Enthusiasm for Sargent's display was widely published, and in a collecting triumph, the Brooklyn Institute of Arts and Sciences (now the Brooklyn Museum) purchased eighty-three of the eight-six Sargents on display – everything that could be bought. Sargent had placed restrictions on the sale of his watercolors from the show; the press reported that they were to be sold "only to some museum in an Eastern State or to some large Eastern collector, with the requirement that the collection should be kept together for public exhibition."[184] A. Augustus Healy, the Brooklyn Institute's president and a friend and patron of Sargent's, had made the decision quickly, paying $20,000 for the lot – much to the dismay of the Museum of Fine Arts, Boston, whose offer for the watercolors came in too late.

If Boit was snubbed in New York, he fared better in Boston. The exhibition traveled from Knoedler's to the Boston Art Club in March, and once again the Boit brothers supervised the installation, Ned arranging his own watercolors and Bob hanging Sargent's. The Boston press was kinder to their native son than critics in Manhattan had been. As the *Boston Herald* noted, "In reading over the New York criticisms . . . it didn't seem that the Gotham critics gave enough time or space to Mr. Boit's really excellent work." Bob reported that the success of the show gave Ned "a new lease of life . . . it has filled him with new life + hope and ambition." The next year, Boit held two solo shows at Doll and Richards in Boston – one of his oils and one of watercolors – which Bob noted were successful, generating sales for his brother that were based upon genuine esteem for the work, not upon the charity of friendship. After years of allowing himself to

be preoccupied with family and other concerns, Boit now devoted himself to his art. He earned $5000 from the two shows. It was not that he needed the money, but the income he earned made him feel, at long last, that he had overcome his lingering reputation as an amateur; real sales meant professional success.[185]

Whatever bargain Boit and Sargent had struck did not end with their exhibition in 1909; a second show was planned for 1912. The agreement they had made kept Sargent from displaying his work in Boston in the interim. "It was very distressing for me to go back on any detail of our arrangements," Sargent wrote to an unidentified Boston correspondent (possibly Jean Guiffrey, the Museum of Fine Arts' curator of paintings), "but I had to give way to the protests of my old friend Boit. According to him, my consent to let the watercolors be shown in Boston before New York would be fatal to his plans – for a number of reasons; among others because last year many people from Boston came to see our joint exhibition and he is counting on that again."[186]

The second show opened in New York at Knoedler's in March 1912, and this time the Museum of Fine Arts, Boston, made sure that it was first in line to buy Sargent's watercolors. Jean Guiffrey traveled to London to negotiate with Sargent before the watercolors ever left his studio. Bob Boit noted in his diary in October 1911 that Sargent already hoped that some of his watercolors would go to the museum, and the transaction was completed by January 1912, when the *Boston Transcript* bragged that the MFA had made a "splendid coup" in acquiring a group "superior in quality" to the ones Brooklyn owned. By early March, Ned Boit had been told that thirty-eight of his own watercolors would also be purchased for the museum's collection. Thus by the time the exhibition opened in New York, in

an installation again supervised and arranged by the Boit brothers, all of Sargent's watercolors and most of Boit's were already owned by the Museum of Fine Arts. Admiration for Sargent was again effusive, but now Boit's work received favorable recognition as well. The *New York Times*, for example, paid tribute to his calm detachment and "the charm of [his] unemotional art." The MFA's annual report boasted that the works the museum had selected came from different moments in Boit's career, that they "show admirably the development of the [artist's] talent," and that "they were exhibited at New York with those of Mr. Sargent and obtained a great and legitimate success." Bob wrote that "the summit of Ned's ambition seems to have been reached – and he seems radiantly happy, tho' a little overwhelmed by it."[187]

The 1912 display, which was also presented at the Boston Art Club, was the last exhibition Boit would have during his lifetime. He spent the first four months of 1912 in Boston, enjoying his artistic success while divesting himself of his Boston ties. He had placed his home in Brookline on the market in the fall of 1911, again complaining about life in America and admitting to himself that he would never stay. He worked with Florie to empty the house and sold many of his household effects. "Sargent's great picture of Ned's four children and his picture of Isa are to be loaned indefinitely to the Boston Art Museum," reported Bob. "Sargent's portrait of Ned will be taken to Paris as his girls want it there."[188] In the end, the portrait of Isa went to Paris too; only the "great picture" was sent to the Museum of Fine Arts. It was delivered on March 27, 1912, just after the close of Boit's and Sargent's joint exhibition; Ned sailed to France on April 20.

Ned returned, at age seventy-two, to his beloved Italy. Illness

prevented him from making the transatlantic passage again. When his niece Olivia Cushing Andersen visited him in Rome in 1914, she was "painfully impressed" by his condition:

> *I found him lying on a couch beside the lamp, thin, white haired, his profile still handsome ...* [he] *could speak of nothing but his pain, and the horror of the war ... They think themselves fortunate to have obtained a house adapted to their wants, with room for ten servants, chauffeur, attendants for Uncle Ned, etc. ...* [but] *there is a sort of irony in the whole scene, and the very comforts which my poor Uncle loved all his life and which now surround him, protract by ease and care the long painful hours of the day and sleepless nights.*[189]

161

Ned was ensconced in Rome with Florie, Isa, and Julia in a house on the via Gregoriana, a prestigious neighborhood above the Spanish Steps. Bandaged in silk to alleviate his irritated skin, suffering from a variety of internal complaints, he lived in pain, both physical and spiritual, in a country perched on the brink of war.

Boit died of arteriosclerosis in Rome on April 21, 1915. He was laid to rest in the city's Protestant Cemetery; the next year his remains, along with those of his baby son John, were sent back to his native Boston. "He had been surely a very beautiful and benignant person," wrote Henry James to his friend and fellow writer Howard Sturgis, Ned's cousin. "A natural *grand seigneur* of purely private life," James continued, noting that Boit had had a certain diffidence that separated him from the world. "He was so noble and tranquil, so harmonious and sublime a host ... but there was always in him to my sense something tepid and detached, something almost of fine hol-

.

AFTERLIFE: NED AND ISA

low pasteboard or papier-mâché quality, out of which the passions and troubles of men didn't ring and in which they didn't reverberate – though they *ought* to have done so in that cool clear interior void, as expensively unfurnished and 'hard-floored' as a modern music-room." James was compassionate about the physical ailments Boit had suffered, particularly since the degeneration must have been especially painful to a man who had been proud of his elegant appearance:

> *His personal break-up, however, must have been very dreadful to him, and what refuge of silence indeed and withdrawal his extraordinary physical dignity must have had to take from it. He was in that quality of aspect and elegance, of natural aristocraticality, an extraordinary product of the thrifty old Puritan town – just as Iza [sic] had been in her entirely consumptional and petite comtesse way, though with a kind of toy-shop rattling, or tinkling, humanity that was in excess of his. They both seem to me to have been thrown back, as by the violence of our awful present, into the same sort of old-régime fabulous air into which the French Revolution must have thrown of a sudden the types of the previous age.*

And at the last, James mentioned Boit's daughters, calling them the virgins of the rocks, after Leonardo's famous painting and Gabriele d'Annunzio's 1895 novel, a Symbolist romance of superior beings and aristocratic decline: "And one wonders about those queer charming girls and their Tuscan territory, *Le Vergini delle rocce*, as D'Annunzio has the title of one of his fictions." [190] At his death, Boit left behind him a war-torn world and a complex estate that included two vibrant teenage sons, those "queer charming girls," and Sargent's masterpiece.

SARGENT'S DAUGHTERS

Afterlife

*L*IKE THE BOY who never grew up in J. M. Barrie's 1904 play
Peter Pan, the four daughters of Ned and Isa Boit live forever as
children in Sargent's timeless portrait. But the girls were not fictional
characters and they did become adults, remaining together as best
they could as the world changed around them. Like those of so many
women of the period, their lives are difficult to reconstruct, partly
because they never "did" anything "important" and partly because
they lived according to the self-effacing conventions of behavior for
women of their social class. Their long periods of residence outside
of the United States make their lives even more difficult to trace, as
records were left in several different countries. Additionally, expatri-
ates, unless they were famous, did not receive the same level of
bureaucratic attention as national citizens. The Boit "girls" exist in
the shadows of history, seldom appearing in newspapers or in pub-
lic documents. They are mentioned only in passing in the diaries
and correspondence of others; their own journals, if they kept them,
were destroyed or remain undiscovered. None of them married, so
their lives cannot be traced through the biographies of their hus-
bands. Many writers have been tempted to read something tragic
into these circumstances, unfairly assuming that unmarried women

must somehow be unfortunate or unhappy. How, then, to reconcile that impression with the memories of family members, who knew Aunt Julia, for instance, as talented, vivacious, and lively, with a great sense of fun?

Florence Dumaresq Boit

Instead of seeking a husband, Florie – described by one relative as "not good looking, rather awkward and angular, but a very good sort" – quietly undertook the expected and customary duties of an unmarried woman, acting as companion and caretaker for other family members. In the summer of 1890, for example, after her grandmother's death, she spent the summer in Newport with her mourning grandfather, whose health was also failing. She traveled frequently, often accompanying her father on his transatlantic voyages. Her apparent lack of interest in marriage seems uncharacteristic for a nonprofessional woman of her generation; most women were expected to wed and to have children. But Boston, in particular, was famed for the great number, high profile, and public activism of its "mighty maidens," unmarried women (often sisters) who were vibrant, energetic, and accepted both intellectually and socially. Florie had many role models she could choose to follow.[191]

Aside from occasional illnesses, she was strong and fit, and one of her passions was golf. In the early 1890s, when her family was living at Pau, the fashionable resort near Biarritz famous for its golf course, Florie took up the sport (plate 2.16). In the spring of 1892, visiting her aunt and uncle in America, she was disappointed not to be able to play anywhere in the Boston area. Enlisting the collaboration of her uncle, Arthur Hunnewell (Ned's sister Jane's husband), Florie set up a

Julia (left) and Florie Boit at Cernitoio, about 1910

demonstration on the lawn of his Wellesley estate, sinking flower-pots into the grass to create the holes. She then helped to create a seven-hole course across the family compound, which attracted a number of local fans. "We are getting quite excited about golf," Hunnewell noted that summer in his diary. Laurence Curtis was among the enthusiastic relatives who played there; by the fall of 1892, Curtis had written to the managers of the Country Club in Brookline, suggesting that golf be added to the club's activities and explaining that a trial course would not be a great financial burden. Curtis and Hunnewell laid out the first golf course at the Country Club in the spring of 1893, eventually taking over most of the land that had once been used for shooting and riding.[192]

The Country Club became one of the country's best-known golf courses, but Florie Boit is recorded in early histories of the sport

only as "the young lady from Pau," her anonymity typical for her time, sex, and social class.[193] She continued to play golf, and many others of her gender began to share her zest for the game. The sport became particularly popular with women; it was a game in which they could excel, either alone or in a team, and one in which they could play in a mixed foursome with men. The United States Golf Association inaugurated a women's championship in 1895, and the names of early competitors from the Boston area demonstrate that Florie's passion had quickly spread to others from her set, among them the champion golfers Harriot and Margaret Curtis, Laurence Curtis's cousins. But whether Florie felt the irony that while she could play golf at the Country Club, because of her sex she could not be admitted to full membership there, is unknown.

In addition to her love of sports, Florie was interested in handicraft, finding (like many women of the age) a creative outlet in the arts. "Florie has a great deal of mechanical and artistic talent," wrote Bob. "The handsome embossed and beautifully colored leather portfolio on which I am writing was made by her, and she works in silver and brass and ornamental wood work. She has made many very handsome things in leather, and at Lilian's and my silver wedding this Spring presented us with a silver spoon very handsome in design and finish which she made for the occasion. She sends some of her things to the 'Society of Arts and Crafts' to be disposed of, and is certainly a craftswoman of great merit." Florie was serious about her art; it was much more than an idle hobby. She was a craftsman member of the prestigious Society of Arts and Crafts in Boston from 1906 to 1914, listing herself as a leatherworker. In 1915, she was elected by the society's council to master craftsman status,

an honor conferred upon an individual artist only after he or she had established a consistent record of excellence. Florie exhibited her work each year in the society's juried exhibitions, but no surviving examples of her art have been securely identified.[194]

Florie's interests mark her alliance with a particularly American type – the "new woman," an active and independent sort of female that emerged in the United States after the Civil War. New women were physically active, independent, and unafraid to try novel things. They were sometimes perceived in the popular press as a threat, characterized as too masculine and therefore upsetting to the stability of the family and the home. Such women could also present a challenge to the conventions of European social behavior, a theme Henry James had explored at length in his 1878 novel *Daisy Miller*, in which an American girl runs afoul of the social expectations of her European counterparts. Daisy, a straightforward, friendly, and passionate young American visiting Europe, is considered uncivilized (and is ultimately punished) for her failure to respect boundaries of class and her resistance to accepted patterns of good behavior. She dies in Rome, and at the end of the novel, the American expatriate Mr. Winterbourne, the man who should have understood and loved Daisy, realizes his mistake and remarks, "I have lived too long in foreign parts."[195]

James was only one of a long line of writers to discuss the shocking freedom of speech, manner, and action displayed by American girls in Europe. Perhaps Florie Boit also found the constraints and conventions of European society too restrictive. Unlike her mother, who chose life in Europe, she seems to have taken every occasion to extend her stays in the United States, and her uncle Bob realized that "she is the only one of Ned's girls, who prefers America to

Europe."[196] Florie may also have come to favor America for another reason: it was in her native land that she found real companionship. She became devoted to her cousin Jane Boit Patten, also known as Jeanie and nicknamed "Pat" to distinguish her from the other Janes and Jeanies in the family. Patten was the daughter of Ned and Bob's sister Lizzie; the cousins had been friends since childhood, but their relationship became closer as they grew older.

Jeanie Patten was a serious scholar, one of a large number of women academics in the Boston area. Her field was science, a subject often considered more appropriate for men. Bob Boit wrote about her in 1904, after she had returned from university in Dresden and enrolled at the Massachusetts Institute of Technology. He characterized her as "a pretty woman of about thirty three . . . She is most feminine + attractive." He then added, in a perplexed tone, "yet she told me the other day she had never cared the 'least little bit' for any man – which to my mind argues something a little abnormal about her."[197] Jeanie Patten studied biology at MIT and received her bachelor of science degree in 1906, with Bob and Florie in attendance. That same year she coauthored an article, based on her thesis, on the influence of neutral salts on salivary digestion for the *American Journal of Physiology*. She became an instructor of biology, botany, and horticulture at Simmons College, which had been founded in 1899 as a liberal arts college for women.[198]

By the time they were in their forties, Florie Boit and Jeanie Patten had become very close friends. Bob wrote about the two of them at length, recounting a relationship that might best be defined as a Boston marriage, a term used for women who formed amorous bonds to one another, sometimes sexual and sometimes not. In 1911, Bob wrote:

To go back to Jeanie Patten and Florie Boit. They are between forty one and forty three years old, first cousins, and intimate and deeply attached to one another. Since Ned went abroad in the spring Florie has been stopping with Jeanie Patten – or Pat as we have always called her for short – in her pretty house in South Natick which her Aunt Jeanie Hunnewell (my sister) built over and gave to her a year or two ago. Well they are two of the most amusing and peculiar and thorough old maids I have ever known, and counterparts. Pat is a great talker, short, stout, and rather pretty still, with good regular teeth which she shows when she smiles, sparkling brown eyes – and always "with a chip on her shoulder" and ready to take offense. Florie is tall and rather slight, but exceedingly strong + muscular for a woman, a match for most men. She stands erect and serious with a rather sunken face, but is a fine looking woman, without being at all what we call good looking. She is serious and at times very sarcastic and more or less biting and witty. She seldom speaks, but when she does it always means something. They are a funny couple together, as they constantly are, and each one does not hesitate to say behind her back, that the other is exceedingly peculiar and eccentric.

The precise nature of the relationship between these two women will never be known, but Bob admitted that "man as such does not enter into the lives of either of them – so far as one can judge. That is [a] 'man' of their own age and as a thing to become exclusively interested in." He went on to think about Florie in greater detail:

Both [Pat and Florie] are strong characters. Florie, tho' the daughter of a well-off man, never wasted a cent in her life, [she] is careful to an extreme, and very sarcastic about her father's princely ways. She

dresses neatly but inexpensively, and would be as happy in the clothes of a German peasant – if they were warm (she must be warm!) and clean – as a Worth costume. In fact far happier for nothing would induce her to wear really fashionable clothes, and I don't think I ever saw her in really low neck and short sleeves. She [is] really kindhearted and fonder of her family and relations than she shows. She is the only one of Ned's girls . . . who has shown any real affection for Ned's two young boys by his second marriage. In fact I think she would have been a good mother to them, if Ned had kept them with him.

Florie found, with Jeanie Patten, a relationship that has all the hallmarks of marriage. "To see these two strong minded women together is as good as a play," wrote Bob:

Pat will say something with rather fiery eyes to Florie, and Florence will look up at her + with her steady voice and touch of foreign accent say "I am not speaking to you" and go on with her reading. Nor can Pat get another word from her. The play between them is always going on with varying success, but Florie, with her stronger character and personality and sarcasms and underlying kindliness generally has her own way in the end. Pat does not hesitate to whisper that Florie has the largest appetite she ever saw – and eats her almost out of house and home and never seems to realize it. Yet she knows that if Florie should hear of her saying such a thing, she would never stay with her again – and that would be the last thing she would wish.

Florie continued to travel back and forth the across the Atlantic, but by 1913 she was using Pat's address as her own during her residences in Boston. It is clear that when they were together, Flo-

rie and Pat enjoyed a regular routine of domestic happiness and companionship.[199]

Jane Hubbard Boit

Jeanie never completely recovered from her breakdown; her troubles lasted throughout her life. During most of the 1890s, she lived with her family and participated as best she could in the activities appropriate for a young woman of her age and condition. When Bob Boit visited Paris in 1890, he saw that she had improved, declaring, "Jeanie is much more like other people than when I saw her last summer." He added that she "takes her meals with the family + has I am told got over her violent tempers. She still looks very delicate but is so much better they have let her return to her passion – music – + she now practices five hours a day. Her technique is wonderful – thoroughly professional – I have heard her practicing – but not her playing yet. She is very difficult about it." The next summer, John Boit found her "always pitiably overstrung and nervous," and he wrote to his brother Bob that Ned and Isa's largest concern and preoccupation was "Hub's precarious health. Of course she is much improved but still far from looking or acting like a healthy person."[200]

Jeanie ardently loved music, although her apparently compulsive dedication to practicing the piano remained a concern to her parents. She (like her mother and most of their social circle) was an avid admirer of Richard Wagner, and in 1889, when Bob Boit and his sister-in-law Isa traveled to Bayreuth, Germany, they brought with them a wreath from Jeanie to lay on the composer's grave: "Our chief purpose [today]," wrote Bob, is "to place a wreath of Laurel, brought by us all the way from Lausanne (an offering of Isa's Jeanie + the

result of many weeks of saving on her part) upon Richard Wagner's grave. This wreath had been packed in a box at least four feet square – marked on the outside 'Coronna für Wagner grab' + had followed our luggage from place to place, causing us no little anxiety + the officials – especially on the frontier – some amusement." [201]

During his visit in 1890, Bob related that his own interest in and love for music had earned him special attention from Jeanie:

> *Jeanie has a severe cold caught I fear from Ned + me. She is a most affectionate girl and seems to have taken a great fancy to me. She was in bed yesterday. I sent her a couple of roses with my card. She told me last night she should keep my card forever. Isa (mère) asked her if she "loved or adored" her Uncle Bob. She said "Adore!" I suppose it arises from my interest in her one pursuit – her music. Poor girl, with her nervous, sensitive disposition she has I fear no end of unhappiness in store for her – Her nerves seem all as finely strung as a violin and as sensitive as a harp to the breath. She reminds me of those plants that expand in the warm sunlight – + shrivel at an unfriendly touch.* [202]

For Jeanie, music provided not only solace but also an acceptable mechanism through which she could relate more easily to other people.

All of the girls played instruments, and since their youth they had performed for family and guests. "Isa (daughter) is now practicing the harp in the next room," noted Bob in 1890. "Florie is an excellent violinist – + Julia is studying the cello. They all have great talent." [203] The girls' love of music sustained them throughout their lives, as photographs made in Italy attest. Jeanie is noticeably absent from

these pictures. As Bob had reported already in 1892, her illness was still taking a toll on the family:

> *Jeanie Boit's health does not improve and she continues as a source of great unhappiness to Ned's household. She is hopelessly ungovernable in temper if not actually out of her mind – and all physicians have advised their sending her to some retreat or at least to some place away from home – Thinking the influence of the family on her + hers on the family bad for them all. In fact John writes she is spoiling the lives of the whole family. Yet naturally enough Ned and Isa find it very hard to make up their minds to the parting, unhappy tho' they be with her at home. They should unquestionably make the move if only for the sake of their younger children. Said Jeanie is now over twenty and the family barometer is gauged day by day by the condition of her temper – or rather distemper. Her one delight is her music – for which she undoubtedly has genius.[204]*

By the next year, a decision had finally been made: during the winter of 1892–93, Jeanie was sent to live with "some private family in Paris where she is able to gratify her one passion – or rather her habitual passion – for Music." Ned dreaded that she soon would end up in a mental asylum, as his son Neddie had. But in 1894, during the summer of her mother's illness and death, Jeanie was back with the family, managing to behave "like other people." She was subdued after Isa's passing and fearful of being sent away from home again.[205] Eventually she did come to live away from her family, in her own apartment in Paris with people to care for her. Her health fluctuated over the years, but she seemed content.

Mary Louisa Boit and Julia Overing Boit

Isa, who stands at the left in Sargent's portrait, was described by a family member as "the beauty of the family, with delicate features and curly hair, who played the harp." She turned eighteen in June 1892, but she was not one of the Boston "buds" that year; the family was in Europe, on the move between Pau, Paris, England, and Switzerland, her mother's health diminishing. Most often, Isa is recorded in the company of her younger sister Julia, whom the same relative characterized as "rather Mongolian looking with flat features and straight hair, clever with her brush and particularly good at caricatures of animals." When Julia was old enough to go out into society, the two sisters appeared now and again in the social notices of the newspaper. In 1896, for example, two years after their mother's death and one year after their father's romance with Florence Little began, Isa (age twenty-two) and Julia (age eighteen) were mentioned in a *New York Times* column about the opening of the social season in Newport, Rhode Island. Amid the breathless discussion of grand summer activities, new houses and yachts, and the year's record number of "society buds" who were planning "brilliant" coming-out parties was a brief remark that "Miss Julia Boit and Miss Isa Boit of Paris are guests at the cottage of Thomas F. Cushing," their uncle.[206] Neither girl was characterized as one of the year's "buds," but instead, despite their many connections to Newport, they were listed as visitors from France. In March 1903, Isa and Julia were listed again several times in the society pages in the company of singer Emma Eames, who had been a friend of the family for many years. Thirty-five years later, little had changed; the *New York Times* related in 1938 that "Misses Mary Louisa and Julia O. Boit"

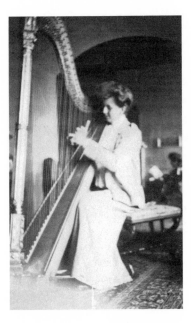

Isa Boit at Cernitoio, about 1910 Julia Boit wearing a kimono, about 1896

had shared a box with their Hunnewell cousins at the celebratory concert for the opening of the new music shed at Tanglewood, in Western Massachusetts, "an outstanding event of the Berkshire season." [207]

In Sargent's painting, Isa Boit seems as if she has few secrets, but her life is the hardest to document. Julia, who sits on the floor with her doll in the portrait, is easier to trace. The baby of the family (at least until her father's second marriage and the birth of his sons), Julia was, according to her uncle, "the apple" of her parents' eyes. In 1892, when she was fourteen, she became seriously ill. "I had a letter from [Ned] yesterday," wrote Bob, "stating [that Julia] had been gradually losing flesh + strength. That nothing organic was the mat-

AFTERLIFE: THE DAUGHTERS OF EDWARD BOIT

ter but it seemed to be a decline in strength from overgrowth. She's about 15 and very large [for] her age." Perhaps the Boits feared that upon reaching adolescence Julia would develop the same problems that Jeanie had presented, but her fortunes were better and she recovered from her undiagnosed ailment.

Julia's illness and the attention the family accorded her made Bob take time to consider his niece. He noticed her special gifts in art and wrote about her in some detail:

> She is . . . a girl of rare character and remarkable ability. I am not a genius hunter + don't easily "enthuse," but this girl is the only one I have personally ever known who seemed to be a "genius." She has never had regular instruction in drawing + watercolors. Yet today do I believe she could make her living at illustrating books. She has wonderfully [sic] facility with her pen, pencil, + brush – Draws with wonderful rapidity and freedom – colors with taste – But her drawing of the human body is most extraordinary to me. She seems to have a natural eye for anatomy + can throw in figures in any position whatever, in perfect drawing, always active, strong + individual. Her conceptions keep pace with her drawing + the designs and thoughts drawn are themselves charming too. If she lives she is sure to make her mark in the Artistic world.[208]

Bob was both correct and incorrect in his assessment. Julia was indeed skilled as a watercolorist and especially as an illustrator, but like so many talented women of her generation, her mark in the art world was only lightly rendered.

Having a gift for illustration and devising a professional career were two very different things. Illustration was one of the more lucra-

tive branches of art, and many women were able to earn their living from it. But Julia Boit, with a trust fund established for her from her mother's estate, had no need to make money. In her time and place in society, it would have been perceived as an act of selfish fancy for her to take a professional position that might have gone to a woman who needed the income. Nor does it seem likely that she would have made a concentrated attempt to seek critical acclaim, something her father had found very difficult himself. If Ned Boit – trained as an artist in Rome and Paris and a contributor to the Paris Salon and other important exhibitions – was often frequently dismissed as a gentleman amateur, his daughter probably expected even less.

Facility with watercolor painting, however, was a skill encouraged in young ladies, and Julia Boit's work is much in keeping with that tradition. Small-scale watercolor sketches enlivened letters and diaries, were exchanged with friends, and provided a record of travel. These were often created in a transcriptive, linear style that employed strong contour lines and washes of color to depict the real people and places surrounding the painter. The practice was followed by large numbers of women artists who always considered themselves amateurs, no matter what training they had undertaken or what level of accomplishment they achieved. "Amateur" was understood in its original meaning: amateurs painted because they loved to paint, not because they intended to become professionals – that is, to earn a living from their art.[209] It was not expertise that necessarily divided an amateur from a professional, but money.

Bob knew that his nieces had a reliable income from the family trust, but he was impressed by the artistic talents they demonstrated and he was convinced that their skills could have proven marketable, something that might come to be beneficial should they never marry.

In 1905, when Florie Boit had started to show her work at the Society of Arts and Crafts, Bob wrote, "They are all nice girls if getting a little beyond the age of merchantable youth." He added:

> *I tell Ned's girls if they would set up a little shop for works of their own Art, they would become the rage of the town and make a fortune. Florie's embossed leather work is really beautiful, and she does much other artistic work of the same kind. Julia's painting of figures and animals, and scenes from life, are most graphic, and lively and amusing – altogether unique. She is really an admirable illustrator, but has never been known or done any work for publication. Jeanie, who lives by herself in Paris, does needlework and embroidery that should be owned by Museums – it is simply beautiful [in] work and color.*[210]

Characteristically, Bob's confidence and interest in the girls' talents had a practical streak, for art, particularly handicraft, was very often recommended as a field in which women could appropriately earn a living.

Julia Boit is not known to have attended any art school (she most likely studied informally with her father), but her technical skills are equivalent to those who did. Her flair for design, her talent with the brush, and her sense of humor are perhaps most evident in a charming work from 1897, an illustrated birthday book. Inside a hand-tooled leather cover (likely also made by Julia, or perhaps Florie) is a book of days annotated with the birthdays of family and friends, each personalized with aphorisms and autographs. Julia illustrated each one with an appropriate picture and caption, fluidly delineated in ink. Many of the drawings are enhanced with thin washes of watercolor. For Florie, on May 6, Julia chose verses from Longfellow

about a violin. For her troubled sister Jeanie, whose birthday was January 17, she painted a woman playing a piano and selected lyrics from a song used by William Shakespeare in *Romeo and Juliet*, "When griping grief the heart doth wound, and doleful dumps the mind opresses, then music, with her silver sound, with speedy help doth lend redress." Sister Isa (June 5) earned a drawing of birds, while Julia's father (May 16) was represented in a portrait. Ned Boit is shown from behind, painting out of doors under a large white umbrella. The scene before him is an old fence and an empty field; the caption reads (in French), "By the work one knows the workman," a quotation from the famous French poet and fabulist Jean de la Fontaine.

The birthday book, along with similar sketchbooks, reveals Julia's decided talent for illustration. Her drawings are carefully made, with delicately applied color washes in the

top: Julia Overing Boit, Jane Boit's Birthday Book page, January 17, 1887–88

right: Julia Overing Boit, Julia Boit's own Birthday Book page, November 15, 1887–88

Julia Overing Boit, *Sketchbook – Girls in Pinafores*, about 1900

background that set off the bolder strokes of the foreground fig-
ures. Most are not historical scenes or fairy tales but lively depictions
of incidents from modern life, presenting details of costume and
expression with a sure hand and a minimum of fuss. Julia's work was
as accomplished and clever as the drawings that appeared in many
contemporary books and periodicals, but there is only one known
instance of her illustrations being published. In 1958, when she was
seventy years old, her pictures appeared in a privately printed book
of children's fairy tales, *Old Friends Retold in Verse* by Margaret Blake,
a cousin. One scene bears an uncanny resemblance to Julia's own
likeness in Sargent's portrait.

Julia also made independent watercolors, favoring interiors (both
with and without figures) and landscapes. Many of them are views
of her studios and apartments or sometimes of the halls of historic

houses. Such depictions were common among women artists, whose lives revolved around domestic spaces, although many Boston painters, both male and female, made interior scenes their specialty. Julia Boit doubtless knew the work of her father's friend and compatriot Walter Gay, who also lived in Paris, moved in a similar social circle, and specialized in painting furnished rooms that seem similar to hers. Julia held at least one exhibition, in March 1929 at the Copley Gallery in Boston, where she displayed sixty-six watercolors. Their subjects trace her life: views of the house and landscape of Norwich,

England, where she and her sister Isa spent several summers; images of Isa reading; scenes of Paris and Brittany. The *Boston Herald* described them as "well bred and inspiring," making sure to add that Miss Boit was the girl on the floor in Sargent's portrait. "Grown up since then," the notice continued, "she has painted in Paris, as one would expect her to do."[211] All but five of the watercolors were for sale (prices on application), but whether or not the show was a success in economic terms is unknown. The largest group of Julia's watercolors is now in the collection of the Newport Art Museum, most of them received as a gift from a family member many years after Julia's death.

Julia Overing Boit, *When This King Was Just a Boy*, from *Old Friends Retold in Verse*, 1958

Julia Overing Boit, *A Corner of the Studio* (*Isa Reading*), 1922

Virgins of the Rocks

Were the Boit girls unusual for never having married? Their single status was not as extraordinary as one might expect, for by the 1870s and 1880s, there were more unmarried women in the United States than there had ever been before. This was not just a result of the enormous number of male casualties during the Civil War, but a deliberate choice that had become more and more economically viable. As one 1887 American etiquette manual explained, "So many delightful women are late in loving, so many are true to some buried love, so many are 'elderly girls' from choice, and from no neglect

of the stronger sex, that to them should be accorded all the respect which is supposed to accrue naturally to the married. 'It takes a very superior woman to be an old maid' said Miss Sedgwick," the author continued, referring to the writer of the popular 1846 book *Morals of Manners*.[212]

Spinsterhood continued to be an option through the turn of the twentieth century. The Boit daughters certainly did not need to marry for money – their Cushing inheritance left them in comfortable circumstances – nor did snaring an aristocratic husband seem important to them, as it was for other society girls of the day. But neither did they have cause to reject marriage as an institution, like the many women of their time who aspired to become teachers, doctors, lawyers, writers, or artists. For those women, marriage was often perceived as a bond that would prevent or preclude them from their serious pursuit of a profession; most felt that marriage had a deleterious effect upon a woman's career (and that a woman's career was bad for a marriage).

None of the Boit sisters ever seems to have declared those sorts of professional ambitions. Perhaps they were kept from marriage by a combination of individual circumstances – their constant travels, the insularity of their family group, Florie's apparent disinterest, Jeanie's illness. They may have seemed too European for Boston suitors, too Bostonian for the Europeans. Or they simply may never have met the right men, men who not only could meet the approval of their family but also could fulfill new and commonly held ideals about matrimony, modern beliefs based on the romance of true love and moral excellence. Fellow Bostonian Ella Lyman spent two years trying to decide whether or not Richard Cabot could fulfill her conception of "the meaning of marriage," which she told him was "so sacred a tie"

that she felt entirely "unworthy to share your life unless I can give myself to you with perfect oneness." [213]

Lyman and Cabot did eventually marry, but plenty of Boston women did not; as William James (Henry's brother) once noted, "First class young spinsters do not *always* keep for ever, although on the whole they tend to, in Boston." Four unmarried sisters of the Webster family lived in the Harrison Gray Otis House behind Beacon Hill on Cambridge Street in the 1850s and 1860s, running a genteel boarding house. Three unmarried sisters from the Pratt family resided together in one of Mount Vernon Street's most beautiful dwellings from the 1850s until the 1880s; in 1911, their three unmarried nieces, the Searses, took over the same building, keeping it in the family until the last sister died in 1966. Four Curtis sisters lived just up the street, where they made their home a "focus of friendship, intelligence, and countless good works." [214] Spinster sisters Ida and Ellen Mason supported a variety of charitable causes from their residence around the corner on Walnut Street in the 1880s and 1890s. Sisters Hannah and Grace Edwards (along with their unmarried brother Robert, who also lived with them) amassed a remarkable collection of Impressionist paintings in their townhouse on Beacon Street between 1907 and 1924. On Boston's Chestnut Street alone, according to a 1910 social directory, more than a dozen homes were occupied by one or more women listed as "Miss." On Colchester Street in Brookline, the Misses Boit appear at number 29, the Misses Saunders at number 67, and a Miss Richards at number 98. [215] Whatever their reasons for remaining single, the Boit daughters were certainly not unusual, nor necessarily unhappy, in their spinsterhood.

"They can hardly be called girls any longer," wrote Bob Boit in 1911 of his four nieces:

Last week I saw [Ned's] *oldest daughter Florie off for Paris . . .* [she] *remained when Ned went abroad in the Spring and has passed most of the time with Jeanie Patten at So. Natick, visiting her other relations from time to time. She proposes to come back with Ned when he returns to this country in February . . . Poor Florie! She seemed to me a rather pitiable object going off to Paris all by herself! She is so diffident, so bashful, so retiring, even at forty three or four. She is really a very fine woman and has a strong character and affectionate disposition, and yet no one but those very near to her would realize it. She is most simple and economical in her tastes and habits.*

185

Always practical, Bob outlined the girls' finances. "Her father allows [Florie] $600 per annum, and of course her traveling expenses to and from Europe. He allows his other two girls Julia and Isa the same. Jeanie who lives by herself in Paris and has done so for many years costs him from $3600 to $5000 per annum." [216]

Thus the daughters of Edward Darley Boit continued to live for some years to come, traveling frequently and spending their summers with their father at Cernitoio until his death in Rome in 1915. Bob, who had always been the loyal manager of the family's business affairs, continued to look after them from afar. "Ned Boit's children by Isa Cushing have not had their fair share of health, which I attribute to dear Isa's own condition and peculiarities and carelessness + activities while carrying them," Bob explained. "Since Ned's death the four daughters have been living in Paris, where much of their lives have been spent. Florie, Isa, and Julia in their old apartments + Jeanie by herself where she has lived with her two servants for many years." [217]

The outbreak of the First World War brought financial concerns,

with banking transfers made more difficult, but more than that, the Boits' world was changing; expectations collapsed. The violence of the conflict, the sheer horror of it, shattered nineteenth-century ideals. Combined with their father's death, it took a mental toll on the girls, particularly on Florie, which Bob related with characteristic candor:

> Since the war began Florie has been working very hard in one of the charitable societies – devoting her whole time to it. Last summer she got so run down with it she became melancholy and then out of her head and was later sent to a private institution near Paris, where she seems to have become quite crazy. She is about fifty but I have little hope of her recovery ... It is very hard for the other two girls or women I should say. It is sad enough to see a shadow like this cast over a family. It is probably just as well that none of these girls ever married – + yet on the other hand if they all had married young it might have freed them from all such troubles.[218]

Bob's comments were deeply rooted in the same commonly held medical theories that he had espoused since Jane's first illness, notions that equated disturbances in women's mental health with their feminine biology. Hysteria, by its very etymology a female complaint, had been one of the nineteenth century's most common diagnoses for women and one deeply rooted in the patient's sexual life – or the lack of it. Thus Bob could see his niece's problems in one of two ways, either caused or cured by her spinsterhood.[219]

Robert Boit died in March 1919, and with him was lost the most detailed recorder about the activities of the family. Florie Boit, the most active and seemingly physically healthy of the girls, was the first of them to pass away – at age fifty-one, on December 8, 1919,

in Paris, just two years after her uncle expressed his fears about her recovery, perhaps vulnerable to the influenza epidemic that had just begun to abate. Jeanie, Isa, and Julia stayed on in Paris, where they had lived for so many years. "Isa and 'Yaya' live alone and seem perfectly happy," wrote their relative Olivia Cushing Andersen. "They have a pretty apartment in Paris overlooking the Trocadero, and for a time there lived with them an old decayed gentlewoman . . . who seemed their only contact with the outside world." Isa and Julia "are now two dried-up old maids," she callously concluded.[220] The two sisters continued to spend many summers at Cernitoio, along with their half brothers Julian and Edward. In 1939, with the inevitability of war between France and Germany, the three surviving sisters moved back to the United States. Jeanie Boit had always seemed the most fragile of the family, but she lived to be eighty-five years old. She died in Greenwich, Connecticut, on November 8, 1955. Julia and Isa had moved to Newport, becoming involved in activities for the Red Cross and the Redwood Library and in a variety of musical events. Isa died in Newport on June 27, 1945, at age seventy-one. She left the bulk of her estate to her sister Julia, making cash bequests to Jeanie and to her half brothers. Isa also established a trust fund that would pay an annual income for life to her cousin Jane Boit Patten (Florie's friend), as well as to Beveridge Webster, a celebrated American pianist active in Paris and a friend of Isa's.

Julia lived at 210 Eustis Avenue in Newport and then moved to 125 Rhode Island Avenue, where she stayed for the rest of her life. As long as her health allowed, she maintained commitments to charitable and musical events. She also continued to paint, occasionally displaying her work at the Newport Art Association. She was close to her extended family and affectionate with her young nieces and

nephews. Julia died in February 1969, at the age of ninety-one. On her death, she at last received an identity separate from her sisters; the headline in the *Newport Daily News* read, "Miss Julia Boit, An Artist, Dies."[221]

As Olivia Cushing Andersen put it, Ned and Isa Boit's family had experienced a long and slow decline. Its members seemed to her "like flowers that are fading. The whole group has wilted away like the branches of a plant without roots and soon there will remain of these lives but the dust of their bones and a few pale watercolor paintings, faint transcripts from life without any imagination, conception, or anything to convey."[222] But this account neglects the most vivid testament to the lives of Florie, Jeanie, Isa, and Julia, a flower that has fueled the imaginations of many. In Sargent's haunting portrait, the daughters of Edward Boit remain vividly alive.

Afterlife

*S*ARGENT'S PAINTING of the daughters of Edward Boit had a life
of its own, at first intertwined with the Boit family and then sepa-
rate from them, taking on a timeless resonance quite apart from the
identity of the four girls. Sargent had used the portrait to represent his
professional aspirations three times – first in the independent exhi-
bition arranged by Georges Petit in 1882, then at the Salon in 1883,
and again in his first solo exhibition and American debut in 1888.
He asked the Boits to allow him to show it once more, in 1889 at the
great international world's fair in Paris. This time, Sargent reintro-
duced the portrait to the public as a patriotic achievement, present-
ing it in the American section of the fine arts display in a room
devoted to the expatriates.

The painting had been sent to Paris from the Museum of Fine
Arts, Boston, in February 1889; when the crate arrived in mid-March,
the portrait was varnished and sent directly to the Champs de Mars
to join the rest of the American works that had been gathered in
preparation for the exhibition.[223] The big canvas, by then entitled
Portrait of the Misses B., as well as Sargent's recent likeness of Isa Boit,
were two of the six portraits that the artist showed at the fair. "He
will never consent to be commonplace," wrote *Harper's* critic Theo-
dore Child:

He loves rarity . . . his talent is prodigious; his sensitiveness to all artistic manifestations is extremely delicate; his intelligence, his verve, and his virtuosité are marvelous . . . To comment upon each of the portraits exhibited at the Paris Exhibition is unnecessary. To my mind the two most personal and most completely charming are those of Mrs. Boit and of the Boit children. This latter picture, painted in 1882, has already been engraved and described in Harper's Magazine, October, *1887. I need only say that as it gains in years this picture has gained in quality. Since it was exhibited in the Salon it has acquired a richness of aspect, a harmony and depth of tone, and a mystery of surface that make it comparable to the great works.*

The portrait was beginning to take on a patina. The display earned Sargent a medal of honor and the prestigious award from the French government of chevalier of the Legion of Honor.[224]

Ned and Bob Boit were among the thirty million people to visit the fair, but Bob made no mention in his journal of seeing the family portraits there. "We wandered about, saw many paintings and statues," he wrote. "A man could pass a year there + not half see it. But such things tire me and are not what I went abroad to see. I am not looking for the new – I can find that at home. I am looking for the old that I may never see again."[225] The painting of the girls was sent back to the Boits when the exposition closed at the end of October. It stayed within the family, visible only to relatives and friends, for more than twenty years.

Despite its disappearance from public view, the portrait was often mentioned in the increasing numbers of articles about Sargent that were published in the 1890s as the artist's international fame

The Boit portrait at the world's fair in Paris, 1889

increased. The British critic and writer Marion Hepworth Dixon, for example, writing in the *Magazine of Art* in 1899, said it was a turning point in Sargent's career, "the picture which was, in a sense, to make his fortune." Calling it (erroneously) a product of Sargent's boulevard Berthier studio, she continued:

> *The large canvas called simply "Portraits of Children," but which is often for purposes of identification, referred to as "The Hall of the Four Children," does, in fact, represent a rich, shadowy ante-chamber, where tall screens and monster Japanese vases mirror themselves in the vast face of a shining floor. Four slim-legged, white-pinafored children group themselves with naïve spontaneity about this happy*

interior; they are seen, that is to say, as if caught unselfconsciously at play, the absolute unconventionality of their attitudes, added to a certain distinction of lighting, constituting one of the picture's chief and foremost merits.[226]

For Dixon, the unusual composition, the deep shadows, and the disparity of scale – all of the same qualities that had seemed remarkably disturbing in 1883 – now were to be counted among the most compelling attributes of the painting.

That same year, in an article about portrait painting and portrait photography, the modernist American critic Sadakichi Hartmann discussed Sargent's portrait in the context of his keen anticipation of color photography and of moving pictures. He used the image, now so well known, as his quintessential example of a painted portrait of children. Hypothesizing the superiority of a moving image to "any representation" of a single pose by a painter, Hartmann added, "A child looking roguishly at us, quickly changing its facial expression into a smile, would mean infinitely more (and it could be equally artistic) than if a Sargent would place the same child like a big doll under a still bigger vase in a hall vibrant with emptiness (viz. Sargent's 'Hall of the Four Children')."[227] The fame of the painting continued to grow, following the trajectory of Sargent's reputation.

When the portrait returned to public view at Boston's MFA in 1912, the event did not go unnoticed in the press. The museum's annual report noted, "The importance of the American collection has for the time [being] been increased by the loan of 'El Jaleo,' by John S. Sargent, from Mr. T. Jefferson Coolidge . . . and of the daughters of Edward D. Boit, from Mr. Edward D. Boit. This great master, of whom America is justly proud, can thus . . . be enjoyed here in the

most complete way." [228] Bob Boit saved a clipping from a local paper, most likely the *Transcript*, entitled "Sargent's Early Masterpiece." The author (probably William Howe Downes) said the portrait was "a marvelous piece of work," adding that Sargent had "done few better things." The painting had only improved, for "the thirty years that have passed have treated the picture kindly, and it is better than ever." Noting the bittersweet passage of time, the writer continued:

> *Those little girls have become women, and they must look back with sentiments of tenderness to the time when they posed in the big, square, shadowy hall, with the blue and white Japanese vases, where their tiny figures still stand so artlessly. That small maid at the left of the foreground, with her hands behind her back, for instance, her slender form outlined against the brown paneled wall – what an immortal vision of the min[?] and boldness and timidity of childhood, worthy to be preserved for all the future, belonging as it does to the same sisterhood of art and nature as the infantas of Velasquez.*

He went on to place Sargent's picture in the pantheon of some of the world's most admired paintings, noting that it surpassed its function as a portrait: "The simplicity and audacity of this composition is a never-failing source of pleasure to the observer. It is so absolutely unconventional, as a portrait group – as much so as Rembrandt's 'Night Watch' which was such a grievous cause of disappointment to the worthy burghers who posed for their likenesses in their best uniforms – and yet it is so everlastingly right and sane and satisfying as a composition." Such artistic achievements were only possible with enlightened patrons, he declared, the rare clients who both recognized the difference between a mere likeness and a great work of

art and allowed the maker "a perfectly free hand." The Boits were named in the article, clearly identified as the people who were "sagacious enough to approve of his [Sargent's] audacity." They were wise, the writer continued, and confident enough in the artist's talents to allow him to subordinate the details of the subject to create the general effect he sought. "The result of this happy combination of circumstances," the author concluded, "is one of the most beautiful and original of modern paintings, and of the most beautiful pictures of children in the world."[229]

This writer's assessment of Sargent's painting raised familiar issues – its unconventional composition, its unusual interpretation of portraiture, its relationship to the old masters – but it also introduced a new theme, one of longevity and artistic appeal. The picture had aged well; it was "better than ever." Now Sargent's portrait could be seen to have transcended the circumstances of its creation, for it had become an image that engaged and enchanted viewers who had never known the sitters. The painting was suitable for hanging in a museum; it had become a "masterpiece" for the ages.

Masterpiece or not, when Ned Boit died in Rome in April 1915, the disposition of the painting was still unsettled. Bob was in charge of Ned's estate, and the estate owed money. By October, Bob had decided that the Sargent, "a wonderful work of art," should be sold:

> I wrote Knoedler + Co. (the big picture dealers) that we as executors of my brother's estate were thinking of selling Sargent's big picture of Ned's daughters – now loaned to the Boston Art Museum. I said I thought it should bring $100,000 or more net to the estate. He thinks I put the price too high. I do not. It is one of John Sargent's great

paintings and will always be recognized as one of the great paintings
of the world . . . No doubt I've described it elsewhere in my journal.
Today it is the most distinguished picture in the Boston Art Museum.
It could well be the central object of Art in any museum.

Knoedler apparently was unable to offer a guarantee that the paint-
ing could be sold at that price, for a few weeks later Bob wrote that
he had put the painting in the hands of a local Boston dealer, Frank
Bayley of the Copley Gallery, with the condition that the estate
receive $100,000 net profit from the sale:

I think no picture by an American was ever sold at such a price, and
yet I am satisfied that sum is not too much to ask for it. The Boston
Art Museum is considering its purchase – I should much prefer its
being owned by them. It should not be allowed to leave Boston . . . I
consider it one of the finest pictures in the world. I am confident that
it will bring my price somewhere in this country. As a matter of family
pride I should like to have it kept in Boston.

Bob explained the financial pressures on Ned's estate, noting that the
sale of the painting was necessary to support the lifetime income of
Ned's four daughters:

It is a pity that the picture could not be presented by Ned's daughters
to the Museum. Unfortunately Ned owed some $125,000 to a Trust
which he established when he married Florence Little. The Trust left
$200,000. to his wife Florence and her heirs, and the rest – some
$600,000. to his four daughters – and also all his personal property.
He borrowed from this Trust, with the consent of his daughters, to

buy Cernitoio in Italy, and also to build his house next to me here in
Longwood.

But the money had never been repaid to the trust, and Bob was
concerned that the girls would suffer economically if the debt went
unpaid. He also worried that he and his coexecutor, Boston lawyer
Amory Elliot, might be financially liable:

> *It is necessary for the protection of the Executors to sell this picture*
> *to pay the Trust, as it is the most available piece of property which he*
> *left. The rest can be paid some time by the sale of the Longwood house.*
> *As this money will go directly into the Trust for his daughters, it will*
> *besides paying up the Trust, increase by so much the income of his*
> *daughters. By his will his Executors are authorized to pay up his debts.*
> *This debt to the trust was his only one. By the terms of his Trust his*
> *daughters have the right to will their shares as they see fit. Otherwise*
> *the income goes to the survivor or survivors of them during their lives,*
> *and thereafter to the Cushing family – the brothers + sisters of his first*
> *wife and their descendents. As yet none of his daughters have made a*
> *will so far as I know, tho' I have often called the matter to their atten-*
> *tion and advised them to do so.*[230]

The girls must have agreed to the sale, but perhaps they were relieved
when, for whatever reason, it failed to take place. The price their uncle
had set was very high; the Museum of Fine Arts, for example, had
paid Knoedler about $20,000 in 1912 for a full-length portrait of
John Eld by Thomas Gainsborough. Gustave Courbet's great painting
The Quarry would cost the museum $75,000 in 1918. Sargent himself
had sold his astonishing portrait of Madame Gautreau (*Madame X*)

to the Metropolitan Museum of Art in 1915 for £1000, just under $5000. In 1916, the Museum of Fine Arts would start negotiations with Sargent for the decoration of their entire rotunda, a commission that was finalized the following year for a fee of $40,000. In the midst of a war in Europe and uncertainty at home, Bob's huge price could not be met, and the painting stayed at the museum on loan.[231]

In the spring of 1916, for the first time in thirteen years, Sargent planned a trip to the United States. He brought with him the paintings he had at last completed for the second part of his Boston Public Library mural commission, a project he had begun in 1890. He was now recognized as America's greatest painter, acclaimed on both sides of the Atlantic for his portraits and equally renowned for his landscapes and watercolors. For a number of years he had devoted himself to mural painting, believing that in this arena, so highly regarded as the traditional pinnacle of artistic accomplishment, he could ensure his lasting reputation. He arrived in Boston in April, and in May the Museum of Fine Arts inaugurated a small show of twenty-three of his paintings, mostly drawn from local collections, in gallery 9 of its newly opened Evans Wing. The portrait of the Boit daughters was the anchor of the exhibition, and critical discussions about the painting began to be shaped by the identification of the sitters. The general press and the public now knew (or could openly talk about) who stood in the "Hall of the Four Children."

One of "the star pictures in this collection ... [is] the early group picture of the Boit children," wrote William Howe Downes of the 1916 show in the *Transcript*. "Without attempting a fresh recapitulation of Mr. Sargent's eminent qualities as an artist-painter," Downes continued, the exhibition could amply demonstrate his "well-earned fame as one of the leading painters of our time":

There are several relatively early examples of his art . . . the group of Boit children is not only the most familiar to Bostonians, but the most interesting as a picture. This large square composition was painted in 1882, and depicts the little daughters of the artist Boit. The exceptional qualities of design and style and decorative effect are no doubt due very largely to the fact of the subject being the children of a fellow artist, and, as a consequence, the freedom allowed the painter in the arrangement, light-and-shade, etc. It is a superb achievement for a young man of twenty-six years of age, and more than merely foreshadows his great virtuosity. He has almost invariably been at his best in painting the portraits of children, and in none of these has he been more spontaneous, more felicitous, and more sympathetic, than in this noble picture.[232]

That the father of the little girls was an artist himself helped critics like Downes explain and, if it were still necessary, excuse the remarkable unconventionality of Sargent's painting.

In the *Boston Journal*, landscape painter and critic Marian P. Waitt echoed Downes's remarks, adding to them her own acknowledgment of children's behavior (even with her faulty memory of their footwear) that she evidently felt also aided Sargent's success:

The largest of the paintings shown at this time is of the Boit children, which has hung in the Museum for some years. It was painted when Sargent was a young man and was proof enough, if proof were needed, of the master. Unconventional in composition, sympathetic in conception, it pictures the Artist Boit's children in their pinafores and, if memory serves, one of the little girls wears slippers. The children have

not been combed to death, or their hair artificially curled, and so they
do not have the strained and posed appearance that, unfortunately,
goes with many child portraits.[233]

For both writers, a more complete understanding of who the sitters were, and for whom the painting had been made, allowed them to speculate that the picture was entirely the product of Sargent's genius rather than his compromise with a concerned client, this aiding their promotion of Sargent's portrait as a masterpiece.

Despite the critical acclaim it had garnered, the painting still had not been sold when Robert Boit died in early March 1919. Before the end of the month, Amory Elliot had approached the Museum of Fine Arts about making it a gift. The arrangements were finalized by the estate on March 31, 1919, and confirmed in a letter from the girls, which Isa signed for her ailing sister Florie:

2 Avenue de Camoëns, Paris, France
To Morris Gray, Esq. President, and to the Trustees of the Boston
Museum of Fine Arts

Gentlemen:
 Our father, Mr. Edward Darley Boit of Boston, had always spoken of presenting our portraits by John Singer Sargent to the Boston Art Museum.
 In his memory we hereby present this canvas of us, his four daughters, to the Boston Museum of Fine Arts.
 We have asked his Executors and our Trustees to deliver the picture to you.

Respectfully yours,

Mary Louisa Boit

Julia Overing Boit

Jane Hubbard Boit

M.L.B. for Florence D. Boit

June 3, 1919[234]

The museum illustrated the painting on the cover of its *Bulletin*, noting that it had once given Ned Boit "great pleasure to see it in the adequate light of a museum gallery" and that he had "expressed to members of the staff his hope that the picture would never leave the Museum." Understanding the magical appeal of the portrait, the writer confirmed that "perhaps no single picture in the Museum has awakened so much interest in visitors during the past seven years as has this notable work. No comment is necessary on a picture so well known." The president of the Board of Trustees, Morris Gray, wrote in the annual report that Sargent's portrait was "one of the great masterpieces of a great painter … [it] has had a strong appeal to the public. Its assured permanent ownership is a cause of great congratulation."[235] With the museum's acquisition, the public life of Sargent's painting had begun.

This was the age of "Sargentolatry," when Sargent was acclaimed on both sides of the Atlantic as the world's most important living artist. The fact that his paintings were now beginning to enter museum collections only encouraged a desire to place Sargent firmly within the canon of the old masters, while the artist's own attempts to give up painting portraits came to be regarded as a mark of his breadth and depth as a painter. His work won praise from every quarter, garnered numerous medals and awards, and seemed to guar-

antee the success of any exhibition. When the Pennsylvania Academy of the Fine Arts awarded Sargent a gold medal of honor in 1903, the *New York Times* reported that "Mr. Sargent seems to have made a ten-strike this year, what with the honors accorded him in London, Paris, and the United States."[236] That same year, a deluxe volume of photogravures illustrating Sargent's paintings (including "The Children of E. D. Boit") was published in New York and in London. The book's superior reproductions brought his work to a wider audience, allowed painters an opportunity to study his technique, and gave critics another opportunity to glorify him.

Such constant and effusive applause was bound to cause protest from other quarters, and among the first to deride Sargent were the partisans of his longtime rival James McNeill Whistler, who died in 1903, just when Sargent's fame was at its height. Both the French Symbolist writer Robert de Montesquiou and the British artist and critic Walter Sickert wrote satiric articles that playfully mocked Sargent and his work. By 1910, Sickert had coined the phrase "Sargentolatry" as part of his complaint that contemporary critics were overlooking many other worthy painters in their instantaneous rush to heap tribute on Sargent. "It was discovered," he wrote in 1910, "that [Sargent] was the North Pole towards which the critical needles must all point." Sickert, while admitting that Sargent's work brought him pleasure, dismissed his aesthetic achievements, grumbling that it was "a pitiable thing ... that Sargent's painting is accepted, as it is, as the standard of art, the ne plus ultra and high-water mark of modernity."[237]

Starting with Sickert, Sargent's artistic reputation became precarious among supporters of modern art, particularly the British writer Roger Fry, with whom Sargent became involved in a public flap

about Post-Impressionism. Avant-garde writers in the United States frequently began to echo Fry's complaints that Sargent's work, while technically accomplished, had no soul. In 1921, modernist photographer Paul Strand claimed that Sargent "escapes the reality of American life, both physically and in spirit . . . he travels about the world to record with undoubted virtuosity the places in which he has not really lived, whose pulsating life he could neither feel nor understand. He gives us merely, but with greater ability, the average vision of the travel-book illustrator . . . a record of something that has been seen rather than life that has been felt." The very success of Sargent's retrospective exhibition in New York in 1924, which attracted record crowds and numerous favorable notices in the press, caused avant-garde critic Henry McBride to complain that Sargent's work was tiresome: "The times and manners have changed . . . the fabric he created for us still dazzles here and there, but in places it has been worn thin . . . in the long run, tricks tire and it is only the soul that counts."[238]

Despite these complaints, encomiums followed Sargent's death in 1925, and two monographs about the painter appeared. William Howe Downes, the Boston critic and biographer of Winslow Homer, had completed most of the manuscript for his book before Sargent died; he noted that Sargent himself had verified much of his data in the summer of 1924. His text consisted of an informal biographical sketch and a listing of the artist's work. Downes discussed the Boit portrait in the context of Sargent's interest in Velázquez, but he was careful to separate Sargent's work from that of the Spanish master. "Although there are some Sargents that remind one more or less of Velasquez," Downes wrote, "there is none of which it can be truthfully said that it . . . is in any sense a *pastiche* of Velasquez. True, in the portrait of the Boit children certain critics found, or thought they found,

a strong tincture of the Velasquez style, but their proclamation of this analogy betrays the superficiality of their acquaintance with the Spanish master. Analyze the 'Boit Children,' its method, style, touch, composition, color, all the elements in its making, and the more it is studied the more personal it seems – and the more beautiful." To counteract the recent criticism of Sargent's work, Downes needed to separate the painter from his sources, emphasizing his originality. To respond to accusations that Sargent was a gifted technician but not a true artist, he stressed Sargent's creativity. He discussed the painting at length in the second part of his book, reiterating the idea that Sargent's friendship with Boit had allowed him considerable freedom with the design. "Here we have not merely a portrait group but a picture; the two things are combined with remarkable success ... while the portrait element is not by any means negligible, it is ... subordinated to the beautiful pictorial impression." In an age when freshness and spontaneity were valued more than tradition, Downes claimed that "never has Sargent been more spontaneous than in this delightful canvas."[239]

Evan Charteris's more comprehensive biography of Sargent was published in 1927. Charteris was a friend of Sargent's and had access to surviving family and other friends; his biography remains an important early and personal source. In his preface, he chose to ignore the comments of modernist detractors, stating that Sargent's reputation had already "passed through and survived a critical period ... his popularity has, in fact, suffered no perceptible diminution to the present day." Claiming that it would be left to the passage of time to determine whether Sargent's fame would be maintained, Charteris set out to "explain why he painted as he did." His text was historical in tone and he sought to be neutral, carefully including, for example,

the opinion of the (unidentified) critic in 1883 who had ridiculed the Boit portrait as four corners and a void. But like Downes, Charteris emphasized Sargent's artistry; he went on to note that the "more captious [observers of the Boit portrait] acknowledged the beauty of the figures of the children . . . the unity of the general impression" and the careful modulations of dark and light crafted by a painter of great skill.[240]

The passage of time that Charteris had contemplated brought disinterest rather than fame to Sargent. His reputation in the art world plummeted rapidly. Not only was his work perceived by modernists as lacking in soul, it also came to be seen as too European and cosmopolitan in a nativist age that began to define and to cherish unique American traditions. Critics and historians ignored Sargent in favor of Winslow Homer, Albert Pinkham Ryder, and Thomas Eakins, painters who devoted themselves to depicting a more masculine world that seemed to these writers somehow bound to the American soil and the American character. Almost thirty years passed before Frederick Sweet, a curator at the Art Institute of Chicago, brought Sargent's work to public attention again. Sweet later summoned up the atmosphere in an oral history interview, "Sargent, of course, had gone way down in public regard . . . I think he was considered too facile. Perhaps it was more . . . the feeling that we want things that are really and truly and [sic] rugged. I think that having Homer and Eakins rise so high, that inevitably Sargent got crushed down and they got pushed up above him."[241]

In 1954, Sweet organized an exhibition of paintings by Sargent, Whistler, and Mary Cassatt. Admitting the current popularity of Homer, Eakins, and Ryder, he noted that his own trio had fallen "into disfavor" because "they represented foreign ways." He tried to excuse

their expatriatism, describing it as an unwanted condition. "Sargent, Whistler and Mary Cassatt shared a common fate in being Americans abroad," wrote Sweet. "They, like numerous others of their countrymen, were numbered among the expatriates, yet their residence in Europe was not due to any wish to deny their American heritage but was virtually forced upon them since adequate art schools in which to study, first-rate galleries of paintings and indeed dependable patronage were not to be found in mid-nineteenth century America." Sweet admitted that "once established abroad, they were, to be sure, quite content to stay," but he carefully emphasized the American qualities of each, hoping to restore their artistic reputations.

The Daughters of Edward Darley Boit was one of the thirty-two Sargent oils Sweet selected for his show, but he said little about the painting in his catalogue, preferring instead to quote Henry James. Sweet's exhibition included an enviable checklist of many of the best works by each of the three painters. Nevertheless, the critic for *Time* magazine declared that these artists came up short, for although he acknowledged that "Chicago's show should do much to restore them to their proper places in the ranks of American artists," he felt that "none of the three ever quite matched the greatness of their deep-rooted contemporaries Winslow Homer and Thomas Eakins." Of Sargent, the writer claimed that he "rose highest in his lifetime and fell farthest afterwards . . . he had more dash than genius, yet in his best moments the portly, full-bearded conservative stood among the immortals." The portrait of the Boit daughters failed to catch the critic's eye.

Edgar P. Richardson, an early and influential historian of American art, illustrated the Boit portrait in his review of the show for *Art News*. Although he said Sargent was a painter who was "at his best . . .

for a brief period in the 'eighties after his visit to Spain," he did not discuss the Boits at all. Using *Madame Paul Escudier* (see plate 2.6) as his example instead, Richardson claimed that Sargent was "sure, easy, convincing" and most interesting when he painted "people in their setting, as genre studies." Similarly, an extensive new biography of Sargent by Charles Merrill Mount, published in 1955, barely mentioned, and did not reproduce, the portrait of the Boit daughters.[242]

Sweet's exhibition and Mount's book (and his subsequent articles) did mark the beginning of a revival of public interest in Sargent's work. They caused Perry Rathbone, director of the Museum of Fine Arts, to declare that the painter's "star appears to be rising again." But he quickly added, "Critical opinion is not yet willing to restore Sargent to the lofty place he once occupied when he easily evoked comparison with Frans Hals and Velasquez; nor is it willing to admit that he is the artistic peer of his now more securely established American contemporaries – Homer, Eakins, Mary Cassatt, Ryder and Whistler." Now Sargent was even the last among the expatriates. His artistry was still somehow invisible, his paintings too securely identified with the aristocratic, cosmopolitan identities of their subjects. Rathbone said Sargent's work was "a social document of a vanished era ... a world in paint that constitutes a vast enrichment of our cultural history."[243] The director made his remarks on the occasion of a large Sargent exhibition that the museum held in 1956, the centenary of the painter's birth. Julia Boit, by then the last living sister, lent Sargent's portraits of her mother and her father to the exhibition, reuniting the family. Once again, *The Daughters of Edward Darley Boit* was barely discussed in the catalogue, even though the painting was one of the few pictures reproduced in color and served as the cover of the book. It was mentioned only briefly in the text

as a picture that had won Sargent acclaim at the Salon. Sargent scholar David McKibbin (head of the art department at the Boston Athenæum) wrote the catalogue's main essay, providing a sense of Sargent's overall breadth as a painter. Most of his attention was centered upon the artist's portraits of Bostonians and his time in America, a tactic intended to help anchor this cosmopolitan painter more firmly in the United States.[244]

In his review of the Boston exhibition, *Time* magazine critic Alexander Eliot dismissed Sargent as "a painter of appearances," adding that "nothing could be more foreign to the modern, analytical temper." He illustrated and described the Boit portrait, but ultimately dismissed it as "mere virtuosity . . . the fortuitous manner in which Sargent's light picks his flowerlike figures out of the gloom smacks more of the theatre than of life."[245] The distances of time and place seemed too great to bring Sargent back to popular acclaim. The hegemony of American patriotism and nationalism, rooted in the 1920s but particularly strong in the 1950s, was hard on Sargent's reputation, for his work was so obviously untethered from nationalist borders.

Soon after "Sargent's Boston" closed, the Museum of Fine Arts lent *The Daughters of Edward Darley Boit* to an exhibition at Wildenstein Gallery in New York. The show consisted of many of the paintings that had been illustrated in a book published in 1957 by *Time* entitled *Three Hundred Years of American Painting*. The book was written by the magazine's art editor (Eliot), who also selected the paintings. Published at the moment when Abstract Expressionism was dominating the international art scene, the book was meant to promote to a wide audience the United States' leadership in cultural matters and to prove that a long history of art existed in America before Jackson Pollock.

Despite the role of American abstraction on the world stage, the publication championed realism as the quintessential American style. It began with the anonymous New England limners of the seventeenth century and ended with Edward Hopper. The text included an introduction by John Walker, director of the National Gallery in Washington, DC. Walker argued that American art was a "newly prized commodity . . . second only to France," and patriotically proclaimed, "today it is challenging even that country for leadership." He confronted the issue of expatriatism – starting with Benjamin West – head-on, seeking "to repatriate our lost artists, to revalidate their citizenship." Quoting Whistler on the lack of nationality in art, Walker declared that the very "rejection of nationalism is in a sense American" since, he continued in a burst of pride, "we have produced the most complete cosmopolites in the world." His text recalls Henry James's contention in 1867 that Americans were "ahead of the European races in the fact that . . . we can deal freely with forms of civilization not only our own, can pick and choose and assimilate and in short (aesthetically etc.) claim our property wherever we find it . . . a vast intellectual fusion and synthesis of the various National tendencies of the world is the condition of more important achievements than any we have ever seen."[246]

Sargent's paintings were featured in a chapter entitled "Sophisticates Abroad" that also included Whistler and Cassatt. But Eliot still found him lacking, writing that "America's most brilliant virtuoso of the brush . . . seems curiously bound to his own era. His very name whispers of the gilt frames, plush draperies, chandeliers, fringed bellpulls, spats, bowler hats, and potted palms that furnished the Victorian and Edwardian ages. Yet he was much more interested in people than in props and backgrounds." Eliot quoted James on the

Boit portrait, noted Sargent's debt to Velázquez, and paraphrased himself, although now his comment about the theatrical and flower-like figures in the gloom was followed by the admission that "no painter alive today could carry off half so well what Sargent set out to do." Ultimately, using the familiar reproach, Eliot dismissed Sargent as a painter of appearance rather than substance. His portrait, once credited as timeless, was now consigned to the unbeloved Victorian past.

Even though Eliot disliked Sargent's works, by including them in his popular and widely promoted project, he did help to bring them back to popular attention – although in academic circles, his book was written off entirely. In a review in the *College Art Journal*, painter and writer Sidney Tillim called it one of the "chauvinistic homiletics" of the Luce publishing empire.[247] After the loan of *The Daughters of Edward Darley Boit* to Wildenstein's exhibition in 1957, the painting remained in the MFA's galleries for twenty-two years, not to be lent again – nor discussed at length – until the 1970s, when a new (and continuing) surge of interest in Sargent and his portraits began.

Modern scholarship on Sargent's portrait of the Boit children reflects a multitude of approaches to the idea of the history of art and its interpretation. Many writers propose to be neutral and factual, starting with Richard Ormond in 1970, whose monograph on Sargent was his first contribution to a lifelong study of the painter. With a detail from *The Daughters of Edward Darley Boit* on the cover of his book showing Julia and her doll, Ormond (both an art historian and the artist's great-nephew) set about to restore Sargent's history and reputation. He placed the painting of the Boit children squarely in the canon of Sargent's early triumphs, designating it an "extraordinary portrait" and the culmination of his series of Venetian interiors

and street scenes. Ormond marveled at the "engaging intimacy" of the image, in spite of its grand scale, and he explained it (echoing James) as "hardly a portrait at all in the conventional sense, but more of a conversation piece." He concluded that what might seem at first to be "a blown-up impressionistic sketch" was in fact "a major work of art."[248]

Ormond was successful in his goal. The Sargent literature grew expansively, and *The Daughters of Edward Darley Boit* appeared in almost every scholarly discussion of Sargent's paintings, identified as one of the masterworks of his career. As popular interest in celebrity and image making increased in the 1980s (perhaps best illustrated by the successful 1984 television series *Lifestyles of the Rich and Famous*), Sargent and his portraits were rescued from Alexander Eliot's stultified world of gilt frames, plush draperies, chandeliers, and fringed bellpulls – they became glamorous again. Abbeville Press brought out an oversized and lushly illustrated biography of Sargent by poet and art critic Carter Ratcliff in 1982; Louis Auchincloss, chronicler and novelist of America's upper classes, declared in *American Heritage Magazine*, "We are now far enough away from Sargent's era to have lost our indignation over its shortcomings." For the pages of *Vanity Fair*, fashion photographer David Seidner posed actresses and aristocrats with costumes and accessories to make them look as if Sargent had painted them. And contemplative "everyman" Sister Wendy, popular demystifier of art, included the portrait of the Boit daughters in her 1999 book of masterpieces.[249]

Sargent's art, particularly the Boit portrait, had clearly reentered the public imagination. "There aren't many paintings that stick in the memory," remarked columnist Christopher Andreae in the *Christian Science Monitor* in 1981. "It must be 15 years since I have seen John

Singer Sargent's painting ... [hanging] at one end of a dark corridor on the way to some offices at the museum." Finding it an "eye-catching masterwork," Andreae was struck by the way in which the space of the hallway – his own space – was seemingly continued in Sargent's portrait, as if he could enter into Sargent's painted world like Alice had passed through the looking glass. He was captivated not only by the artistry evident in the portrait – the composition, the paint handling, the connection to the old masters – but also by the perplexing relationships between the sisters. For Andreae, these were not artistic riddles but psychological ones. "The deepest mysteries suggested [in the painting] are those of identity, of the separate characters and separate dreams of the four girls. Here is no show of sisterly closeness or affection ... the isolation of each individual stands out."[250] The age of psychohistory had arrived.

With the publication in 1967 of Thomas Harris's *I'm OK – You're OK*, which became a national best seller in the 1970s, psychology took on an integral role in American popular culture. Difficult subjects such as mental health were now openly addressed, freely diagnosed, and even celebrated. More and more observers, Andreae among them, began to see Sargent's portrait as an investigation of states of mind and stages of growth.[251] Art historian David Lubin's *Act of Portrayal* of 1985 contained one of the first lengthy psychological interpretations of *The Daughters of Edward Darley Boit*. Lubin's essay on Sargent's portrait is a personal meditation on the painting, an attempt to consider it in a different way – not as a historic relic or as Rathbone's social document of a vanished era but instead as an object that lives in time, that changes as it is reconsidered, that has multiple meanings that are dependant upon each individual viewer. Lubin's approach grew from modern academic developments in liter-

ary and historical theory that proposed the impossibility of neutral analysis of the past: every glimpse back is inevitably shaped by the observer's own taste, interests, and time.

Lubin began his text with a visual analysis of Sargent's painting, attempting to see it independently, without bringing historical background to his analysis and taking only the museum's title (as given on the gallery label), "The Daughters of Edward Boit," as his guide. He sought to ask what the painting said to him in the 1980s, and naturally what he saw there reflected the concerns of his own time, a decade preoccupied with publicity, sexuality, and armchair psychology. Among his many observations, Lubin examined at length the placement of each of the girls on the canvas – that the smallest girl, for example, was lowest in the canvas revealed her to be the youngest child and the one with the least power in the group. She is also closest to the viewer, "nearly within our reach," both physically and psychologically, and therefore the most dependent upon the viewer; she is simultaneously the "star of this family and its most powerless member." Lubin also proposed that the painting could be read, through its sequence of girls at different ages, as the journey of a child through adolescence into young adulthood and even – through the surrogate of the baby doll sitting between the youngest girl's legs – into parenthood. He explained that by necessity his observations and interpretations reflected the characteristic preoccupations of his own age. His lengthy analysis of Sargent's painting – the sexual messages of each of the figures, the container-like space (enhanced, he explained, by the names of the sitters, for *boîte* means "box" in French), the absence of the mother in the painting's title, the visual forms of the vases, and indeed the shapes of the letters of the Boit name – led him to call it, among other things, a feminine procre-

ative space, a sexual "Pandora's box" complete with all of the double entendres conjured by that phrase. Lubin's observations perfectly illustrate his own theory that the writer is never free from his or her own circumstance; in his prefatory note to the reader, he revealed that he had a new daughter – and thus it seems inevitable that he looked at Sargent's painting through the sexualized and sensual eyes of a father of a baby girl.[252]

page 213

Lubin's book occasioned a fountain of ink. Some scholars were delighted by his interdisciplinary approach, up-to-date application of theory, and willingness to look at paintings in a new way, even revitalizing them by making them a subject for discussion and argument. Others were appalled by his ahistoricism, phallocentric interpretations, tangential word play, and willingness (despite his claims to the contrary) to make others see the paintings through his eyes. Among the most vociferous detractors was the conservative social critic Roger Kimball, who devoted a chapter to skewering Lubin's essay in his own book, *The Rape of the Masters: How Political Correctness Sabotages Art.* "Fortunately," wrote Kimball, "Sargent survives [Lubin's] assault unscathed."[253]

Unscathed, certainly, but not unchanged. The new academic method of approaching the study of art through disciplines outside of art history immediately caught on, despite the dogged complaints of traditional formalists against such trends. Most of these novel interpretations were laced with psychology, no doubt in response to contemporary society's new preoccupation with ego, mental development, and analysis. In 1994, Sargent expert Trevor Fairbrother wrote that the painter "intuitively explor[ed] the combined moods of the subjects and their setting"; Fairbrother found in the composition a "sense of ambiguity that derives in large part from the slightly anx-

ious separateness of the four figures . . . [who] share a space but seem to hold back their feelings for each other." Scholar and curator Theodore Stebbins, writing about the Boits in the catalogue for a 1999 Sargent retrospective in London, Washington, and Boston, looked favorably on Lubin's approach, using it to counteract the old arguments that Sargent's work was all style and no substance. Stebbins saw the painting, with its large empty spaces, as an uncanny anticipation of the spinsterhood (and therefore seclusion) of the girls later in life, and he meditated on the absence of Isa Boit's name in the painting's current title, interpreting the composition (at least in part) as a statement about the mother's absence. Even the woman who made art charmingly accessible to the masses, Sister Wendy, while carefully avoiding sex, encouraged her readers to give Sargent's portrait a psychological spin, looking at it as an image of children lost, isolated from one another, "homeless in their own home." James Elkins, writing about the emotional power of art, similarly accepted Lubin's proposal that the painting – with its "dark hollow room" and its "cold invisible spaces" – seemed to be about emptiness.[254]

By 2005, Lubin's psychoanalysis had even made its way into a standard textbook survey of American art, his musings presented to students as bald facts rather than as meditations: the girls, in "attentive, obedient poses . . . [return] the monitoring gaze of their father, who stands opposite them in our space. The very title of the painting suggests the possessive power of the father," and so on.[255] Yet no factual evidence exists to suggest that Ned Boit was ever meant, even through his absence, to be considered part of the painting. The explanation for Isa's absence from the current title (given only in 1912, when the picture was lent to the museum) seems rather simple – when Ned remarried in 1897, another woman became Mrs. Edward

Boit. Even though she too had died by the time the portrait was first exhibited with the title *The Daughters of Edward Darley Boit*, it was the second Mrs. Boit, the most recent one and the mother of surviving sons, who would have been called to mind by the name "Mrs. Edward Boit." By leaving the painting's title to bear only their father's name, Ned's daughters seem to have kept their mother very much in mind. The things even a general audience was now being asked to see in the Boit portrait – the absence of the mother, the uncomfortable supervision of the father, the adolescent rebellion and sexual awakening, the psychic dissonance – had moved very far away from Henry James's "happy play-world of a family of charming children."

Two scholars, both women, accepted Lubin's proposal that Sargent's portrait revealed psychological truths, but each of them divested his interpretation of its predatory sexuality and also attempted to reintegrate the painting into its own era. Susan Sidlauskas, a professor at the University of Pennsylvania, analyzed the image in 2000 as an interior rather than a portrait. Clearly understanding Sargent's actual setting – the foyer or entrance hall of a Parisian apartment – Sidlauskas saw the picture as an essay on the division between exterior and interior space, between public and private life, and on the accessibility (or lack of it) to the adult of the world of a child. She also read it as a meditation on growing up, each girl personifying a different phase of childhood, each one with her own sense of her female body and of the way she presented herself and occupied space. Writing four years later, Brooklyn Museum curator Barbara Gallati expressed her belief that Sargent had "open[ed] a door on the intense inner life of four girls at different ages, and the web of relationships between them as a family group and between them and

their absent parents." She credited the painter with a magical talent for understanding adolescence, a distinct phase of childhood then under considerable research and exploration (but not clearly defined until 1904, long after the picture was made), and attributed the artist's insights to his own experience with his younger sisters. Gallati also brought the composition back to the world of art, reminding her readers of Sargent's self-conscious position as a painter and his calculated desire to create modern works worthy of the old master tradition.[256]

Sidlauskas concluded her chapter on *The Daughters of Edward Darley Boit* with a description of the girls:

> *Julia is not yet able to articulate her inner life and is oblivious to the need to do so; her sense of self resides entirely in the body. Mary Louisa's figure is finely tuned to the expectations of an external authority. She is responsive but self-protective, perhaps without knowing exactly why. She waits, patiently. Florence is impossibly remote. She cedes authority within the hierarchy of childhood, yet cannot assume her role outside the home. Then there is Jane, a figure who I suspect caused Sargent some difficulty . . . she is a fragile but revelatory presence at the core of the painting . . . her painfully apparent discomfort emphasizes that the passage to understanding is fraught with danger.*[257]

Sidlauskas knew some of the then-available biographical details about the lives of the Boit girls, but how much of that knowledge she brought to her careful visual analysis is unclear. Now that additional information about the girls' lives is known, her observations seem even more precise. Or is it instead that Sargent's own eye was so perspicacious? Was it true that a doctor, when faced with Sargent's

portrait of his patient, suddenly declared that he at last understood what was wrong?[258]

Perhaps our desire to credit Sargent with great psychological insight is still simply a continued reaction against interpreting him as a painter of surfaces. It can also justify our own pleasure in those surfaces, ensuring that our attraction is perceived as a serious and intellectual pursuit rather than as (merely?) a pleasurable and sensual one. Must the painting be more important to us if it speaks of science in addition to art? The need of our own time to psychoanalyze and to personalize, to view things only in relation to ourselves, may also be significant here. Our evident hunger to create content in Sargent's painting – psychological, narrative, or otherwise – may also reflect how far removed from our own lives any artistic and aesthetic concerns have become.

What seems more important than any of these individual interpretations is that Sargent's painting has continued to speak. It has inspired poems by Eliza Griswold Allen, who saw in it the sharp growth of the girls' self-awareness; Sarah Bartlett, who wrote about loneliness; and Donald Hall, who used the painting as a pivot in his cycle of verses that revolve around hospital visits, baseball, and death. Playwright Don Nigro imagined a conversation among the girls, each of them imprisoned forever on Sargent's canvas; Bundy Boit created a musical. In a thriller for young adults, Douglas Rees imagined the girls threatened by violence. Both a mystery and a novel about the painting are now being written, and less structured responses multiply on the Internet. Artists study, copy, and quote from it: some add themselves or their surrogates (often a beloved dog or cat) to the composition; painter George Deem put the girls in a schoolroom presided over by a fierce Madame Gautreau; many

others use it as a departure for their own work. Even in an age of instant access to color images, devotees trek to Boston to see the original canvas, travelers on a pilgrimage as meaningful to them as a visit to a sacred relic.[259]

Relics are by definition old, carefully preserved, vested with power. All these things are true of Sargent's painting. But the mystical

Daniel Danger, *Lock and Key or Latchkey,*
A House You Tricked Empty, 2009

potency of this canvas is not restricted to followers of one set of beliefs or another. The portrait has survived the analysis of art historians who believe in formalism as well as those who believe in Marxist theory, social context, psychoanalysis, and deconstruction. Viewers find the painting memorable and remarkable whether or not they have a background in art, in history, or in psychology; it speaks to them directly, even if they do not have sisters or daughters. In the end, it does not really matter who these young girls were, where they were painted, or what psychological insights Sargent may or may not have revealed: what matters is that questions continue to be asked of the painting, and answers found. Sargent's daughters resonate across borders of time and nationality; they ignore the boundaries between youth and old age; they take us both outside and inside our own selves. The painting is today the same combination of pigment and canvas that it was when the artist laid down his brush in 1882, but it has transcended the time and place of its creation. As with all masterpieces, the facts behind it can add to its allure, although interpretations and reactions continually change. Their source, however, is untouched; the girls in this magical, memorable picture still haunt our imagination. The world outside the canvas has been transformed and the daughters of Edward Darley Boit have left us. But Sargent's daughters remain.

1 Robert Apthorp Boit Diaries, 1876–1918, vol. 14, p. 17, March 29, 1908, Massachusetts Historical Society, Boston, MA.

2 Richard Ormond to the author, December 19, 2008. Ned Boit's letters and diaries are preserved on microfilm at the Archives of American Art, Smithsonian Institution, Washington, DC.

3 Julia Boit to Leon Edel, February 10 and May 6, 1960, c. 1/30, Leon Edel Papers, McGill University Library, Montréal, Québec, Canada.

4 James Elkins, *Pictures and Tears: A History of People Who Have Cried in Front of Paintings* (New York: Routledge, 2004), 70–71.

5 Henry James, "John S. Sargent," *Harper's New Monthly Magazine* 75 (October 1887): 688; Skylark, "Discussion Forum for 'The Daughters of Edward Darley Boit,'" http://www.jssgallery.org, posted December 26, 2005 (the discussion forum is not always available online).

6 James, "John S. Sargent," 684. For Sargent's early career and his exhibition strategy, see Marc Simpson, *Uncanny Spectacle: The Public Career of the Young John Singer Sargent* (New Haven: Yale University Press, 1997).

7 Vernon Lee [Violet Paget] to her mother, June 16, 1881, in *Vernon Lee's Letters*, ed. Irene Cooper Willis (London: privately printed, 1937), 61; Fitzwilliam Sargent, October 10, 1870, as quoted in Richard Ormond, "Sargent's Childhood," in Barbara Dayer Gallati, *Great Expectations: John Singer Sargent Painting Children* (New York: Brooklyn Museum, 2004), 57. Sargent had another sister, Minnie, born in 1860, who died at age five, and a younger brother who died at age two. For a complete account, see Ormond, "Sargent's Childhood."

8 These events have been described in a myriad of books and articles, but see

especially H. Barbara Weinberg, *The Lure of Paris: Nineteenth-Century American Painters and Their French Teachers* (New York: Abbeville Press, 1991).

9 James Carroll Beckwith Diary, October 13, 1876, as quoted in Pepi Marchetti Franchi, "Carroll Beckwith, Passionate Conservative of American Art," in *Intimate Revelations: The Art of Carroll Beckwith (1852–1917)* (New York: Berry-Hill Galleries, 2000), 15; Edwin H. Blashfield, "John Singer Sargent – Recollections," *North American Review* 221 (June 1925): 641.

10 Emile Zola, "Salon de 1875," *Le Sémaphore de Marseille*, May 4, 1875; see also H. Barbara Weinberg, "Sargent and Carolus-Duran," in Simpson, *Uncanny Spectacle*, 5–29.

11 For *El Jaleo*, see Mary Crawford Volk, *John Singer Sargent's 'El Jaleo'* (Washington, DC: National Gallery of Art, 1992) and Richard Ormond, "Spain and *El Jaleo*," in Richard Ormond and Elaine Kilmurray, *John Singer Sargent: Figures and Landscapes, 1874–1882* (New Haven: Yale University Press, 2006), 225–79.

12 Maurice du Seigneur, *L'Art et les artistes au Salon de 1881* (Paris: Paul Ollendorf, 1881), 203–4, as excerpted in Simpson, *Uncanny Spectacle*, 133. See the discussion in Weinberg, "Sargent and Carolus-Duran," in Simpson, *Uncanny Spectacle*, 19, 27–29 (and also 113–14, 135), and in Volk, *John Singer Sargent's 'El Jaleo,'* 21. For Sargent and Velázquez, see also Marc Simpson, "Sargent, Velázquez, and the Critics," *Apollo* 148 (September 1998): 3–12; Gary Tinterow and Geneviève Lacambre, *Manet/Velázquez: The French Taste for Spanish Painting* (New Haven: Yale University Press, 2003), particularly the sections by H. Barbara Weinberg, 294–305, and Trevor Fairbrother, 529–37; and M. Elizabeth Boone, "Why Drag in Velázquez?," in Suzanne L. Stratton-Pruitt, ed., *Velázquez's Las Meninas* (Cambridge: Cambridge University Press, 2003), 101–8.

13 Edward Boit, "How I Came to Paint," unpublished manuscript, Edward Darley Boit Papers, roll 85, frame 181, Archives of American Art, Smithsonian Institution, Washington, DC.

14 Robert Boit, *Chronicles of the Boit Family and Their Descendents* (Boston: S. J. Parkhill, 1915), 119, 129; Olivia Cushing Andersen, typescript of recollections in the curatorial files of the Newport Art Museum, p. 17. The main published source for Boit is Kent Ahrens, *Oils and Watercolors by Edward D. Boit* (Scranton, PA: Everhart Museum, 1990).

15 Leon Edel, *Henry James: The Conquest of London, 1870–1881* (Philadelphia: J. B. Lip-

pincott, 1962), 108; James to Henrietta Reubell, October 10, 1894, Correspondence and Journals of Henry James Jr. (MS Am 1094 [1124]), By permission of the Houghton Library, Harvard University, Cambridge, MA.

16 For John Perkins Cushing, see Jacques M. Downs, "American Merchants and the China Opium Trade, 1800–1840," *Business History Review* 42 (Winter 1968): 418–42; Alan Emmet, *So Fine a Prospect: Historic New England Gardens* (Hanover, NH: University Press of New England, 1996), 57–60; and Florence Thompson Howe, "More About Asher Benjamin," *Journal of the Society of Architectural Historians* 13 (October 1954): 17–18.

17 Olivia Cushing Andersen Diary, "Family History as Told by Louisa to Olivia," 1910, typescript of excerpts compiled and annotated by Frederick A. Cushing, Newport, private collection, p. 30 (original diaries, Library of Congress, Washington, DC); *Other Merchants and Sea Captains of Old Boston* (Boston: State Street Trust Company, 1919), 19.

18 Boit, *Chronicles*, 122–23.

19 Edward Boit to his parents, June 8, 1866, Edward Darley Boit Papers, Archives of American Art, Smithsonian Institution, Washington, DC. The Crystal Palace, erected in 1851 for the first world's fair of science and industry, was moved from its original Hyde Park location after the exhibition; it reopened as an attraction in Sydenham Hill in 1854.

20 David B. Dearinger, "Collecting Paintings and Sculpture for the Boston Athenæum," in Stanley Ellis Cushing and David B. Dearinger, *Acquired Tastes: 200 Years of Collecting for the Boston Athenæum* (Boston: The Boston Athenæum, 2006), 33–63.

21 Edward Boit to his parents, June 19, 1866, Archives of American Art.

22 Ibid., January 1, 1867.

23 Robert Apthorp Boit Diaries, vol. 1, p. 21, October 25, 1876.

24 Ibid., vol. 1, pp. 173–74, May 27, 1888. See also James W. Trent, *Inventing the Feeble Mind: A History of Mental Retardation in the United States* (Berkeley: University of California Press, 1994).

25 Maitland Armstrong, *Day before Yesterday: Reminiscences of a Varied Life* (New York: Charles Scribner's Sons, 1920), 213; Henry James to his mother, March 24, 1873, in *Henry James Letters*, ed. Leon Edel, vol. 1, *1843–1875* (Cambridge, MA: Harvard University Press, 1974), 356. Crowninshield, best known for his work as a

223

watercolorist, muralist, stained glass designer, teacher, and director of the American Academy in Rome (1909–11), was five years younger than Boit and three years behind him at Harvard, but he had started his artistic career sooner. He had first studied art in Boston with William Rimmer and entered the Ecole des Beaux-Arts in Paris in 1867; he spent the next eleven years in Europe. See Gertrude Wilmers, "An American Artist in Italy: Frederic Crowninshield and His 'Second Patria,'" in *Spellbound by Rome* (Rome: Palombi Editori, 2005), 37–43.

26 Elihu Vedder to Ellen Sturgis Dixey, April 21, 1876, Vedder Papers, roll 517, frame 350, Archives of American Art, Smithsonian Institution, Washington, DC. For Boit's relationship with Haseltine, see Regina Soria, *Elihu Vedder: American Visionary Artist in Rome (1836–1923)* (Rutherford, NJ: Fairleigh Dickinson University Press, 1970), 108, 196. Andrea Henderson Fahnestock, who has completed extensive research on Haseltine, has no documentary evidence about Haseltine teaching Boit; I am grateful for her assistance.

27 Robert Apthorp Boit Diaries, vol. 1, p. 21, October 25, 1876. For midcentury French landscape painting, see John House et al., *Landscapes of France: Impressionism and Its Rivals* (London: South Bank Centre, 1995) and John House, *Impressionists by the Sea* (London: Royal Academy of Arts, 2007).

28 Henry James to William James, in Edel, ed., *Henry James Letters*, vol. 2, *1875–1883* (Cambridge, MA: Harvard University Press, 1975), 58.

29 Boit continued to paint and to display his art, both oils and watercolors (mostly landscapes), at the Salon through 1886. The works show an artist perpetually on the move. In 1881, he exhibited a view of Cannes; in 1882, Normandy and Spain; 1883, Paris, Cannes, and Brittany; 1884, Leatherhead (England) and Monte Carlo; 1885, Tunbridge Wells (England) and Paris; 1886, Monte Carlo. Whether Boit traveled to these various resorts in the order in which he displayed depictions of them, or whether he selected paintings for exhibition that might have been completed in earlier years, is unknown.

30 Robert Apthorp Boit Diaries, vol. 1, pp. 118–21, July 5–6, 1879.

31 Ibid., vol. 1, pp. 118, 126, July 6, 1879, and December 7, 1879.

32 Cecilia Beaux, *Background with Figures* (Boston: Houghton Mifflin, 1930), 133–34. For the lure of Paris, see Kathleen Adler et al., *Americans in Paris, 1860–1900* (London: National Gallery Publications, 2006).

33 Robert Apthorp Boit Diaries, vol. 3, pp. 37–39, 43, July 24 and 25, 1889.

NOTES

34 Ibid., vol. 3, pp. 45, 59, 61–65, July 25, July 28, and August 4, 1889.

35 Henry James to Henrietta Reubell, March 4, [1882], Correspondence and Journals of Henry James Jr. (MS Am 1094 [1047]), Houghton Library.

36 Edith Wharton, *A Backward Glance* (1934; New York: Touchstone, 1998), 171–72. The Boits also introduced the American singer Emma Eames to James; see Emma Eames, *Some Memories and Reflections* (New York: D. Appleton and Company, 1927), 77.

37 Henry James to Henrietta Reubell, October 10, 1894, Correspondence and Journals of Henry James Jr. (MS Am 1094 [1124]), Houghton Library; Robert Apthorp Boit Diaries, vol. 5, p. 227, November 5, 1894.

38 Wharton, *A Backward Glance*, 7.

39 Ibid., 26, 29; William James as quoted in F. O. Mattheissen, *The James Family* (New York: Alfred A. Knopf, 1947), 303.

40 Wharton, *A Backward Glance*, 29, 32–33, 35.

41 Julia Overing Boit to Mary Anderson Boit, June 18, 1889, Cabot Family Papers, 1786–1945 (A99, box 10, vol. 17, enc.), Schlesinger Library, Radcliffe Institute for Advanced Study, Harvard University, Cambridge, MA. I have corrected Julia's spelling.

42 I am grateful to Samy Odin, director of the Musée de la Poupée in Paris, for his help in identifying Julia's doll.

43 Henry James to Henrietta Reubell, February 9, [1881], and December 31, 1884, Correspondence and Journals of Henry James Jr. (MS Am 1094 [1043 and 1057]), Houghton Library.

44 Wharton, *A Backward Glance*, 48.

45 Jane H. Hunter, *How Young Ladies Became Girls: The Victorian Origins of American Girlhood* (New Haven: Yale University Press, 2002), 140–45.

46 Edward Darley Boit Diary, April 2, 1885, and July 10, 1886, Edward Darley Boit Papers, roll 83, Archives of American Art, Smithsonian Institution, Washington, DC.

47 For Carolus-Duran and Français, see Jean-Louis Augé et al., *Carolus-Duran* (Paris: Réunion des Musées Nationaux, 2003).

48 Julia Boit to Leon Edel, May 6, 1960, c. 1/30, Leon Edel Papers, McGill University Library.

49 Charles Merrill Mount was among the first modern writers to link Sargent's

portrait of the Boit girls to his Venetian interiors; see Mount, "Carolus-Duran and the Development of Sargent," *Art Quarterly* 26 (1963): 399. His perceptive observation has survived in many subsequent interpretations of the painting. See, for example (among others), Linda Ayres, in her essay "Sargent in Venice," in Patricia Hills et al., *John Singer Sargent* (New York: Whitney Museum of American Art, 1986), 62–63.

50 There are numerous studies of Sargent in Venice; for the most recent and comprehensive, see Richard Ormond, "Venice, 1880–1882," in Ormond and Kilmurray, *John Singer Sargent: Figures and Landscapes*, 307–85.

51 Sargent to Matilda Paget, as quoted in Richard Ormond, *John Singer Sargent* (New York: Harper and Row, 1970), 29. See also Ayres, "Sargent in Venice," 62.

52 Martin Brimmer to Sarah Wyman Whitman, October 26, 1882, Archives of American Art, Smithsonian Institution, Washington, DC, as excerpted in Ormond, "Venice, 1880–1882," 311.

53 Theodore Reff, *The Notebooks of Edgar Degas* (Oxford: Oxford University Press, 1976), 1:135 (I am grateful to Richard Ormond for bringing this to my attention); Sargent inscribed a portrait of a young girl "à mon ami Dihau" (Baltimore Museum of Art) and a sketch of a Spanish dancer "à mon ami Chabrier" (private collection); Degas as quoted in Louisine Havemeyer, *Sixteen to Sixty: Memoirs of a Collector* (New York: Ursus Press, 1993), 243.

54 Cassatt's remarks are reported (without attribution) in Frederick A. Sweet, *Miss Mary Cassatt: Impressionist from Pennsylvania* (Norman, OK: University of Oklahoma Press, 1966), 151, 196. Cassatt no doubt agreed with her friend Camille Pissarro, who praised Sargent as a kind person and as an individual who might help his son in London, but who disliked his art, explaining, "As for his [Sargent's] painting, that, of course, we can't approve of; he is not an enthusiast but rather an adroit performer." Camille Pissarro to Lucien Pissarro, October 6, 1891, in Camille Pissarro, *Letters to His Son Lucien*, ed. John Rewald (Boston: MFA Publications ["artWorks"], 2002), 183.

55 See, for example, *A Venetian Woman* (1882, Cincinnati Art Museum) and the discussion in Ormond and Kilmurray, *John Singer Sargent: Figures and Landscapes*, 332, 336–37. For the relationship of Sargent's portrait of Louise Escudier to Stevens, see Mount, "Carolus-Duran and the Development of Sargent," 406–7.

NOTES

56 I would like to thank Rhona MacBeth, Eijk and Rose-Marie van Otterloo Conservator of Paintings, Museum of Fine Arts, Boston, for examining *The Daughters of Edward Darley Boit* with me in great detail, and for our many conversations on the topic.

57 For Sargent's portraits of children, see especially Gallati, *Great Expectations.*

58 Marie-Louise Pailleron, *Le paradis perdu: Souvenirs d'enfance* (Paris: Albin Michel, 1947), 158–59, 161–63. Portions of Pailleron's text are summarized in Richard Ormond and Elaine Kilmurray, *John Singer Sargent: The Early Portraits* (New Haven: Yale University Press, 1998), 51–53.

59 Pailleron, *Le paradis perdu*, 160–63.

60 For the jewelry and the identification of this portrait with Sargent's recent North African works, see Carol Troyen's entry on the painting in *John Singer Sargent*, ed. Elaine Kilmurray and Richard Ormond (London: Tate Gallery, 1998), 91–92.

61 Millais had shown a less sentimental image of children (his own) at the Paris exposition of 1878; see the discussion of Millais's *Sisters* (1868, private collection) in relation to Sargent's work in Jason Rosenfeld and Allison Smith, *Millais* (London: Tate Publishing, 2007), 146.

62 A. Genevay, "Salon de 1881 (Troisième article)," *Le Musée Artistique et Littéraire* 5 (1881): 324; Olivier Merson, "Salon de 1881: IV," *Le Monde Illustrée* 25 (May 28, 1881): 362; both as excerpted in Simpson, *Uncanny Spectacle*, 133.

63 Pailleron, *Le paradis perdu*, 162.

64 Seigneur, "L'Art et les artistes au Salon de 1881," in Simpson, *Uncanny Spectacle*, 133.

65 Henry James, "The Picture Season in London," 1877, in *The Painter's Eye*, ed. John L. Sweeney (Madison: University of Wisconsin Press, 1989), 148.

66 Fitzwilliam Sargent to Thomas Sargent, October 29, 1882, Sargent Papers, roll D317, frame 451, Archives of American Art, Smithsonian Institution, Washington, DC.

67 Five years later, when Sargent painted the girls' mother Isa Cushing Boit, a single figure on a much smaller canvas (see plate 2.13), he took about seven weeks, beginning on November 12 and finishing on December 31. The sittings are recorded in Edward Boit's diary.

68 John Boit to Robert Boit, quoted in Robert Apthorp Boit Diaries, vol. 2, p. 275, November 29, 1891.

69 Stop, "Le Salon de 1883," *Le Journal Amusant* (May 26, 1883): 5; James, "John S. Sargent," 688.

70 Lucy H. Hooper, "The American Colony in Paris," *Appleton's Journal* 11, no. 274 (June 20, 1874): 780. For the history of the avenue de Friedland, see Andrée Jacob and Jean-Marc Léri, *Vie et histoire du VIII^e arrondissement* (Paris: Editions Hervas, 1987). In Boit's watercolor, the Arc de Triomphe is crowned by a lively quadriga created in 1882 by the French sculptor Alexandre Falguière; his design of a chariot pulled by rearing horses was never cast into bronze, and the plaster and wood maquette that Boit recorded atop the arch eventually disintegrated.

71 Anne Dugast and Isabelle Parizet, *Dictionnaire par noms d'architectes des constructions elevées à Paris aux XIX^e et XX^e siècles, première série: Période 1876–1899* (Paris: Editions Service des Travaux Historiques, 1990), 4:112. The street was renumbered: the Boits' home, number 32, later became number 34; the building has since been razed.

72 Henry James, *The American* (1876–77; New York: Signet Classics, 2005), 24.

73 Hooper, "The American Colony in Paris," 780, and Lucy H. Hooper, "Private American Art-Galleries in Paris, No. 1, The Collection of James H. Stebbins, Esq.," *Art Journal*, n.s. 1 (1875): 153–55.

74 John C. Van Dyke, *The Autobiography of John C. Van Dyke*, ed. Peter Wild (Salt Lake City: University of Utah Press, 1993), 63. For Stebbins's collection, see "Pictures of James H. Stebbins," *New York Times*, January 29, 1889. For Stewart, see W. R. Johnston, "W. H. Stewart, The American Patron of Mariano Fortuny," *Gazette des Beaux-Arts* 77 (March 1971): 183–88, and Lucy Hooper, "American Art-Galleries in Paris, No. 2, The Collection of William Stewart, Esq.," *Art Journal*, n.s. 1 (1875): 283–85.

75 Hooper, "The American Colony in Paris," 780. For Cassatt, see Andrew J. Walker, "Mary Cassatt's Modern Education: The United States, France, Italy, and Spain, 1860–73," in Judith A. Barter et al., *Mary Cassatt: Modern Woman* (New York: Abrams, 1998), 32–33.

76 Sir William Rothenstein, *Men and Memories: Recollections of William Rothenstein*, (London: Faber and Faber, 1931–32), 81; Edel, *Henry James: The Conquest of London*, 232; Rothenstein, *Men and Memories*, 81; Henry James as quoted in Ormond and Kilmurray, *Sargent: The Early Portraits*, 154; Julia Boit to Leon Edel, May 6, 1960,

228

c. 1/30, Leon Edel Papers, McGill University Library; Leon Edel, *Henry James: The Middle Years, 1882–1895* (Philadelphia: J. B. Lippincott, 1962), 107.

77 Henry James to Grace Norton, February 23, 1884, in Edel, ed., *Henry James Letters*, vol. 3, *1883–1895* (Cambridge, MA: Harvard University Press, 1980), 32; Henry James to Henrietta Reubell, December 5, [1882], Correspondence and Journals of Henry James Jr. (MS Am 1094 [1051]), Houghton Library; Henry James to Isabella Stewart Gardner, November 12, 1882, in Edel, *Henry James Letters*, 2:386. Edel (in numerous works) and others (see, for example, Jennifer Eimers, "'No Greater Work of Art': Henry James and Pictorial Art," *Henry James Review* 23 [Winter 2002]: 74) have most often offered a spring 1884 date for James's introduction to Sargent. I am grateful to Richard Ormond, Elaine Kilmurray, and James scholars Rosella Zorzi and Paul Fisher for their generous help in verifying my own chronology. The year of James's December 5 letter to Reubell can be confirmed by internal evidence (the queen's presence at the opening of the Royal Courts). Henry's brother William met Sargent in Venice in October 1882 and mentions him as "Sargent the painter, a charming young fellow" in a letter of October 16, 1882, to Henry James, Correspondence and Journals of William James (MS Am 1092.9 [2602]), By permission of the Houghton Library, Harvard University, Cambridge, MA. James could also have met Sargent in Paris at an earlier date.

229

78 Robert Apthorp Boit Diaries, vol. 3, p. 49, July 26, 1889.

79 Ville de Paris, Cadastre de 1876; DP4, carton 471, Archives de Paris, Paris.

80 Edward Strahan [Earl Shinn], *Art Treasures of America* (Philadelphia: G. Barrie, 1879), 1:95–96.

81 Lewis Carroll, *Alice's Adventures in Wonderland* (1869; New York: The Macmillan Company, 1898), 10–11. The concept of linking the Boit portrait to Carroll's novel was first suggested by David Lubin in his book *Act of Portrayal: Eakins, Sargent, James* (New Haven: Yale University Press, 1985), 95.

82 See William Hosley, *The Japan Idea* (Hartford: Wadsworth Atheneum, 1990); Anna Jackson, "Imagining Japan: The Victorian Perception and Acquisition of Japanese Culture," *Journal of Design History* 5 (1992): 245–56; Deborah Levitt-Pasturel, "Critical response to Japan at the Paris 1878 Exposition Universelle," *Gazette des Beaux-Arts* 119 (February 1992): 68–80; Imai Yuko, "Changes in French Taste for

Japanese Ceramics," *Japan Review* 16 (2004): 101–27; and Elizabeth H. Chang, "'Eyes of the Proper Almond-Shape': Blue-and-White China in the British Imaginary, 1823–1883," *Nineteenth Century Studies* 19 (2005): 17–34.

83 See Gisela Jahn, *Meiji Ceramics* (Stuttgart: Arnoldsche Art Publishers, 2004), 50–53ff.

84 Jacob von Falke, curator and later director of the Österreichisches Museum für Kunst und Industrie (now the Österreichisches Museum für Angewandte Kunst), writing in 1873, as quoted in Jahn, *Meiji Ceramics*, 52; Captain F. [Francis] Brinkley, *Japan: Its History Arts and Literature* (Boston: J. B. Millet, 1902), 8:93. I am grateful to Joe Earle for pointing me toward Brinkley's assessment.

85 Jahn, *Meiji Ceramics*, 88, 190. The marks also indicate that these are workshop pieces rather than productions of the master's hand. See the present author's correspondence with Louise Cort, ceramics specialist at the Freer Gallery of Art, August 8, 1986, and with Gisela Jahn, December 15, 2007, in the Department of Art of the Americas curatorial files, Museum of Fine Arts, Boston.

86 *Official Catalogue of the Japanese Section and Descriptive Notes on the Industry and Agriculture of Japan* (Philadelphia: Japanese Commission, 1876), 15. Hirabayashi's name does not appear in the Philadelphia catalogue.

87 Henry James to Mrs. Mahlon Sands, n.d. [1893–94], in Edel, *Henry James Letters*, 3:456.

88 Ormond and Kilmurray, *John Singer Sargent: Figures and Landscapes*, 197–99.

89 Ibid., 198, 214–15.

90 Gallati, *Great Expectations*, 83.

91 Fitzwilliam Sargent to Thomas Sargent, May 18, 1883, Sargent Papers, roll D 317, frame 456.

92 Seigneur, "L'Art et les artistes au Salon de 1881," in Simpson, *Uncanny Spectacle*, 133.

93 Philippe Burty, *Salon de 1883* (Paris: Librairie d'Art, 1883), 103–4; S. Hollis Clayson, "Paris by Night," paper for the symposium "Americans in Paris, 1860–1900," National Gallery of Art, London, April 7–8, 2006.

94 See the discussions in *Impressionist Interiors*, ed. Janet McLean (Dublin: National Gallery of Ireland, 2008).

95 Stéphane Mallarmé, "The Impressionists and Edouard Manet" (1876) and Edmonde

Duranty, "The New Painting: Concerning the Group of Artists Exhibiting at the Durand-Ruel Galleries" (1876), both as reprinted in *The New Painting: Impressionism 1874–1886*, ed. Charles S. Moffett (San Francisco: Fine Arts Museums of San Francisco, 1986), 30, 44–45.

96 Linda Nochlin, "Impressionist Portraits and the Construction of Modern Identity," in Colin B. Bailey, *Renoir's Portraits: Impressions of an Age* (New Haven: Yale University Press, 1997), 53–75. See also Fred Licht's discussion of nineteenth-century group portraits, which links the Degas and the Sargent, in his article "Goya's Portraits of the Royal Family," *Art Bulletin* 49 (June 1967), 128.

97 Vernon Lee to her mother, June 25, 1885, as quoted in Simpson, *Uncanny Spectacle*, 130. Trevor Fairbrother discusses the Boit portrait in the context of Degas's work (and other modern interiors) in his entry for the painting in Tinterow and Lacambre, *Manet/Velázquez*, 534.

98 For an examination of other such "threshold" spaces in modern French painting, see Hollis Clayson, "Threshold Space: Parisian Modernism Betwixt and Between (1869–1891)," in *Impressionist Interiors*, ed. Janet McLean (Dublin: National Gallery of Ireland, 2008), 15–29.

99 James, "John S. Sargent," 688; Susan Hale, "Susan Hale's Chit-Chat," *Boston Sunday Globe*, February 5, 1888, 13.

100 James, "John S. Sargent," 688.

101 Robert Jensen, *Marketing Modernism in Fin-de-Siècle Europe* (Princeton, NJ: Princeton University Press, 1994), 20–35, 42–48, 60–61, 63–67. See also Elaine Kilmurray and Richard Ormond, "Sargent in Paris," *Apollo* 148, no. 438 n.s. (September 1998): 19.

102 Paul Mantz, "Exposition de la Société Internationale," *Le Temps*, December 31, 1882, 3.

103 For an extensive discussion of Sargent's exhibition strategy, see Simpson, *Uncanny Spectacle*.

104 G. Dargenty [Arthur-Auguste Mallebay du Cluseau d'Echérac], "Exposition Internationale des Peintres et des Sculpteurs," *L'Art*, January 14, 1883, 40; Mantz, "Exposition de la Société Internationale," 3.

105 Mantz, "Exposition de la Société Internationale," 3.

106 Arthur Bagnères, "Première Exposition de la Société Internationale de Peintres

et Sculpteurs," *Gazette des Beaux-Arts* 27 (February 1883): 189–90; Dargenty, "Exposition Internationale des Peintres et des Sculpteurs," 40; Olivier Merson, *Le Monde Illustrée* 52 (January 27, 1883): 58.

107 In a letter to Fanny Watts, Sargent writes, "I should have sent you a photo of my Boit children, for they are not [illustrated] in the catalogue, but the photograph is too large to go by the post" (June 5, 1883, private collection). Sargent must have had the painting photographed before the Salon opened. For Americans and the Salon, see "The Paris Salon," *Art Amateur* 9 (June 1883): 2. See also Lois Marie Fink, *American Art at the Nineteenth-Century Paris Salons* (Washington, DC: Smithsonian Institution, 1990).

108 Simpson, *Uncanny Spectacle*, 117–18.

109 Henry Bacon, *A Parisian Year* (Boston: Roberts Brothers, 1882), 67.

110 Sargent to Margaret White, March 15, 1883, roll 647, frames 856–58, Archives of American Art, Smithsonian Institution, Washington, DC. March 15 was the final submission date for the 1883 Salon.

111 "Chronique des ateliers: Envois au Salon de 1883," *Courrier de l'Art* 3 (March 29, 1883): 147.

112 Sargent to unidentified correspondent [Jean Guiffrey?], January 6, [1911/12?], private collection, courtesy Catherine Barnes. Sargent's letter is written in French and is clearly addressed to someone in the United States, most probably in Boston. Based on the content of the letter, it is possible the unidentified recipient was Jean Guiffrey, the French-born curator of paintings at the Museum of Fine Arts, Boston.

113 G. Dargenty [Arthur-Auguste Mallebay du Cluseau d'Echérac], "Promenade au Salon de 1883," *L'Art* 33 (May 6, 1883), 118; Edmond About, *Quinze journées au Salon de peinture et de sculpture* (Paris: Librairie des Bibliophiles, 1883), 74; Charles Bigot, "Le Salon de 1883," *Gazette des Beaux-Arts* 28 (July 1883): 9, 22–23; Roger Ballu and Guillaume Dubufe, "Dialogue sur la Salon de 1883," *La Nouvelle Revue* 22 (May–June 1883): 714–15.

114 Henry Houssaye, "Le Salon de 1883," *Revue des Deux Mondes* 57 (June 1, 1883): 616.

115 Philippe Burty, *Salon de 1883* (Paris: Librarie d'Art, 1883), 103–4; Fitzwilliam Sargent to Thomas Sargent, May 18, 1883, Sargent Papers, roll D 317, frame 456; Evan Charteris, *John Sargent* (New York: Charles Scribner's Sons, 1927), 57. "Four corners and a void" is the critical statement most often repeated about the paint-

232

ing. Reportedly from a French journal, its origin remains untraced. Charteris is the first to repeat it.

116 "Le Salon de Paris: Quatrième article," *L'Art Moderne* 3 (June 10, 1883): 184. Sargent sent his portrait of Dr. Samuel Pozzi to the first exhibition of Les XX.

117 Joséphin Péladan, "L'Esthétique au Salon de 1883 – IX. La femme," *L'Artiste* 53, part 1 (May 1883): 385; Hippolyte Duvillers [*sic*], "Le Salon de Paris," *La Jeune Belgique* 2 (June 5, 1883): 285–86.

118 "The Paris Salon," *Saturday Review*, May 26, 1883, 664; *London Morning Post*, as quoted in "Art and Artists," *Daily Evening Transcript*, May 28, 1883, 3; "The Salon, Paris," *Athenæum*, no. 2904 (June 23, 1883): 803; *London Illustrated News* 82 (June 9, 1883): 587; "Gallery and Studio Notes," *Boston Daily Advertiser*, July 4, 1883, 4.

119 "The Salon," *American Register*, June 2, 1883, 12; "The Paris Salon," *Art Amateur* 9 (June 1883): 2. I am grateful to Marc Simpson for sharing the *American Register* review with me.

120 M. B. W. [Margaret Bertha Wright], "American Art at the Paris Salon," *Art Amateur* 9 (July 1883): 24.

121 Montezuma [Montague Marks], "My Note Book," *Art Amateur* 9 (August 1883): 46; Montezuma [Montague Marks], "My Note Book," *Art Amateur* 9 (September 1883): 69.

122 For a description of the mission and audience of these two magazines, see "Notices of New Books," *New Englander* 4 (1881): 413–14.

123 William C. Brownell, "American Pictures at the Salon," *Magazine of Art* 6 (1883): 492–501; Wharton, *A Backward Glance*, 145.

124 Brownell, "American Pictures at the Salon," 494, 497–98.

125 See Simpson, "Sargent, Velázquez, and the Critics," 3–12.

126 Brownell, "American Pictures at the Salon," 498.

127 Sargent to Vernon Lee, quoted in Charteris, *John Sargent*, 59.

128 Edward Darley Boit Diary, October 17, 1885. The name may actually read Pozzi, rather than Poggi; it is difficult to decipher. It recurs in Boit's diary, always in connection with a variety of tasks, manual and otherwise. It seems unlikely that Boit is referring to Dr. Samuel Pozzi, the Parisian gynecologist and a patron of Sargent's.

129 J. C. [Jules Claretie], "La vie à Paris: Paris artiste," *Le Temps*, May 2, 1884, 3, as quoted in Kilmurray and Ormond, "Sargent in Paris," 14.

130 Vernon Lee to her mother, June 23, 1883, as quoted in Kilmurray and Ormond, "Sargent in Paris," 22.

131 Ralph Curtis to Daniel and Ariana Curtis, [May 2, 1884], quoted in Charteris, *John Sargent*, 62. Sargent had been in Siena in the fall of 1883. The controversy surrounding his portrait of Mme. Gautreau has been well documented; among the many sources, see especially Deborah Davis, *Strapless* (New York: Tarcher/Penguin, 2003).

132 Unlike Isa Boit, whom James described as unsympathetic to the English and their society by nature, "Sargent . . . gets on with them beautifully." Henry James to Henrietta Reubell, November 1, 1884, Correspondence and Journals of Henry James Jr. (MS Am 1094 [1056]), Houghton Library.

133 Sargent to Edwin Russell, September 10, 1885, Archives, Tate Britain, London, as quoted in Ormond and Kilmurray, *Sargent: The Early Portraits*, 130.

134 Sargent to Edwin Russell, September 10, 1885, Archives, Tate Britain, London, as quoted in Simpson, *Uncanny Spectacle*, 127.

135 Greta [pseud.], "Boston Correspondence," *Art Amateur* 42 (January 1881): 27–28. Boit's coexhibitors in 1881 were Frederic Crowninshield and Ernest Longfellow.

136 Robert Apthorp Boit Diaries, vol. 1, p. 149, January 2, 1887.

137 Henry James to Henrietta Reubell, November 12, 1886, Correspondence and Journals of Henry James Jr. (MS Am 1094 [1068]), Houghton Library.

138 Robert Apthorp Boit Diaries, vol. 1, p. 149, January 2, 1887. Tom Cushing was Isa Boit's brother. The house at 170 Beacon Street was built in 1861 for Jack Gardner, who had sold it to the Cushings.

139 Marian Lawrence Peabody, *To Be Young Was Very Heaven* (Boston: Houghton Mifflin, 1967), 57–61.

140 Wharton, *A Backward Glance*, 78; Peabody, *To Be Young Was Very Heaven*, 61.

141 Peabody, *To Be Young Was Very Heaven*, 34; Edward Darley Boit Diary, April 16, 1888. "Isa (2)" refers to "little Isa," Ned's daughter, not his wife.

142 Edward Darley Boit Diary, December 13, 1886.

143 Boit also exhibited at the American Water Color Society in New York in 1886 and at the Boston Water Color Society in 1887; he held one-man shows at Boston's Noyes and Cobb Gallery in 1887 and at Doll and Richards in 1888.

144 *Boston Evening Transcript*, April 9, 1887, 11.

145 Edward Darley Boit Diary, November 8, 1887. Emily Sargent suffered from a spinal deformity caused by an accident in her youth.

146 James, "John S. Sargent," 684, 688–89.

147 Lilian Whiting, "Life at the Hub," *Chicago Inter Ocean*, November 26, 1887, 12. Even after almost fifteen years, James's words continued to circulate, although their source sometimes went unacknowledged. Sadakichi Hartmann's 1901 *History of American Art*, for example, one of the very first survey texts in the field, includes a lengthy description of the Boit portrait that borrows extensively from James's text. See Sadakichi Hartmann, *A History of American Art* (New York: Tudor Publishing Company, 1901), 2:215–16.

148 *Boston Evening Transcript*, November 22, 1887, 6. For a full discussion of Sargent's visit to Boston and his exhibition, see Trevor J. Fairbrother, *John Singer Sargent and America* (New York: Garland Publishing, 1986), 87–141.

149 In a letter written from Newport, Sargent mentions that he will travel to Boston to paint Isa Boit's portrait (Sargent to Frank Millet, October 20, 1887, Archives of American Art, Smithsonian Institution, Washington, DC).

150 Robert Apthorp Boit Diaries, vol. 1, pp. 148–49, December 17, 1887.

151 Boit, *Chronicles*, 123; Olivia Cushing Andersen Diary, "Family History as Told by Louisa to Olivia," 1910, typescript of excerpts compiled and annotated by Frederick A. Cushing, Newport, private collection, p. 30 (original diaries, Library of Congress, Washington, DC).

152 See David McKibbin, *Sargent's Boston* (Boston: Museum of Fine Arts, 1956), 33. McKibbin describes the setting as 170 Beacon Street (rather than 65 Mount Vernon) and identifies the dress as one Mrs. Boit wore for "one of the coming-out parties which she had marshalled for her second daughter," although it was her first daughter, Florie, who had had her debut. McKibbin's text is likely based on slight misremembrances, possibly those of Julia Boit.

153 Robert Apthorp Boit Diaries, vol. 1, p. 166, December 17, 1887.

154 Henry James to Henrietta Reubell, April 1, 1888, in Edel, *Henry James Letters*, 3:231; "The Royal Academy—Fourth Notice," *Athenæum*, no. 3165 (June 23, 1888): 802.

155 *Boston Evening Transcript*, January 30, 1888, 4; "Susan Hale's Chit-Chat," *Boston Daily Globe*, February 5, 1888, 13; Greta [pseud.], "Art in Boston," *Art Amateur* 18 (April 1888): 110.

235

156 Henry James to Henrietta Reubell, February 22, [1888], Correspondence and Journals of Henry James Jr. (MS Am 1094 [1074]), Houghton Library.

157 Robert Apthorp Boit Diaries, vol. 1, 170–71, March 11, 1888; Henry James to Henrietta Reubell, September 10 [1893], Correspondence and Journals of Henry James Jr. (MS Am 1094 [1119]), Houghton Library.

158 Edward Darley Boit Diary, October 10, 1886; Robert Apthorp Boit Diaries, vol. 1, p. 170, March 11, 1888.

159 Edward Darley Boit Diary, April 7, 1888; Robert Apthorp Boit Diaries, vol. 1, pp. 173–74, May 27, 1888.

160 Edward Darley Boit Diary, October 10, 1886, and April 21, 25, 26 and May 6, 1888; Robert Apthorp Boit Diaries, vol. 1, pp. 170, 173, March 11, 1888, and May 27, 1888.

161 Robert Apthorp Boit Diaries, vol. 1, p. 173, May 27, 1888.

162 Sargent to Henrietta Reubell, letter enclosed in correspondence from Henry James to Reubell, June 4, 1888, Correspondence and Journals of Henry James Jr. (MS Am 1094 [1079]), Houghton Library.

163 Edward Darley Boit Diary, June 27, 1888. See also Edward Shorter, *A History of Psychiatry* (New York: John Wiley and Sons, 1997), 125, and Stanley W. Jackson, *Care of the Psyche: A History of Psychological Healing* (New Haven: Yale University Press, 1999), 256.

164 Un monsieur de l'orchestre, "Paris l'été: Auteuil," *Le Figaro*, August 10, 1880, 3, as quoted in Juliet Wilson-Bareau and David Degener, *Manet and the Sea* (Chicago: Art Institute of Chicago, 2003), 99.

165 For parting "calmly," see Edward Darley Boit Diary, July 4, 1888. For the required "taming" of hysterics, see Shorter's synopsis of Béni-Barde's cure in his *History of Psychiatry*, 125.

166 Robert Apthorp Boit Diaries, vol. 1, pp. 188–89, October 20, 1888, and November 18, 1888, and vol. 2, p. 28, November 28, 1889; Edward Darley Boit Diary, February 19–23, 1889. Physiologist Dr. Charles Richet taught at the Sorbonne in the 1880s; he was later awarded the Nobel Prize for medicine.

167 Henry James, *The American*, 318.

168 Robert Apthorp Boit Diaries, vol. 2, pp. 123, 143, February 8 and April 26, 1891. In 1891, for the second consecutive year, two rival Salon exhibitions existed in Paris – the newly formed, more liberal display organized by the Société Nationale

des Beaux-Arts and held on the Champs-de-Mars, and the more conservative, traditional one of the Société des Artistes Français (sometimes called the Salon ancien), on the Champs-Elysées. The SNBA was more hospitable to foreign artists (36 percent of the paintings displayed there were by non-French artists, as opposed to 15 percent at the Société des Artistes Français), but American painters continued to show their work at both venues. See Fink, *American Art at the Nineteenth-Century Paris Salons*, 122–25. The details of Boit's 1891 Salon submission – and to which group's jury he had submitted it – are unknown.

169 Robert Apthorp Boit Diaries, vol. 2, pp. 141–43, 181, April 26 and July 12, 1891.

170 Ibid., vol. 2, pp. 185–87, 257, 275, July 19, September 27, and November 29, 1891.

171 Ibid., vol. 5, pp. 205–27, June 17, September 15, October 10, and November 5, 1894.

172 Henry James to Henrietta Reubell, October 10 and November 5, 1894, Correspondence and Journals of Henry James Jr. (MS Am 1094 [1124, 1125]), Houghton Library; Edward Darley Boit Diary, December 1894, as quoted in Ahrens, *Oils and Watercolors by Edward D. Boit*, 15.

173 Robert Apthorp Boit Diaries, vol. 7, p. 3, June 14, 1896; Mary Anderson Boit Cabot Travel Diary, 1896–98, pp. 15, 20, 39, Cabot Family Papers (A99, box 10, vol. 18), Schlesinger Library, Radcliffe Institute for Advanced Study, Harvard University, Cambridge, MA. See also Hunter, *How Young Ladies Became Girls*, 125–26.

174 Robert Apthorp Boit Diaries, vol. 7, p. 168, December 16, 1898, and vol. 9, p. 115, April 29, 1902. Edward Darley Boit Diary, April 1902, as quoted in Ahrens, *Oils and Watercolors by Edward D. Boit*, 15.

175 Henry James to Edith and Edward Wharton, August 11–12, 1907, *The Letters of Henry James*, ed. Percy Lubbock (New York: Scribner, 1920), 2:81; Honor Moore, *The White Blackbird* (New York: Viking, 1996), 52; Robert Apthorp Boit Diaries, vol. 10, pp. 129–31, December 13, 1903 (transcribing Lilian Boit's letter of September 3, 1903).

176 Philip L. Hale, *Boston Herald*, March 26, 1909, 6; A. Dubuisson, "E. D. Boit," in "Echoes from the Sacred Grove (Memoirs of a Painter from Rome to Barbizon)," 1924, typescript, Department of Art of the Americas curatorial files, Museum of Fine Arts, Boston.

177 Robert Apthorp Boit Diaries, vol. 12, pp. 51, 149, March 4 and May 27, 1906.

178 In his diaries for March 1908, Robert Boit mentions Ned's trip abroad at the end of the month and notes that Sargent will paint Ned's portrait in London. April 1908 would be the only moment that year when these two peripatetic artists were in the same place at the same time. Robert Apthorp Boit Diaries, vol. 14, pp. 9, 15, 17, 23–5, 61, March 1 and 29 and April 19, 1908.

179 Sargent to unidentified correspondent [Jean Guiffrey?], January 6 [1911/12?], private collection, courtesy Catherine Barnes. Boit's role as the instigator of the exhibitions is also evident in Sargent's February letter to Isabella Stewart Gardner: "You must also go and see my watercolours that Boit has asked me to send over and that the Brooklyn Museum has gobbled up" (Sargent to Isabella Stewart Gardner, February 24 [1909], Archives, Isabella Stewart Gardner Museum, Boston).

180 As reported in Barbara Dayer Gallati, "Controlling the Medium: The Marketing of John Singer Sargent's Watercolors," in Linda S. Ferber and Barbara Dayer Gallati, *Masters of Color and Light: Homer, Sargent, and the American Watercolor Movement* (Washington, DC: Smithsonian Institution, 1998), 140.

181 For the promotion of Sargent's watercolors, see Gallati, "Controlling the Medium," 117–41. Sargent's letter explaining Boit's initiative in the matter of the exhibitions had not yet come to light when Gallati's essay was published.

182 Robert Apthorp Boit Diaries, vol. 14, p. 105, February 21, 1909.

183 Royal Cortissoz, unidentified clipping, Knoedler Archive, quoted in Gallati, "Controlling the Medium," 128; *American Art News* 7 (February 20, 1909): 6; "Gallery Notes: Water Colors by Sargent and Boit," *New York Times*, February 16, 1909, 8.

184 "Sargent Paintings Sold," *American Art News* (February 27, 1909): 1.

185 Philip L. Hale, *Boston Herald*, March 26, 1909, 6; Robert Apthorp Boit Diaries, vol. 14, pp. 137, 199, 217, February 27, 1909, February 6, 1910, and April 17, 1910.

186 Sargent to unidentified correspondent [Jean Guiffrey?], January 6 [1911/12?], private collection, courtesy Catherine Barnes.

187 "Art Museum Buys Fine Sargents," *Boston Transcript*, January 6, 1912, as quoted in Carol Troyen, "Watercolors: Sargent's Pictorial Diary," *Magazine Antiques* 150 (November 1996): 670; "Water Color Gems by Sargent Shown," *New York Times*, March 17, 1912, 14; *Museum of Fine Arts, Boston, Thirty-seventh Annual Report for the Year 1912* (Boston: Metcalf Press, 1913), 112; Robert Apthorp Boit Diaries, vol. 15, p. 199, April 7, 1912.

188 Robert Apthorp Boit Diaries, vol. 15, p. 197, March 3, 1912.

189 Olivia Cushing Andersen Diary, 1914, typescript of excerpts compiled and annotated by Frederick A. Cushing, Newport, private collection, pp. 90–91 (original diaries, Library of Congress, Washington, DC).

190 Henry James to Howard Sturgis, April 27, 1915, in Edel, ed., *Henry James Letters*, vol. 4, *1895–1916* (Cambridge, MA: Harvard University Press, 1984), 753–54.

191 Olivia Cushing Andersen, typescript of recollections in the curatorial files of the Newport Art Museum, p. 17. See Helen Howe, *The Gentle Americans* (New York: Harper and Row, 1965), 185–233. Howe devotes an entire chapter to Boston's "mighty maidens."

192 Arthur Hunnewell Diary, September 15, 1892, as quoted in Henry Leach, "Glances upon American Golf History, Part II," *American Golfer* 19 (March 1918): 504. See also Robert Sidorsky, *Golf: 365 Days, A History* (New York: Abrams, 2008); Robert Sidorsky, "Florence Boit and the Annals of Golf and Art," typescript, courtesy of the author; Bunker Hill [pseud.], "Eastern Department: New England Notes," *American Golfer* 1 (January 1909): 117–24. I am grateful to Robert Sidorsky for his interest, enthusiasm, and generosity with his own research.

193 Dubbed the "godmother" of Boston golf, Florence Boit was at last identified as the young lady from Pau in 1948, although Leach's 1918 article had mentioned "a young lady from Pau" along with one "F. B." (p. 504). See Herbert Warren Wind, *The Story of American Golf* (1948, rev. 1956; New York: Alfred A. Knopf, 1975), 19.

194 Robert Apthorp Boit Diaries, vol. 15, p. 109, June 27, 1911; Karen Evans Úlehla, *The Society of Arts and Crafts, Boston: Exhibition Record 1897–1927* (Boston: Boston Public Library, 1981), 32.

195 Henry James, *Daisy Miller* (1878; New York: Dover Publications, 1995), 59.

196 Robert Apthorp Boit Diaries, vol. 15, p. 109, June 27, 1911.

197 Ibid., vol. 10, p. 253, April 17, 1904.

198 Patten taught at Simmons from 1906 until 1920. I am grateful to Donna Webber, Simmons College archivist, for her assistance.

199 Robert Apthorp Boit Diaries, vol. 15, pp. 109–13, June 27, 1911.

200 Ibid., vol. 4, p. 20, November 10, 1890, and vol. 2, p. 185, July 19, 1891.

201 Ibid., vol. 3, pp. 101–3, August 6, 1889.

202 Ibid., vol. 4, p. 30, November 16, 1890.

203 Ibid., vol. 4, p. 20, November 10, 1890.

204 Ibid., vol. 5, p. 29, April 17, 1892.

205 Ibid., vol. 5, pp. 71, 227, February 19, 1893, and November 5, 1894.

206 Olivia Cushing Andersen, typescript of recollections in the curatorial files of the Newport Art Museum, p. 17; "In the City-By-the-Sea," *New York Times*, July 12, 1896, 21.

207 "Many Have Guests at Music Festival," *New York Times*, August 5, 1938, 20.

208 Robert Apthorp Boit Diaries, vol. 5, p. 47, October 30, 1892.

209 See the discussion of these issues in Erin L. Pipkin, "'Striking in its promise': The Artistic Career of Sarah Gooll Putnam," *Massachusetts Historical Review* 3 (2001): 89–115.

210 Robert Apthorp Boit Diaries, vol. 11, p. 59, January 4, 1905.

211 F. W. Coburn, "The Art World of Boston and New York: Miss Boit – Mr. Dawson," *Boston Herald*, March 24, 1929, 15 (social section).

212 Mrs. John Sherwood, *Manners and Social Usages* (New York: Harper and Brothers, 1887), 228–29. See Nancy M. Theriot, *Mothers and Daughters in Nineteenth-Century America* (Lexington: University Press of Kentucky, 1996).

213 Ella Lyman to Richard Cabot, 1892, Ella Lyman Cabot Papers, Schlesinger Library, Radcliffe Institute, Harvard University, Cambridge, MA, as quoted in Zsuzsa Berend, "'The Best or None!' Spinsterhood in Nineteenth-Century New England," *Journal of Social History* 33 (Summer 2000): 935–57.

214 William James to Henry P. Bowditch, August 12, 1869, *The Letters of William James*, ed. Henry James (Boston: Atlantic Monthly Press, 1920), 155; Howe, *The Gentle Americans*, 189. I am grateful to Barbara Hostetter for providing me with information about the maiden sisters of the Pratt and Sears families.

215 *Clark's Boston Blue Book, 1910* (Boston: Sampson and Murdock, 1909).

216 Robert Apthorp Boit Diaries, vol. 15, p. 167, November 17, 1911.

217 Ibid., vol. 16, p. 325, December 31, 1917.

218 Ibid., vol. 16, pp. 325–27, December 31, 1917.

219 For the history of hysteria, see Mark S. Micale, "On the 'Disappearance' of Hysteria: A Study in the Clinical Deconstruction of a Diagnosis," *Isis* 84 (September 1993): 496–526. See also Mark S. Micale, *Approaching Hysteria* (Princeton: Princeton University Press, 1994), and Barbara Ehrenreich and Deirdre English, *The Sexual Politics of Sickness* (New York: The Feminist Press at CUNY, 1977).

220 Andersen, typescript of recollections in the curatorial files of the Newport Art Museum, p. 19.

221 *Newport Daily News*, February 10, 1969, 2.

222 Olivia Cushing Andersen Diary, 1914, typescript of excerpts compiled and annotated by Frederick A. Cushing, Newport, private collection, p. 91 (original diaries, Library of Congress, Washington, DC).

223 Edward Darley Boit Diary, March 18, 1889.

224 Theodore Child, "American Artists at the Paris Exhibition," *Harper's New Monthly Magazine* 79 (September 1889): 504. Harold Frederic, an Anglo-American novelist and journalist, recognized most of the paintings Sargent had submitted for display. Writing for the *New York Times*, he noted that despite the absence of newer work, the portraits Sargent showed in Paris were a representative group, ranging "from flat and discolored ugliness, purposely insisted upon and exaggerated, up to one of the most luminous and magnificent creations of soulful intelligence and beauty that painter's brush has ever compassed." Where exactly the painting of the Boit children fit along the spectrum Frederic described is left unclear, but his general remarks about Sargent, like those of most of the other critics, were favorable. Harold Frederic, "American Art in Paris," *New York Times*, June 16, 1889, 11.

225 Robert Apthorp Boit Diaries, vol. 3, p. 33, July 23, 1889.

226 Marion Hepworth Dixon, "Mr. John S. Sargent as a Portrait-Painter," *Magazine of Art* 23 (1899): 115. Charles Merrill Mount also proposed that the painting was crafted in the boulevard Berthier studio, and that Sargent used the alcove in that studio to create the shadowy interior of the Boits. See Mount, "Carolus-Duran and the Development of Sargent," 398.

227 Sadakichi Hartmann, "Portrait Painting and Portrait Photography," *Camera Notes* 3 (July 1899): 21. I am grateful to John Davis for bringing this text to my attention. Hartmann was not an admirer of Sargent's portraits; like many modernist critics, he preferred Whistler's work.

228 Jean Guiffrey, in *Museum of Fine Arts, Boston, Thirty-seventh Annual Report for the Year 1912* (Boston: Metcalf Press, 1913), 113–14.

229 "Sargent's Early Masterpiece," unidentified newspaper clipping, Robert Apthorp Boit Diaries, vol. 15, clipping pasted in before p. 167.

230 Robert Apthorp Boit Diaries, vol. 16, pp. 199, 205, October 17, 1915, and November 7, 1915.

231 For the Gainsborough and Courbet prices, see the curatorial files of the Department of Art of Europe at the Museum of Fine Arts, Boston. For *Madame X*, see Ormond and Kilmurray, *John Singer Sargent: The Early Portraits*, 115. For Sargent's mural commission, see Carol Troyen, *Sargent's Murals in the Museum of Fine Arts, Boston* (Boston: Museum of Fine Arts, 1999), 13.

232 W. H. D. [William Howe Downes], "The Fine Arts: Mr. Sargent's Paintings," *Boston Evening Transcript*, May 10, 1916, 12.

233 Marian P. Waitt, "Loan Exhibit of Sargent Art at Museum," *Boston Journal*, May 11, 1916, artists' clippings file, Boston Public Library, Boston, MA.

234 A photocopy of the letter is in the Department of Art of the Americas curatorial files, Museum of Fine Arts, Boston. The sisters apparently did not realize that the painting was already at the MFA (there is no record that it was removed between 1912 and 1919).

235 "Paintings by John S. Sargent," *Museum of Fine Arts Bulletin* 17 (October 1919): 50; *Museum of Fine Arts, Boston, Forty-fourth Annual Report for the Year 1919* (Boston, T. O. Metcalf, 1920), 17.

236 "Art Notes," *New York Times*, February 22, 1903, 8.

237 Walter Sickert, "Sargentolatry," *The New Age* (May 19, 1910), in *Walter Sickert: The Complete Writings on Art*, ed. Anna Gruetzner Robins (Oxford: Oxford University Press, 2000), 232–33.

238 Paul Strand, "American Water Colors at the Brooklyn Museum, *The Arts* 2 (December 1921): 149; Henry McBride, "A Sargent Retrospective," *The Dial* (April 1924), in Henry McBride, *The Flow of Art: Essays and Criticisms* (New Haven: Yale University Press, 1997), 196. See the extensive discussion of these issues in H. Barbara Weinberg, "John Singer Sargent: Reputation Redivivus," *Arts Magazine* 54 (March 1980): 104–9, and Fairbrother, *John Singer Sargent and America*, 279–350.

239 William Howe Downes, *John S. Sargent: His Life and Work* (Boston: Little, Brown, 1925), 11, 130–31.

240 Charteris, *John Sargent*, vii, 57–58.

241 Interview with Frederick Sweet conducted by Robert Brown in Sargentville, Maine, February 13 and 14, 1971, Archives of American Art, Smithsonian Institution, Washington, DC (http://www.aaa.si.edu/collections/oralhistories/transcripts/sweet71.htm).

242 Frederick A. Sweet, *Sargent, Whistler, and Mary Cassatt* (Chicago: Art Institute of

Chicago, 1954), 7; "Expatriates in Chicago," *Time* 63 (January 11, 1954); Edgar P. Richardson, "Sophisticates and Innocents Abroad," *Art News* 53 (April 1954): 22–23; Charles Merrill Mount, *John Singer Sargent: A Biography* (New York: Norton, 1955).

243 Perry T. Rathbone, "Foreword," in McKibbin, *Sargent's Boston.*

244 This canny observation is Barbara Weinberg's; see Weinberg, "John Singer Sargent: Reputation Redivivus," 105.

245 Alexander Eliot, "Painter of Appearances," *Time* 67 (January 9, 1956).

246 John Walker, introduction to Alexander Eliot, *Three Hundred Years of American Painting* (New York: Time, Inc., 1957), viii; Edel, *Henry James Letters,* 1:77.

247 Eliot, *Three Hundred Years of American Painting,* 117–19, 124; Sidney Tillim, Review, *College Art Journal* 18 (Autumn 1958): 99.

248 Ormond, *John Singer Sargent,* 27, 30.

249 Louis Auchincloss, "A Sargent Portrait," *American Heritage Magazine* 37 (October/ November 1986): 42; Betsey Osborne (with photographs by David Seidner), "Sargent's Bloodlines," *Vanity Fair* 459 (November 1998): 291ff.; Sister Wendy Beckett, *Sister Wendy's 1000 Masterpieces* (London: Dorling Kindersley, 1999), 415.

250 Christopher Andreae, "Together, Apart," *Christian Science Monitor,* May 20, 1981, 20.

251 See the discussion of psychology and popular culture in the 1960s, '70s, and '80s in Eva S. Moskowitz, *In Therapy We Trust: America's Obsession with Self-Fulfillment* (Baltimore: Johns Hopkins University Press, 2001), 218–46.

252 Lubin, *Act of Portrayal: Eakins, Sargent, James,* ix–xiii, 83–122. Lubin's arguments are circular and complex, and I have greatly simplified them here (with apologies to the author).

253 Roger Kimball, *The Rape of the Masters: How Political Correctness Sabotages Art* (San Francisco: Encounter Books, 2004), 96. Kimball also published the gist of his complaint about Lubin's work in the *Wall Street Journal* ("The Relegation of Art History to Pop Psychology," *Wall Street Journal,* July 29, 2004, D8). For examples of academic reviews of Lubin's book, one from each camp, see Joseph W. Reed, "American Portraits," *Reviews in American History* 15 (March 1987): 44–47, and Jane Turano in *American Art Journal* 17 (Autumn 1985): 89–94.

254 Trevor Fairbrother, *John Singer Sargent* (New York: Abrams, 1994), 44–45; Theodore E. Stebbins, Jr., catalogue entry for *The Daughters of Edward Darley Boit* in

Kilmurray and Ormond, eds., *John Singer Sargent*, 98; Beckett, *Sister Wendy's 1000 Masterpieces*, 415; Elkins, *Pictures and Tears*, 71, 94.

255 David Bjelajac, *American Art: A Cultural History* (Upper Saddle River, NJ: Prentice Hall, 2005), 276–78.

256 Susan Sidlauskas, *Body, Place, and Self in Nineteenth-Century Painting* (Cambridge: Cambridge University Press, 2000), 61–90; Gallati, *Great Expectations*, 57–58, 60, 79–84. I have freely summarized (and no doubt oversimplified) these authors' discussions of the Boit portrait. The first major publication on adolescence as a distinctive phase of childhood was G. Stanley Hall's 1904 two-volume study *Adolescence: Its Psychology and Its Relations to Physiology, Anthropology, Sociology, Sex, Crime, Religion, and Education*; see Lawrence Steinberg and Richard M. Lerner, "The Scientific Study of Adolescence: A Brief History," *Journal of Early Adolescence* 24 (February 2004): 45–48, and Gretchen R. Sinnett, "Envisioning Female Adolescence: Rites of Passage in Late Nineteenth- and Early Twentieth-Century American Painting" (PhD diss., University of Pennsylvania, 2006).

257 Sidlauskas, *Body, Place, and Self*, 90.

258 The story about a physician's new understanding of his patient's illness based upon Sargent's likeness has long been part of the Sargent myth; among other sources, it is related by Blashfield, "John Singer Sargent – Recollections," 649. "Perhaps . . . [it] is a true story, and perhaps it isn't," wrote Blashfield.

259 E. Griswold Allen, "John Singer Sargent," *Antioch Review* 56 (Winter 1998): 46; Sarah Bartlett, "Four Corners and a Void," *Free Verse* 10 (Spring 2006), http://english.chass.ncsu.edu/freeverse; Donald Hall, "Extra Innings," *White Apples and the Taste of Stone: Selected Poems 1946–2006* (Boston: Houghton Mifflin, 2006), 273–91; Don Nigro, "The Daughters of Edward D. Boit," *Green Man and Other Plays* (New York: Samuel French, 1991); Bundy H. Boit, "My Oriental Vases: A One-Act Musical," typescript, Department of Art of the Americas curatorial files, Museum of Fine Arts, Boston; Douglas Rees, *The Janus Gate: An Encounter with John Singer Sargent* (New York: Watson-Guptill Publications, 2006); Kent Barker has written a mystery; Mary F. Burns is at work on a novel. Newport painter Richard Grosvenor reinterpreted Sargent's composition by including, next to Julia, his sleeping black Labrador retriever. Other artists to use the picture in their own work include Carol Wald and Daniel Danger.

Illustrations not otherwise credited were photographed by the Imaging Studios, Museum of Fine Arts, Boston.

2.5 Edgar Degas, *Dancers in the Classroom*, about 1880. Oil on canvas, 39.4 × 88.4 cm (15½ × 34¾ in.). Sterling and Francine Clark Art Institute, Williamstown, Massachusetts, 1955.562. Photo: © Sterling and Francine Clark Art Institute, Williamstown, Massachusetts.

2.6 John Singer Sargent, *Madame Paul Escudier (Louise Lefevre)*, 1882. Oil on canvas, 129.5 × 91.4 cm (51 × 36 in.). Art Institute of Chicago, Bequest of Brooks McCormick, 2007.391. Photography © The Art Institute of Chicago. Photograph by Robert Hashimoto.

2.7 John Singer Sargent, *Portrait of Edouard and Marie-Louise Pailleron*, 1881. Oil on canvas, 152.4 × 175.3 cm (60 × 69 in.). Des Moines Art Center, Iowa, Purchased with funds from the Edith M. Usry Bequest, in memory of her parents, Mr. and Mrs. George Franklin Usry, the Dr. and Mrs. Peder T. Madsen Fund, and the Anna K. Meredith Endowment Fund, 1976.61. Photo: Des Moines Art Center.

2.8 Edgar Degas, *Family Portrait*, 1858–69. Oil on canvas, 200 × 250 cm (78¾ × 98½ in.). Musée d'Orsay, Paris. Photo: Gérard Blot / Réunion des Musées Nationaux / Art Resource, NY.

2.9 William Stott of Oldham, *The Kissing Ring* (*Ronde d'enfants*), 1882. Oil on canvas, 114.2 × 150 cm (44⅞ × 59 in.). Durban Art Gallery, South Africa. Photo: Durban Art Gallery.

2.10 Thérèse Schwartze, *Three Girls from an Amsterdam Orphanage*, 1885. Oil on canvas, 81.5 × 96 cm (32 × 37⅞ in.). Rijksmuseum, Amsterdam. Photo: © Rijksmuseum Amsterdam.

2.11 John Singer Sargent, *The Misses Vickers*, 1884. Oil on canvas, 137.8 × 182.9 cm (54¼ × 72 in.). Sheffield City Art Galleries, Bequest of Douglas Vickers, 1938 2601. Photo: Sheffield Galleries and Museums Trust, UK / © Museums Sheffield / The Bridgeman Art Library.

2.12 John Singer Sargent, *Carnation, Lily, Lily, Rose*, 1885–86. Oil on canvas, 174 × 153.7 cm (68½ × 60½ in.). Tate Britain, London, Presented by the Trustees of the Chantrey Bequest, 1887. Photo: © Tate, London 2009.

2.13 John Singer Sargent, *Mrs. Edward Darley Boit* (*Mary Louisa Cushing*), 1887. Oil on canvas, 152.4 × 108.6 cm (60 × 42¾ in.). Museum of Fine Arts, Boston, Gift of Miss Julia Overing Boit, 63.2688.

2.14 Edward Darley Boit, *Poppi in the Casentino, Tuscany*, 1910. Watercolor on paper,

41.3 × 62 cm (16¼ × 24⁷⁄₁₆ in.). Museum of Fine Arts, Boston, Picture Fund, 12.152.

2.15 John Singer Sargent, *Edward Darley Boit*, 1908. Oil on canvas, 88.9 × 60.8 cm (35 × 24 in.). Private collection. Photograph courtesy of Adelson Galleries, Inc., New York.

2.16 Julia Overing Boit, *Sketchbook – Girls Playing Golf*, about 1890–95. Watercolor on paper, 22.9 × 27.9 cm (9 × 11 in.). Newport Art Museum and Art Association, Rhode Island, Gift of Mrs. Edward Boit, Jr. Photo: Newport Art Museum and Art Association.

ILLUSTRATIONS IN THE TEXT

Page 10. John Singer Sargent, about 1883. Photograph. Private collection.

Page 16. John Singer Sargent, *Portrait of Frances Sherborne Ridley Watts*, 1877. Oil on canvas, 105.9 × 81.3 cm (41¹¹⁄₁₆ × 32 in.). Philadelphia Museum of Art, Gift of Mr. and Mrs. Wharton Sinkler, 1962-193-1. Photo: Philadelphia Museum of Art.

Page 17. John Singer Sargent, *Portrait of Carolus-Duran*, 1879. Oil on canvas, 116.8 × 95.9 cm (46 × 37¾ in.). Sterling and Francine Clark Art Institute, Williamstown, Massachusetts, 1955.14. Photo: © Sterling and Francine Clark Art Institute, Williamstown, Massachusetts.

Page 22. François-Louis Français, *Portrait of Edward Boit*, about 1880. Oil on canvas, 45.7 × 33 cm (18 × 13 in.). Newport Art Museum and Art Association, Rhode Island, Gift of Mrs. Edward Boit, Jr. Photo: Newport Art Museum and Art Association.

Page 23. Asher Benjamin, arch., *Bellmont* (*Cushing Payson House*), 1837, Belmont, Massachusetts, demolished 1927. Special Collections, Fine Arts Library, Harvard College, Cambridge, Massachusetts. Photo: Courtesy of Special Collections, Fine Arts Library, Harvard College.

Page 24. Henry Dexter, *Mary Louisa Cushing* [*Boit*] *as a Child* (*The First Lesson*), 1848. Marble, 57.2 × 38.1 × 53.3 cm (22½ × 15 × 21 in.). Newport Art Museum and Art Association, Rhode Island, Gift of Mrs. Reginald Norman, to whom it was given by Julia Overing Boit. Photo: Newport Art Museum and Art Association.

Page 33. Edward Darley Boit, *Study of Old Oak*, 1880. Watercolor on paper, 25.4 × 35.6 cm (10 × 14 in.). Farnsworth Art Museum, Rockland, Maine, Museum purchase, 1944.127. Photo: Farnsworth Art Museum.

Page 39. Robert Apthorp Boit with his two daughters, Mary and Georgia, 1896. Gelatin silver print, 14.9 × 10.2 cm (5⅞ × 4 in.). Cabot Family Papers. The Schlesinger Library, Radcliffe Institute, Harvard University, Cambridge, Massachusetts, A99-149-4. Print by Max Fischer. Photo: The Schlesinger Library, Radcliffe Institute, Harvard University.

Page 47. Julia Overing Boit, illustrated program for a concert given by "Les Mademoiselles Boit," 1891. Original manuscript from the Robert Apthorp Boit Diaries, 1876–1918, vol. 2, pasted in at p. 143. Massachusetts Historical Society, Boston. Photo: Courtesy of the Massachusetts Historical Society.

Page 55. John Singer Sargent, *Robert de Cévrieux*, 1879. Oil on canvas, 84.5 × 48 cm (33¼ × 18⅞ in.). Museum of Fine Arts, Boston, Charles Henry Hayden Fund, 22.372.

Page 61. Chromolithograph after Sir John Everett Millais, *Cherry Ripe*, 1880. Elida Gibbs Collection, London. Photo: Elida Gibbs Collection, London, UK / The Bridgeman Art Library.

Page 62. Pierre-Auguste Renoir, *Madame Georges Charpentier (née Marguérite-Louise Lemonnier, 1848–1904) and Her Children, Georgette-Berthe (1872–1945) and Paul-Émile-Charles (1875–1895)*, 1878. Oil on canvas, 153.7 × 190.2 cm (60½ × 74⅞ in.). The Metropolitan Museum of Art, New York, Catherine Lorillard Wolfe Collection, Wolfe Fund, 1907, 07.122. Image © The Metropolitan Museum of Art.

Page 67. *Avenue Hoche, Avenue de Friedland, and Montmartre Heights*, about 1900. Stereograph. Published in New York by Underwood and Underwood. Library of Congress, Washington, DC. Photo: Library of Congress, Washington, DC.

Page 68. Edward Darley Boit, *Arc de Triomphe, Paris*, 1883. Watercolor on paper, 56 × 77 cm (22 1/16 × 30 5/16 in.). Museum of Fine Arts, Boston, Gift of the Artist, 88.330.

Page 71. John Singer Sargent, *Henrietta Reubell*, about 1884–85. Watercolor and gouache on paper, 34.9 × 25.1 cm (13¾ × 9⅞ in.). Private collection. Photograph courtesy of Adelson Galleries, Inc., New York.

Page 73. John Singer Sargent, *Henry James*, 1913. Oil on canvas, 85.1 × 67. 3 cm (33½ × 26½ in.). National Portrait Gallery, London. Photo © National Portrait Gallery, London.

Page 75. Robert Boit, sketch of the Boit apartment on the avenue de Messine, 1889.

Original manuscript from the Robert Apthorp Boit Diaries, 1876–1918, vol. 3, p. 49. Massachusetts Historical Society, Boston. Photo: Courtesy of the Massachusetts Historical Society.

Page 76. James Jacques Joseph Tissot, *Hide and Seek*, about 1877. Oil on wood, 73.4 × 53.9 cm (28⅞ × 21¼ in.). National Gallery of Art, Washington, DC, Chester Dale Fund, 1978.47.1. Image courtesy of the Board of Trustees, National Gallery of Art, Washington, DC.

Page 80. Japanese gallery at the world's fair, Vienna, 1873. MAK - Austrian Museum of Applied Arts / Contemporary Arts, Vienna. Photograph © MAK.

Page 86. John Singer Sargent, *Las Meninas, after Velázquez*, 1879. Oil on canvas, 113.7 × 100.3 cm (44¾ × 39½ in.). Private collection. Photograph courtesy of Adelson Galleries, Inc., New York.

Page 88. Diego Rodríguez de Silva y Velázquez, *Las Hilanderas* (*The Spinners*), 1657. Oil on canvas, 220 × 289 cm (86½ × 113¾ in.). Museo Nacional del Prado, Madrid. Photo: Erich Lessing / Art Resource, NY.

Page 106. Stop, "Sargent: Grand déballage de porcelains, objets chinois, jouets d'enfants, etc., etc.," 1883. Illustration from *Le Journal Amusant*, May 26, 1883, p. 5. Courtesy of the Fine Arts Library, Harvard College Library.

Page 119. John Singer Sargent in his studio on the boulevard Berthier (with his painting *Madame X*), about 1884. Photograph, 21 × 28 cm (8¼ × 11 in.). Courtesy of the Artists in their Paris studios collection, 1880–1890, Archives of American Art, Smithsonian Institution, Washington, DC.

Page 121. John Singer Sargent, *Garden Study of the Vickers Children*, about 1884. Oil on canvas, 137.6 × 91.1 cm (54³⁄₁₆ × 35⅞ in.). Collection of the Flint Institute of Arts, Michigan, Gift of the Viola E. Bray Charitable Trust Via Mr. and Mrs. William L. Richards, 1972.47. Photo: Flint Institute of Arts. Photographed by R. H. Hensleigh.

Page 124. Childe Hassam, *Boston Common at Twilight*, 1885–86. Oil on canvas, 106.7 × 152.4 cm (42 × 60 in.). Museum of Fine Arts, Boston, Gift of Miss Maud E. Appleton, 31.952.

Page 145. Photograph of Edward Darley Boit's painting *Cliffs at Cotuit* [lost]. Original photograph from the Robert Apthorp Boit Diaries, 1876–1918, vol. 2, pasted in at end of volume. Massachusetts Historical Society, Boston. Photo: Courtesy of the Massachusetts Historical Society.

Page 149. "Uncle Ned," 1896. Cyanotype, 5.4 × 4.1 cm (2⅛ × 1⅝ in.). Cabot Family Papers. The Schlesinger Library, Radcliffe Institute, Harvard University, Cambridge, Massachusetts, A99-18v-2. Photo: The Schlesinger Library, Radcliffe Institute, Harvard University.

Page 150. Edward Darley Boit with his sons Julian and Edward, about 1910. Photograph. Collection of Susan F. Flier.

Page 151. View of the house at Cernitoio, Sturgis family album, about 1912. Photograph. Private collection.

Page 152. View of the gardens at Cernitoio, Sturgis family album, about 1912. Photograph. Private collection.

Page 153. Henry James at Vallombrosa (James at Cernitoio with Ned Boit and Howard Sturgis), 1907. Photograph. Houghton Library, Harvard University, Cambridge, Massachusetts, pf MS Am 1094, box 2. By permission of the Houghton Library, Harvard University.

Page 154. Edward Darley Boit, *East River, New York*, 1911. Watercolor on paper, 56 × 68.6 cm (22 1/16 × 27 in.). Museum of Fine Arts, Boston, Picture Fund, 12.132.

Page 165. Julia and Florence Boit at Cernitoio, Sturgis family album, about 1910. Photograph. Private collection.

Page 175 (left). Isa Boit playing the harp at Cernitoio, Sturgis family album, about 1910. Photograph. Private collection.

Page 175 (right). Julia Boit wearing a kimono, Paris, about 1896. Photograph. Collection of Susan F. Flier.

Page 179 (top). Julia Overing Boit, Jane Hubbard Boit's page from JOB's Birthday Book, January 17, 1887–88. Watercolor and ink on paper, 21.6 × 16.5 cm (8½ × 6½ in.). Newport Art Museum and Art Association, Rhode Island, Gift of Mrs. Edward Boit, Jr. Photo: Newport Art Museum and Art Association.

Page 179 (bottom). Julia Overing Boit, Julia Overing Boit's page from JOB's Birthday Book, November 15, 1887–88. Watercolor and ink on paper, 21.6 × 16.5 cm (8½ × 6½ in.). Newport Art Museum and Art Association, Rhode Island, Gift of Mrs. Edward Boit, Jr. Photo: Newport Art Museum and Art Association.

Page 180. Julia Overing Boit, *Sketchbook – Girls in Pinafores*, about 1900. Watercolor on paper, 14 × 21.6 cm (5½ × 8½ in.). Newport Art Museum and Art Association, Rhode Island, Gift of Mrs. Edward Boit, Jr. Photo: Newport Art Museum and Art Association.

Page 181. Julia Overing Boit, *When This King Was Just a Boy*, 1958. Illustration from Margaret Blake, *Old Friends Retold in Verse* (privately printed, 1958). Private collection.

Page 182. Julia Overing Boit, *A Corner of the Studio (Isa Reading)*, 1922. Watercolor on paper, 36.8 × 49.5 cm (14½ × 19½ in.). Newport Art Museum and Art Association, Rhode Island, Gift of Mrs. Edward Boit, Jr. Photo: Newport Art Museum and Art Association.

Page 191. John Singer Sargent's *Daughters of Edward Darley Boit* displayed in the United States fine arts section of the Paris world's fair, 1889. Photograph from [Rush Christopher Hawkins], *Report of the United States Fine Arts Commissioner to the Universal Exposition of 1889 at Paris* (Washington, 1892).

Page 218. Daniel Danger, *Lock and Key or Latchkey, A House You Tricked Empty*, 2009. Four-color silkscreen, 76.2 × 50.8 cm (30 × 20 in.). Edition of 200. Photo: daniel danger niejadlik, 2009.

251

Page numbers in italics refer to illustrations.

Boit, Edward Darley (*cont.*)
Edward Darley Boit (Sargent), *pl. 2.15*, 155–56, 160, 206; friendship with Sargent, 4, 49–50, 84, 103, 123, 132–33, 145, 155–57, 159, 203; illness and death of, 6, 161–62; Henry James on life of, 31, 34, 148, *155*, 161–62; law career, 22, 25, 29, 30; marriage of, to Florence Little (1896), 148–50, 174, 195, 214–15; marriage of, to Isa Cushing, 25; images of, *21, 149, 150, 153*; residences. *See* Boston, Newport, Paris; siblings, 20, 22

Boit, Edward Darley ("Ned"), and art
Arc de Triomphe, Paris, *68*, 69; art career, decision to follow, 29–30; art critics, on, 125, 129, 154–55, 157–58, 160; art education, 26–29, 32–33; artistic influences on, 31, 32–34, 154; art patronage, 27–28, 33, 49, 64; and art medium, choice of, 144; *Cliffs at Cotuit*, 143–44, *145*; *East River, New York*, 154, *154*; exhibitions, joint (with Sargent), 4, 155–60; exhibitions (Boston), 32, 125, 128–29, 155, 158, 160; exhibitions (Paris Salon). *See* Salon (Paris); *Place de l'Opéra, Paris*, *pl. 2.3*, 40; *Plage de Villers* (*Calvados*), *La*, 33–34; *Poppi in the Casentino, Tuscany*, *pl. 2.14*, 152; studios, 31, 32, 34, 35, 126, 143; *Study of Old Oak*, *33*; travels, as inspiration for, 34, 37, 154. *See also specific locations*; watercolors acquired by Museum of Fine Arts, Boston, 159–60

Boit, Edward ("Neddie") (son of Ned and Isa Cushing), 26, 29, 30, 137–38, 139, 173

Boit, Edward (son of Ned and Florence Little), 150, *150*, 187

Boit, Elizabeth ("Lizzie") (sister of Ned), 22, 168

Boit, Florence Dumaresq ("Florie") (daughter of Ned and Isa Cushing)
adult life, 48, 140, 160, 161, 164–71, *165*, 185; behavior problems, 135–36, 186; birth of, 30; "coming out" (social debut) of, 125–26, 127–28, 133, 136; and craftwork skills, 166–67, 178; in *Daughters* painting, *pl. 1.2*, 4, 48, 95, 96, 216; death of, 186–87; effect of World War I on, 186, 199; and golf, *pl. 2.16*, 147, 164–66; relationship with Jeanie Patten, 168–71, 185; and violin, 36, 44, 46–47, 172, 178–79; *See also* Boit daughters

Boit, Florence Little (wife of Ned)
children of, 150, *150*. *See also specific names*; death of, 150; marriage of, to Ned (1896), 148–50, 214–15; trust fund for, 195

Boit, Georgia (daughter of Bob), *39*, 149

Boit, Georgia Mercer (wife of Bob), 36

Boit, Jane Hubbard ("Jeanie," also called "Hub") (daughter of Ned and Isa Cushing)
adult life, 48, 171–73, 178, 185, 187; birth of, 30; in *Daughters* painting, *pl. 1.2*, 4, 95, 96, 216; death of, 187; nervous problems, 136–37, 138–39, 140, 141–42, 146, 148, 171–73; and piano, 46–47, 142, 171, 179; *See also* Boit daughters

Boit, Jane (mother of Ned), 5, 20, 35, 139, 143; children, 20, 22. *See also specific names*

Boit, Jane (sister of Ned). *See* Hunnewell, Jane Boit ("Jeanie")

Boit, John (brother of Ned), 20, 66, 144–46, 171, 173

Boit, John (grandfather of Ned), 20

Boit, John (son of Ned and Isa Cushing), 28, 29, 161

Boit, Julian (son of Ned and Florence Little), 150, *150*, 187

Boit, Julia Overing (daughter of Ned and Isa Cushing)
adult life, 6, 161, 164, *165*, 174–81, *175*, 185, 187–88; artistic abilities, 44, 47, *47*, 176–81, *179–81*; baby doll of, *45*; birth of, 35; and cello, 46–47, 66, 172; *Corner of the Studio* (*Isa Reading*), *A*, *182*; in *Daughters* painting, *pl. 1.6, pl. 1.7*, 4, 25, 55, 87, 95, 180, 212, 216; death of, 181, 188; on life in Paris, 44–45, 73; portraits of mother and father loaned to Museum of Fine Arts, Boston (1956), 206; *Sketchbook – Girls in Pinafores*, *180*; *Sketchbook – Girls Playing Golf*, *pl. 2.16*; watercolor exhibition (Boston, 1929), 181; *When This King Was Just a Boy*, *182*; *See also* Boit daughters

Boit, Julia (sister of Ned), 22

Boit, Lilian (second wife of Bob), 125, 151–53, 166

Boit, Mary (daughter of Bob), *39*, 44–45, 48, 149; photograph of "Uncle Ned," *149*

Boit, Mary Louisa Cushing ("Isa") (wife of Ned)
birth of, 22, 24; childhood, 24–25, *24*; children, 26, 28, 29, 30, 35. *See also specific names*; and *Daughters* title, lack of Isa's name in, 212, 214–15; death of, 147–48; death of parents, 25; described, 22, 31, 36, 42, 133, 136, 145, 146; friendship with Henrietta Reubell, 71, 72; friendship with Sargent, 4, 49–50; illnesses, 28, 29, 46, 126, 147; life in Boston, 22, 24, 25, 26, 29, 123, 125, 126, 129, 131–34, 135–36, 137–40; life in Paris, 41, 42, 46, 67, 71, 73; marriage of, 25; *Mary Louisa Cushing [Boit] as a Child* (*The First Lesson*) (Dexter), 24, *24*, 25; *Mrs. Edward Darley Boit* (*Mary Louisa Cushing*) (Sargent), *pl. 2.13*, 5, 132–34, 140, 160, 189–90, 206; siblings, 24, 25, 26; and wealth, inheritance of, 26, 82

Boit, Mary Louisa ("Isa") (daughter of Ned and Isa Cushing)
adult life, 161, 174–75, *175*, 181, 185, 187; as artistic subject for Julia, 181, *182*; birth of, 35; in *Daughters* painting, *pl. 1.4, pl. 1.5*, 4, 48, 94, 95, 96, 216; death of, 187; described by Bob Boit (about 1886), 126; friendship with Florence Little, 148; and harp, 46–47, 66, 172, *175*; *See also* Boit daughters

Boit, Robert ("Bob") (brother of Ned)
attempt to sell *Daughters* painting (1915), 194–97; on Boit daughters' adult lives, 166, 168–70, 176, 178, 184–85; death of, 186, 199; as family historian, 5, 6, 186; friendship with Isa, 25, 42, 133; marriage to Lilian (second wife), 125, 166; on Ned and Isa's

256

259

261

262

INDEX